DIGITAL AND VIDEO ART

DIGITAL AND VIDEO ART

Florence de MÈREDIEU

CHAMBERS

For the English-language edition:

Translator
Richard Elliott

Art consultant
Dr Richard Williams, University of Edinburgh

Publishing manager
Patrick White

Editor
Camilla Rockwood

Prepress manager
Sharon McTeir

Prepress
Vienna Leigh

Proofreaders
Stuart Fortey
Virginia Klein

Originally published by Larousse as *Arts et nouvelles technologies* by Florence de Mèredieu

© Larousse/VUEF 2003

English-language edition
© Chambers Harrap Publishers Ltd 2005

ISBN 0550 10170 5

Cover image: Philippe Parreno, *Anywhere out of the World*, 2000. Courtesy Air de Paris and the artist.

Typeset by Chambers Harrap Publishers Ltd, Edinburgh
Printed in France by MAME

CONTENTS

Introduction

'Recording something, I feel, is not so much capturing an existing thing as it is creating a new one... Each time a tape is finished it is like the release of a long-held breath, and with it, naturally, is signalled the need for another.'
Bill Viola

Art and technology have always been inseparable. Throughout the ages, artists have used complex and unfamiliar tools and techniques to stimulate their imaginations. Technology is not a neutral instrument: it can impose practical limitations on artists' work. Nevertheless, artists continually take up the challenges posed by technology, shaping and subduing their material with tools and techniques which are often so internalized as to be invisible, but which are also sometimes flaunted like trophies.

Art's relationship with technology is nothing new. However, given the increasing pace of technological advances, the invasion of our lives by machines and the proliferation of tools that come between us and the world around us – even (in the form of artificial organs) intruding upon the living body – we are entitled to ask whether art is currently undergoing a fundamental transformation and whether technology is exerting an increasingly powerful influence on artistic procedures. Or, rather than a radical transformation, are we simply witnessing the inevitable convulsions as new technology takes its place at the heart of an ancient pattern of evolution?

Both views are tenable. Some people point to a qualitative leap and hail the appearance of a 'technological art' whose scope and rules have been precisely defined, with specific techniques serving to map out this new territory. Others, however, emphasize the purely instrumental aspect of techniques that allow different forms of art or expression to meet or merge at the heart of what is referred to as multimedia art.

These two positions are not incompatible: it has been clear since the time of Marcel Duchamp (who added his signature to an

assortment of ready-mades) that artists alone have the authority to determine or define the scope of art. Some people will therefore loudly proclaim the supremacy of technology, while others will continue to see it simply as a tool to be disguised and then forgotten about, like scaffolding or a cumbersome prosthesis.

Wolf Vostell and Nam June Paik invented video art in the 1960s by 'appropriating' the tool: that is, by subverting and disrupting the normal operation of the television set. More complex is the computer in its current form: an apparently efficient, though restrictive, tool that is difficult to appropriate other than by combining it with other media and disciplines capable of redressing or restricting the sometimes excessively academic quality of digital imagery.

It is a complex issue, therefore – all the more so as a genuine transformation of civilization seems to be taking place at the same time. Television and the computer – which have given birth to the two main art forms at the heart of this book (video art and digital art) – have invaded our homes and are now part of the everyday lives of a large portion of humanity.

Another revolution has recently begun that threatens to transform our traditional relationship with the world to an even greater extent: that of the virtual world, of computer-generated images, of interactivity, of spectator participation, of a world of synthetic sensations – all of these contribute to the development of artificial universes which could conceivably compete with, or even to some extent replace, our traditional modes of perception. Our connection with the real world and the relationship we have had with our planet since time immemorial risk being turned upside down as the artificial universe and the world of the image start to predominate.

Communications technology, which is developing at breakneck speed and has become a major economic and political factor, also serves as a support for new forms of art focusing on society and mass communications (sociological art, Internet art, virtual galleries, networks, etc), thus realizing Marshall McLuhan's famous vision from the end of the 1960s of the 'global village'.

The very status of the image seems to have changed and grown at the same time as the relationship we maintain with the world as we perceive it (and thus our sense of reality) has been disrupted. Admittedly, the image has always been the subject of much manipulation and discussion – take, for example, the 7th-century controversy in Byzantium over iconoclasm, which set defenders and

Gary Hill, *Beacon*, video installation, 1990. Aluminium tube, two modified video monitors, projection lens, motor, loudspeakers.

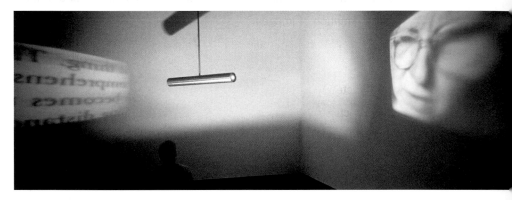

opponents of the image against one another. The 20th century invented neither the disturbingly persuasive power of the image (which has always been used and abused by religion and politics) nor the suspicion with which the realism of the image makes us view the world around us. What is without doubt new, however, is the wide proliferation of this manipulation and the increased power of a system of representation that has now infiltrated all aspects of our daily lives and even our minds and feelings.

The new technological devices operate like invisible and highly efficient branches of a network. These new devices frequently merge with what they convey (meaning, material, organ or object); they are no longer of a tangible nature.

Over the last few decades, the reduction in size of previously highly cumbersome technical devices has had significant consequences for the artist; the development of portable video machines and home computers – easier to use and available to a wider public – has made technology much more accessible. The 19th century was a century of heavy machinery with a strong physical presence: the industrial machines of the day shaped the landscape. The 20th

century ushered in an age of microprocessors, miniaturization, compact devices, and information amassed and stored in invisible databases. Many of these devices are now invisible to the naked eye. This miniaturization is accompanied by a breathtaking acceleration in the processing of data. Artificial intelligence now supports and anticipates human work, and the computing power of today's machines facilitates the rapid transformation and auto-transformation of images.

The images that form the everyday texture of our lives are becoming more and more programmed, artificially generated, calculated and constructed. What power does this give those who create them? As the French cultural theorist Jean Baudrillard observed, today's world has been reduced to a mere imitation of itself. 'Reality' seems to be dissolving and swaying, and virtual worlds are making themselves more 'real' than the natural world. Technology is already providing us with ever more efficient models for action and artificial behaviour; is it now poised to shape all our systems of representation and, as a result, to influence our behaviour and actions? The question remains open.

Faced with such technical efficiency, and with the various constraints that always come with technology, the approach of artists was, for a long time, one of appropriation, vigilance and refusal. In its early days at least, video art was a strongly anti-establishment art form. It developed out of the Fluxus movement (with artists such as Vostell, Paik, George Maciunas and Joseph Beuys) in Germany and America in the 1960s. The first video art by women grew out of the feminist movements of the 1970s.

Heavily dependent on technology and situated in a global context in which art is increasingly regarded as a commodity, art at the turn of the 21st century seems in general more representative of its time and less protest-orientated. And where there is criticism or protest, this is immediately assimilated by the Establishment and the art market.

The areas covered by this book (video art, computer art, multimedia installations, digital art, virtual worlds, interactivity, artists'

CD-ROMs, networks and art on the Net) encompass the whole range of high technology that developed in the second half of the 20th century – video art appeared in the 1960s and computer art (followed later by 3-D art) during the 1970s. But the book also touches on post-World War II art history in general, and in particular explores the invention of the happening and of performance art, and the development of the installation. These structural possibilities have exerted a strong influence on video art and play an increasingly important role in multimedia art today.

Video art and computer art derive from two different technologies and came into being independently of each other. Very soon, however, they started to merge or to complement each other; hence the increasing number of hybrid works that began to be created in the early 1990s consisting of images taken from different sources (both analogue and digital) and whose exact provenance is not in the end always clear.

The dividing line between different art forms – painting, sculpture, installation, photography, performance, and so on – is becoming more and more fluid. All of these forms continuously interact with and feed off the new technologies. These structural changes have been accompanied by a redefinition of the very notion of art, which has become self-effacing to the point of merging with life, or has transformed itself into sociological art, or has gone down the route of protest and political struggle.

Activist video art has been a prominent art form and many artists have used video as a tool in their struggle. Feminist artists have been strongly represented in this area and today women are still especially active in the field of technological art.

However, it is not only the visual arts (painting and sculpture) that have been invaded by new technology; cinema, dance, theatre, music, architecture and photography are also increasingly adopting the new tools. This book can do no more than touch on the vast field of music, but it will examine – from a visual or aesthetic point of view – how architecture, photography, cinema, dance and theatre have been transformed by the introduction of cutting-edge technology.

The means by which works of art are disseminated have also undergone a major transformation. Traditional methods of presentation (in museums and galleries) have been challenged by the emergence of virtual museums and galleries. Many works of art (both old and new) can now be viewed on the Internet or on interactive terminals in art galleries themselves. The number of artists' websites is growing rapidly – these are particularly good at showing work that is in a state of perpetual evolution. Artists now produce work specifically for CD-ROM and for distribution on networks. The means by which works of art are presented to the public is in a state of constant flux, and this influences the nature, the content and the structure of the art. The works themselves are growing lighter; they can cross borders with ease and be exhibited in real time on different sides of the planet. Ubiquity is now the rule. As a consequence, works of art are insinuating themselves into the system of networks – data transmission routes operating via satellites, cables, dish aerials and optical fibres – that encircle the planet like a thick mesh. What might be the impact of these new works conceived specifically for the Web, immaterial works that are present both everywhere and nowhere? It is as if the image is losing everything of which it used to be composed: its pigments, its grain, its very substance.

The image is becoming a ghost image. Computer code is taking over, and our everyday lives are being invaded by artificial substitutes.

BIBLIOGRAPHY

Battcock, G (ed), *New Artists Video: A Critical Anthology*, E P Dutton, New York, 1978

Buskirk, M, *The Contingent Object of Contemporary Art*, MIT Press, Cambridge, MA, 2003

Coyne, R, *Technoromanticism: Digital Narrative, Holism and the Romance of the Real*, MIT Press, Cambridge, MA, 1999

Gere, C, *Digital Culture*, Reaktion Books, London, 2002

Godfrey, T, *Conceptual Art*, Phaidon, London, 1998

Goldberg, R, *Performance Art: From Futurism to the Present*, Thames and Hudson, London, 2001

Goldstein, A and Rorimer, A (eds) *Reconsidering the Object of Art: 1965–1975*, Museum of Contemporary Art, Los Angeles, 1995

Grau, O, *Virtual Art: From Illusion to Immersion*, MIT Press, Cambridge, MA, 2004

Greene, R, *Internet Art*, Thames and Hudson, London, 2004

Hopkins, D, *After Modern Art, 1945–2000*, Oxford University Press, Oxford, 2000

McLuhan, M, *Understanding Media: The Extensions of Man*, Routledge and Kegan Paul, London, 1964

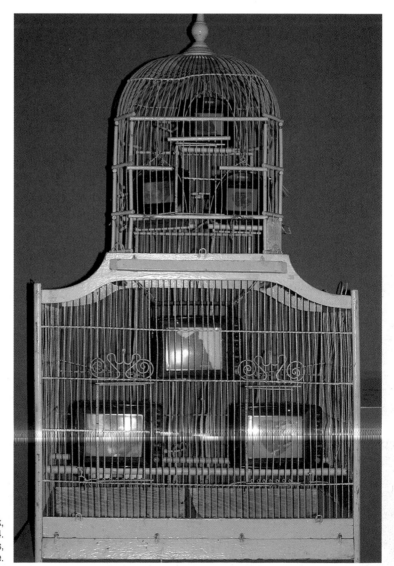

Nam June Paik,
Cage in Cage, 1984.
Birdcage, monitors,
video footage.

Mitchell, W J, *City of Bits: Space, Place and the Infobahn*, MIT Press, Cambridge, MA, 1995

Mitchell, W J, *E-topia: "Urban Life, Jim – but not as we know it"*, MIT Press, Cambridge, MA, 2000

Oliveira, N de, et al, *Installation Art*, Thames and Hudson, London, 1994

Paul, C, *Digital Art*, Thames and Hudson, London, 2003

Popper, F, *Art of the Electronic Age*, Thames and Hudson, London, 1993

Rush, M, *New Media in Late 20th-Century Art*, Thames and Hudson, London, 1999

Rush, M, *Video Art*, Thames and Hudson, London, 2003

Stallabrass, J, *High Art Lite: British Art in the 1990s*, Verso, London, 1999

Stallabrass, J, Broekman, Pauline van Mourik, and Ratnam, Niru, *Locus Solus: Site, Identity and Technology in Contemporary Art*, Black Dog, London, 2000

Stallabrass, J, *Internet Art: The Online Clash of Culture and Commerce*, Tate Publishing, London, 2003

Warr, T and Jones, A, *The Artist's Body*, Phaidon, London, 2000

Youngblood, G, *Expanded Cinema*, E P Dutton, New York, 1970

Synesthésie, an online art review *(www.synesthesie.com)*
This electronic art review – the creation of Anne-Marie Morice and a team of professionals from both the printed and audiovisual media – came online in 1995 with the specific intention of bringing cultural and artistic content to the Internet. The site presents an original, ongoing analysis of contemporary artistic creation and related aesthetic, organizational and social issues in the context of the development of digital networks. The authors are professionals: art critics, academics, writers, sociologists, philosophers and artists. Alongside works of international importance, Synesthésie also presents the work of younger artists and plays an important role as a platform for all kinds of experimentation. Each themed, specially designed issue can be openly accessed. A centre for virtual art (Centre d'art virtuel, CAV) was added to the site in 2002. The site also offers an international diary for contemporary art events with a detailed search function. Events created on the Internet include: Odor, eau d'or, eau dort (a site created at the French pavilion at the 1997 Venice Biennale), Effet de Serre (created in conjunction with the Mission Livres du Conseil général de Seine Saint-Denis in 1999), Identités multiples (review no. 9, created to coincide with the exhibition 'Le Temps déborde' in 2000) and Signes extérieurs (review no. 15, created in partnership with the Art Grandeur Nature biennial, 2004).

Computer art and video art emerged from two technologies which had initially nothing at all to do with art. The function of the computer is to manage information and data logically, rationally and as efficiently as possible. Television is a communications tool that, by adding pictures to sound, extended a process of broadcasting and supplying information that had begun with radio. The basic principles of these two technologies were established in the 1920s, although their technological applications were not developed in the main until after World War II. Artists eagerly took advantage of these tools as soon as they were put on the market, and computer art and video art went on to develop more or less in parallel – it is impossible to determine which came first. An important difference between the two, however, is that television underwent its mass-market development at a relatively early stage, while the computer – technologically more unwieldy and also more expensive – made its appearance in art schools, universities and research centres before it was made available to a wider public at the end of the 1980s. Recent advances in home computers and digital camcorders have put the ability to create and mix sound, images and text within everyone's reach. This is a revolutionary development, whose consequences have still to be assessed.

Key moments in the development of new technologies

1848. In London, Charles Babbage designs the Analytical Engine, the 'forerunner' of the computer, which could be programmed by punched cards.

1923. Invention of the cathode-ray tube.

1926. First demonstration of a television set (John Logie Baird, UK)

1936. First television transmitter.

1937. Howard Aiken designs an electronic calculator.

1940. First experiments with colour television.

1943. Development of the Colossus computer (Great Britain).

1946. Construction of the ENIAC electronic computer (USA).

1948. Program run on world's first electronic computer, the Small Scale Experimental Machine, or 'Baby' (University of Manchester, UK).

1949. First graphic printout from a digital computer (MIT, USA).

1950. First computer connected to a cathode ray tube.

1958. Computers equipped with interactive devices for the first time.

1963. Computer-generated images: first computer graphics software (Ivan Sutherland).

1965. Sony launches the first half-inch black-and-white videotape recorder on the American market.

Development of the computer

'A computer is a system which processes "elements of information" by converting them into signs (numerals, letters of the alphabet, symbols) within a given framework... The computer's task is to transfer the elements from one register to another after subjecting them to certain operations.'
Abraham Moles

The first computers appeared in the 1940s. They were preceded by computing and calculating machines whose origins went back a very long way. In 1643, Blaise Pascal constructed a machine (called the 'Pascaline') which was designed to improve the management of Brittany's finances. This machine was capable of performing additions and subtractions and converting the different currencies of the day. In the 19th century, Charles Babbage developed a machine that could carry out complex arithmetical and logical calculations. Its rudimentary technology, however, means that it cannot really be considered the true forerunner of the computer. This machine was followed by highly specialized calculating machines which used the punched-card system and required lengthy programming. The first electromechanical and electronic calculators were built in the 1930s. The first entirely electronic computer was the ENIAC (Electronic Numerical Integrator and Computer), which was also of the punched-card type.

Before long, machines were being developed that could record programs. These machines had a memory that could store both programs and the data to be processed. Such computers consisted of a calculating unit (arithmetic and logic unit or ALU), a central memory (for storing the programs and the data to be processed) and peripheral input and output devices (allowing contact with the human operator or the environment). A control unit (or internal clock) was responsible for regulating the whole system. Early computers were designed to process digital information. There was a real revolution when it became apparent that all kinds of information could be translated into digital form. This is when the computer started to become a universal data processing tool.

The term 'computer' came into widespread use in the 1950s. The computer's subsequent history took the form of a long series of

improvements with regard to memory capacity (information storage), programming languages, miniaturization, processing speed, the possibility of 'real-time' responses, and so forth. Users were provided with more and more complex machines which were also increasingly efficient and ergonomically easier to use.

The emergence of computer art

'The scientific image – technical, medical, geographical – lies... at the very origins of what we shall refer to here as computer art...'
Abraham Moles

As is always the case with cutting-edge technology (which involves high levels of scientific and financial investment), the digital image was developed initially in an industrial context – in the research departments of a number of large international companies (for example, aeronautical companies such as Boeing and telecommunications groups such as Bell) – and in medical laboratories. The aim of the research in each case was to develop specific technical applications, such as flying instructions for aircraft, the rapid low-cost transmission of information (and images), medical imaging and the construction of robots designed to perform remote surgery. It was only later that the same machinery and techniques were made available to artists. Working with professional artists often allowed industrial companies to acquire a kind of aesthetic and cultural credibility. The work of painters and computer-graphics artists could serve as a foil to the purely technical research, which was far removed from the experience of the general public. The artists' experiments with the new technology, as well as the errors they made, could in certain cases further the purely technical research.

Consequently, a number of companies surrounded themselves with artists and gave them free rein in the knowledge that they would in turn benefit from the artists' discoveries, which were often made in a less restrictive, more random context.

A number of universities (including the Massachusetts Institute of Technology, MIT) soon set up multidisciplinary laboratories in which artists and technicians could work side by side. Computer art in the true sense was therefore preceded by this preliminary stage,

during which technicians engaged in all sorts of experimentation and began to discover the graphic possibilities of the new technology. The first work produced using a cathode-ray tube and an analogue computer was Ben Lapovsky's *Electronic Abstractions*, created in 1952. In 1956, Herbert Franke used the same technology to produce 'Gothic' effects, and Dick Land focused on contrasts of light and dark. A number of artists used the machinery as a tool to generate images that they subsequently worked up using traditional techniques and then turned into paintings, mobiles, and so on. The first computer-generated images were produced in Germany in 1960 by Kurd Alsleben and William A Fetter.

It was not until around 1965, with the pioneering work of Frieder Nake, Georg Nees and Michael Noll, that what could be described as the first proper research into computer-based aesthetics took place. All three artists stressed the experimental nature of their work at that time. Michael Noll, an engineer with the company Bell, embarked in 1963 (with *Gaussian-Quadratic*) on a body of work that strongly reflects the rigour of the medium.

Graphics palette

A graphics tool consisting of a workstation connected to a computer. The graphics palette was widely used during the 1980s.
'My current method involves toing and froing between my manual work table and my automatic drawing table. I amend the program step by step to take account of my manual sketches and in turn amend the manual versions to take account of certain fortuitous results. It is a confrontation between a program that often produces something wild and a human hand which has a tendency to civilize any excesses.' (Vera Molnar)

The first drawing machines and automatic drawing tables also came into being in around 1965. They consisted of a horizontal tray, onto which a sheet of paper was fixed, and a carriage that travelled over the surface of the paper. A computer controlled the movements of the carriage and located the chosen coordinates, and the 'pen' or stylus moved as directed by the machine. Initially, these machines could only be used for line drawings. This explains why the first works made using a computer bore the triple stamp of rigour, geometricism and minimalism – all characteristics of the machines themselves during the early days – and also why these works attracted the attention of artists who sought to achieve this very rigour.

The line is precisely what interested Vera Molnar, the rigour of whose earlier work already bore similarities to what was to follow. A significant part of the attraction of the drawing table with its stylus or electronic pen was that it allowed for the recreation of all the curves and suppleness of the hand-drawn line. Certain tables

– equipped with rolls of paper that could be moved on by winding –
also allowed long sheets of drawings, or 'calligrams', to be
produced.

Next came visual display units using television screens, and
software that allowed a more realistic image to be achieved (such
as landscapes seen from a plane, reflections, transparency and
effects of light). The introduction of graphics cards – allowing for
real-time drawing where the graphic line followed the artist's
movements precisely – represented a considerable advance. As for
realism itself, this depended on the abundance and precision of
details, on textures and on the modelling of light. Research into
movement would later make a decisive contribution to realistic
representation.

The first exhibitions dedicated to the relationship between art and
the computer were held around this time. They immediately met
with resistance, as expressed in the nagging question: 'can
machines create art?' (has anyone ever wondered whether
paintbrushes can create art?). In 1965, the Howard Wise Gallery
in New York staged the exhibition Computer-Generated Pictures,
which featured works by Noll and Bela Julesz. This is generally
considered to have been the first exhibition of computer art,
although Galerie Niedlich in Stuttgart had already exhibited the
work of Noll and Nees a little earlier. These exhibitions were soon
followed by others, such as Computer Gravure in New York and
Cybernetic Serendipity in London.

In Hanover in 1970, an exhibition entitled Komputerkunst
('Computer Art') was held, in which Richard Raymond presented a
new process of disseminating information called 'time-sharing'.
Using a telegraph and a telephone, he established contact with the
computer of General Electric in Los Angeles and succeeded in
broadcasting the contents of its directory.

This link – between Hanover and Los Angeles – was the first
demonstration of what later came to be known by the name
'network'.

In the 1970s, other groups active in the field of computer art
included the Computer Art Society (London), the Computer
Technique Group (Japan) and the Compro Division US (USA). The
development of the drawing machine continued, and the 1970
Venice Biennale devoted a large amount of space to computer-

based work. Eastern Europe and Latin America entered the picture, and research into computer art quickly developed into an international art form.

A mathematical basis

'The square... with all its solidity, the straight line, unperturbed by any sense of relativity, and the curve, which forms a straight line at each of its points; all these realities, which on the face of it have nothing to do with man's daily life, are... of prime importance.'
Max Bill, 1949

In Europe – and in particular in Hungary, Austria, Switzerland, Germany and France – a whole host of artists began working with computers: these included Manfred Mohr, Torsten Ridell, Michael Noll, Vera Molnar and François Morellet. Their work was conducted against the background of a revival of the theories of the ancient Greek philosopher Pythagoras, who regarded the universe as resting on a mathematical framework. The Constructivist and Formalist aesthetics of the early years of the 20th century had given rise to renewed interest in his theories, and generations of artists (Bauhaus, De Stijl, etc) were influenced by the works of Matyla Ghyka (*L'Esthétique des proportions*, 1927, and *Le Nombre d'or*, 1931), Theo van Doesburg *(Composition arithmétique*, 1930) and Georges Vantongerloo (*L'Art et son avenir*, 1924). Mention should also be made here of the role played by decorative arts teaching, which was based largely on manuals and catalogues of easily reproducible motifs and friezes that could be formalized and expressed mathematically. These theories were soon superseded by those of Max Bill (*Die Mathematische Denkweise in der Kunst Unserer Zeit* ('The Mathematical Way of Thinking in the Visual Art of Our Time'), 1949), whose functionalist views paved the way for the art of subsequent decades.

Artists who used the computer began by manipulating concepts rather than images, and by applying mathematical or graphics codes and formulae to their work. The computer simply accentuated and promoted the development of a movement that had already been anticipated by visual artists. A number of artists initially 'simulated' the computer, imitating its procedures by

Nicolas Schöffer

Born Kalocsa (Hungary) 1912. Died Paris 1992.

'From now on, we can no longer make a clear-cut distinction between the visual and the acoustic. The computer will guide us towards an all-encompassing form of perception and creation that clearly represents both the present and future states of human creativity.'

Widely known for his *Cybernetic Towers* (Paris, Liège), Nicolas Schöffer was one of the first artists to recognize the significance of the changes brought about by the development of the computer. He was a fervent defender of cybernetics and a proponent of a 'total art' situated at the crossroads between the visual arts, acoustic art and the performing arts, and as such he established a link between art and high technology. The creation of his famous cybernetic sculpture *Cysp 1* in 1956 was a landmark in his career. *Cysp 1* was a tall piece of machinery consisting of different elements and devices arranged at right angles, with an electronic brain that controlled the movements of its various parts. Equipped with microphones and photoelectric eyes, *Cysp 1* reacted to stimuli from the external world (noises, words, the stamping of feet, the clapping of hands, etc). The work was the centrepiece of a ballet of the same name choreographed by Maurice Béjart and first performed in Marseilles in 1956. Schöffer applied his research to the world of performing arts, collaborating with musicians such as Pierre Henry and dancers such as Alwin Nikolais and Carolyn Carlson (*Kyldex 1*, 1973). In the 1980s he created a series of graphic works with the computer based on the superimposition and permutation of figures (*Choreographics* and *Ordigraphics*).

SELECTED WORKS

– *Cysp 1*, 1956.
– *Kyldex 1*, experimental cybernetic show, Hamburg Opera, 1973.
– *Choreographics* and *Ordigraphics*, 1988–9.

BIBLIOGRAPHY

– Schöffer, N, *La Ville Cybernétique*, Tchou, Paris, 1969
– Institute of Contemporary Arts, *Schöffer*, Institute of Contemporary Arts, London, 1960

operating within a system of extremely strict data and constraints. Art was gradually infiltrated by the methods of scientific research. Vera Molnar in particular was engaged in this type of work between 1960 and 1968. The picture plane was simply regarded as a framework with two axes (horizontal and vertical); each point on the image was given x and y coordinates to which different values could be assigned and which could be varied in a systematic manner (Vera Molnar, *Slow Gyratory Movement*, 1957; *Structure Based on the Letter N*, 1961).

Influenced by Gestalt theory and the functionalist aesthetic of the Bauhaus, the work of the pioneers of computer art (Michael Noll, Manfred Mohr, Roger Vilder, Jacques Palumbo, Vera Molnar, etc) was characterized by its rigour. 'Good forms', geometric simplicity, abstraction and minimalism were the main features of the period. It made perfect sense for artists associated with the Op Art movement to call upon the computer for help. Indeed, much optical art relied on geometric calculations and benefited from the experimentation made possible by a technological treatment of the image. Vasarely, Soto and many others made abundant use of grids, frameworks and watered effects, while Herbert W Franke's work focused on interlocking spherical forms (*Computer Graphics*, 1969). Adopting Abraham Moles' 'informational aesthetic' ('the most simple, most efficient forms are also the most attractive'), Georg Nees created graphic works on the computer during the 1970s (*Computer Graphics*) based on simple, economical forms: shapes redistributed according to the laws of Classical perspective, thus allowing the viewer to play an active role in the process of constructing the image; the proliferation of formal matrices; and the distribution of cubes in space and variations on the theme of the cube, such as cubes that edge surreptitiously out of formation until they merge into one another with overlapping, transparent lines.

Cubes and superimpositions are also to be found in the work of Frieder Nake, who also tried his hand at scrolls and curves. This was the time when Leonardo da Vinci's *Mona Lisa* underwent her first digital transformations (Philip Peterson, *Digital Mona Lisa*, computer graphic, 1965). Lillian Schwartz worked in a similar way at this time (*Pixillation*, 1970).

Vera **Molnar**

Born Budapest 1924. Lives in Paris.

'Ethereal lines emerging on the display screen; these are not real lines but a succession of luminous, shimmering points.'

A pioneer of computer art and the co-founder, in 1960, of GRAV (Groupe de recherché d'art visuel), Vera Molnar has been working with computers since 1968. Influenced by the functionalist aesthetic of the Bauhaus and the rigour of Constructivism rather than by the optical games of kinetic art, she soon developed an interest in the possibilities afforded by the computer. Closely related to both abstract and geometric minimalism, Vera Molnar's work – in which minimal forms (circle, square, etc) are organized into series – lends itself particularly well to execution by computer. The artist plays on the infinite variations made possible by the interaction of a number of simple parameters: for example, the intersecting of lines or surfaces, variations in colour, or the progressive displacement of a line within an ensemble.

Vera Molnar was fascinated by the handwriting in letters sent to her by her mother, and set about simulating the letters (*My Mother's Letters*, 1981–90): 'I am writing to myself, or rather simulating to myself – on the computer – her Gothic-hysterical letters.' Order and disorder, equilibrium and disequilibrium, composition and decomposition meet in these works. Contrary to all the rules of classical composition, the 'hysterical' handwriting tilts towards the right, yet Vera Molnar accentuates the disorderly crescendo of the lines, gradually increasing it. The lines start to repeat the disorder of the previous lines, thereby ultimately creating a certain order and rhythm. Switching between the pen of the plotter, the lines produced by the printer and the manual simulation of her mother's handwriting, she overlaps the different lines, causing them to cross over one another and throwing the whole into disarray.

SELECTED WORKS

– *My Mother's Letters*, 1981–90
– *Quadrilateral Structures*, 1986.
– *How to Upset a Square*, 1988.

BIBLIOGRAPHY

– Hollinger, L, et al, *Vera Molnar: Inventar 1946–1999*, Preysing Verlag, Ladenburg, 1999
– Molnar, V, *ReConnaître*, exhibition catalogue, Musée de Grenoble, Grenoble, 2001

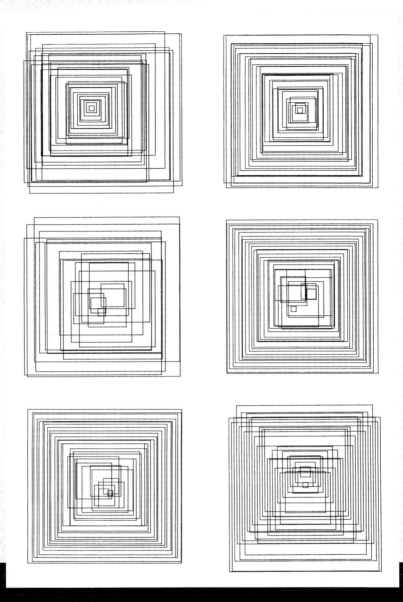

30 Non-Concentric Squares, *1974.*

Here we see six moments, six variations of a single work, presenting interlocking centred and off-centre squares. Vera Molnar has a particular liking for the square because of its perfection and simplicity. The interlocking effect is achieved through a steady reduction in the size of the squares, but instead of being centred on the axis of the first square, the added squares are off-centre, biased to the left, the right, the top or the bottom. This decentring, which occurs within certain limits (neither too great nor too small), is random. The figure thus enriches itself, gaining in complexity.

'From the moment a painter turns to the computer, the emerging image ceases to be a mass of unknown or badly defined forms and colours and becomes a matrix of thousands of distinct, discontinuous, quantified dots. The spatial positions and colorimetric value of these thousands of dots are perfectly defined and digitized. The painter is able to exercise control over each and every one of them, and at any given moment can change the value of a single dot, of several at a time, or of all of them together. As a result, the painter can make countless successive variations (or sketches, to use the 'official' artistic term) appear on the screen. Proceeding by small steps, he can arrive at the precise image of his dreams.'
(Vera Molnar)

Order and disorder, variations and contrasts

'I completed a series of studies in which disorder increased steadily, indeed to such an extent that the basic regular structure disappeared completely. In order to see "how far I could go too far" (Cocteau), I treated myself to a slow visual progress from order to chaos.'
Vera Molnar

Strictly governed by codes and programs, the digital image is the perfect example of an image that can be controlled from beginning to end, and one can understand why artists chose to experiment with this rigour and regularity. It was possible to exploit the potential for variation by introducing parameters which were designed to upset the symmetry or harmonious organization of the image. Naturally this process of 'disruption' is also strictly controlled, but it nonetheless constitutes an interesting formal game. By introducing 1% uncertainty into a quadrilateral made up of 25 quadrilaterals themselves composed of other, strictly interlocking quadrilaterals, Vera Molnar (*1% disorder*, 1976) has pointed up in ironic fashion the implacable nature of computer graphics.

One of the characteristics of these works is their unfixed, indeterminate nature. From a given series of variations produced by the computer, artists can choose one or several versions that they can fix and make permanent by according them the status of 'works of art', but the system still remains unfixed to a dizzying extent. Thus Vera Molnar can talk about the 27,600 versions of a work that can be obtained by systematically varying the parameters of a specific program. The term 'permutational art' came into use to describe digital images that admitted all kinds of variations as well as works that presented themselves as a series of individual versions. These different versions could remain virtual, while certain of them could be recognized by the artist as particularly striking, printed onto a support and preserved.

At the same time as experimenting with form, artists embarked on systematic studies of colour: chromatic games, simultaneous contrasts and the relationship between form and colour. These studies were based on a thorough knowledge of the psychophysiology of perception. The study of optical games led to the animation of coloured surfaces. Games with kinetic lighting

represented the first forms of what would later be described as 'environments'.

During the decades that followed, however, there was a trend towards more complex forms: an interest in figuration, in vivid colours, in the use of textures and in computer-generated lighting effects. This led to elaborate spatial productions that opened up the way for a new form of realism based on the systematic use of formal stereotypes.

BIBLIOGRAPHY

Goodman, C, *Digital Visions: Computers and Art*, Harry N Abrams, New York, 1987

Loveless, R L, *The Computer Revolution in the Arts*, University of South Florida Press, Tampa, 1986

Malina, F, *Visual Art, Mathematics and Computers*, Pergamon Press, Oxford, 1979

Mohr, M, *Divisibility: Generative Works 1980–1*, Galerie Gilles Gheerbrandt, Montreal, 1981

Moles, A, *l'Art et l'ordinateur*, Casterman, Paris, 1970

Molnar, V, *ReConnaître*, Musée de Grenoble, Grenoble, 2001

Noll, M A, 'The Beginnings of Computer Art in the United States: A Memoir', *Leonardo*, September 1994

Paul, C, *Digital Art*, Thames and Hudson, London, 2003

Popper, F, *Art of the Electronic Age*, London, 1993

The development of television and the emergence of video art

'As collage technique replaced oil paint, the cathode ray tube will replace the canvas.'
Nam June Paik.

Television is a mass-market tool that has had enormous repercussions on society. Its widespread nature and the dense communications network into which it has gradually developed have fundamentally changed the way we live and think. It is not surprising that artists seized upon it so readily, creating from it what came to be known as 'video art' – an art form that continues

to develop and to go from strength to strength even now, at the start of a new millennium.

The first 'image analysers' came into use in 1936, the year in which the first major television broadcast (in Berlin, during the Olympics) took place. The types of broadcasting system currently in use first appeared in 1941 (in the USA) and 1951 (in Europe). Colour television saw the light of day in 1953 in the USA (the NTSC system, followed in 1966 by PAL and SECAM). The video image is an image converted into an electronic signal. This conversion is carried out dot by dot and is the result of scanning the even and odd lines that form an interlaced raster.

The first artistic experiments with video need to be considered both from a technical point of view and in terms of the institutions involved. It is not enough for a new technology simply to develop; the relevant machines and tools also need to be made available to artists. In the case of video art this happened at different times in different countries. At the forefront of technological developments was the USA, and it was there that the first small groups of video artists sprang up. These artists enjoyed pre-eminence for a considerable time before the baton was passed on to Japanese and European artists.

In America, large television companies were very quick to place equipment and TV channels at the disposal of artists, thereby allowing them to get their work out to a wide audience. From the 1950s onwards, WGBH (a Boston-based television station) made airtime available for all sorts of experimentation, broadcasting a series called *Jazz Images* in which music was accompanied by abstract electronic images. In around 1970, the San Francisco channel KQED started up the experimental workshops that later became the National Centre for Experiments in Television. These workshops attracted considerable artistic talent. Other channels and experiments followed. American artists thus benefited from a far more favourable working climate than was available in Europe at the time.

American video art got off to a head start and for a long time Europe lagged behind. In Great Britain in the 1980s, institutions such as the British Film Institute and the Greater London Council promoted early experiments with video, and Channel 4 soon followed suit.

Fluxus, Paik and Vostell: the birth of video art

```
'I use technology in order to hate it more properly.'
'I make technology look ridiculous.'
Nam June Paik
```

In any discussion of video art, mention must be made of Fluxus, the movement founded by George Maciunas in Germany in 1962–4, and the pioneering role played by a number of exceptional individuals involved with it, such as Nam June Paik and Wolf Vostell. Video art arose in the double context of the experiments conducted on the one hand by artists such as John Cage, Robert Rauschenberg, Merce Cunningham and David Tudor in the USA and on the other hand by the artists in Germany associated with the Fluxus movement, which would soon bring European and North American artistic energies closer together. The movement found itself from the outset at the crossroads between a number of different art forms (painting, sculpture, music, dance, performance, etc), and video art was therefore exposed from the start to a wide range of diverse influences. The influence of Fluxus (whose name was chosen to convey the movement and fluidity of life and refers to the ideas of Heraclitus) extended far beyond its official lifespan, whose brevity can be explained by the experimental, chaotic and anti-establishment character of its members' work. The first major Fluxus festival was held in Wiesbaden in 1962. Uniting European, American and Japanese artists strongly influenced by Duchamp, Dada and the demonstrations organized at Black Mountain College from 1952 onwards by Cage, Cunningham and Rauschenberg (who used television screens during the course of one of these demonstrations), the spirit of Fluxus was actually born towards the end of the 1950s. It was to have a lasting impact.

Through the dissemination of tracts and the organization of Fluxus festivals, George Maciunas created a federation between all the various individuals on both sides of the Atlantic.

The use of television (by Paik, Vostell and, occasionally, Beuys) was only one of the ingredients that went into Fluxus, which considered itself primarily as a experimental movement uniting all the arts. The history of Fluxus is intertwined with that of the happening, launched by the American Allan Kaprow in 1958. It was

Joseph **Beuys**

Born Krefeld (Germany) 1921. Died Düsseldorf 1986.

'I am not saying the medium (television) is bad in itself. I am simply suggesting that it be used in a different way. What interests me is how I should approach it - both mentally and physically - in order to turn it into something completely new.'

Joseph Beuys was one of the greatest German artists of the post-war period. He produced a large number of works, creating sculptures, objects and installations as well as performances, but turning only occasionally to the medium of television. During the 1960s, Beuys was one of the main members of the Fluxus group, and it was during this time that he integrated video into his work. The notion of 'social' sculpture was important to him and led him to accord an important place in his work to the media and tools of mass communication, diverting them from their primary purpose. In 1965, Beuys presented his performance action *How to Explain Pictures to a Dead Hare*. His head covered with gold leaf and honey, and wearing an iron-soled shoe on his right foot, Beuys explained and commented on paintings, for three hours, to a dead hare held tightly in his arms. The action taking place in the gallery was watched by the public from the outside – through a glass door and a window that looked out onto the street. A television set outside on the road broadcast live images of what was going on inside the gallery. In 1977, during a satellite link between Kassel and Caracas involving Paik and Douglas Davies, Beuys assumed the role of a journalist in order to present his own version of the television news. A number of his works were transferred onto video (in the form of 'multiples'). In 1984 he took part in the media arts event organized by Nam June Paik at the Centre Georges Pompidou in Paris, giving a performance with his daughter Jessyka which was relayed by satellite to New York.

BIBLIOGRAPHY

– Beuys, J, *Joseph Beuys: Films et Vidéos*, exhibition catalogue, Centre Georges Pompidou, Paris, 1994
– Buchloh, B H D, 'Twilight of an Idol: Preliminary Notes for a Critique', *Artforum*, 18 (5): 35–43, January 1980
– Ray, G (ed), *Joseph Beuys: Mapping the Legacy*, Distributed Art Publishers, New York, 2001

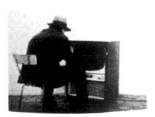

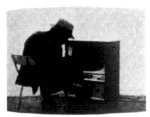
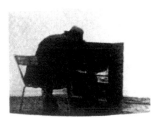

Felt TV

An action performed at Gallery 101 in Copenhagen in 1966 and filmed in Düsseldorf in 1970 by Gerry Schum.

Wearing his felt hat, Beuys sits in front of a television whose screen is covered by a panel of felt (an insulating material used systematically by Beuys in all his work). He lifts a corner of the felt to reveal interference on the screen. Slipping on a pair of boxing gloves, Beuys begins to hit his own face and shoulders. He then performs various rituals of 'energy transmission' using a piece of black pudding, whose 'bloody' end he applies to the felt. The noise of the television – music and talks about animals and the economy – can be heard throughout the entire action.

In this work, Beuys treats the medium of television as a source of energy, but also as a device to capture and redirect energy. Hence the creation of a ritual designed to protect or augment human energy potential.

Nam June **Paik**

Born Seoul (South Korea) 1932. Lives in New York.

`'I am a poor man from a poor country, so I have to be entertaining all the time.'`

The history of video art is difficult to separate from the figure of Nam June Paik, one of the principal founders of the art form. After studying aesthetics, philosophy and music (in Tokyo and then Germany), he discovered the work of John Cage and decided to apply the principles of the 'prepared piano' (whereby various objects are placed on the strings inside the instrument) to electronics. Paik's first work involved distorting and interfering with pictures from television programmes by bringing a magnet into contact with the cathode-ray tube. He gave the first public demonstration in the Galerie Parnass in Wuppertal in 1963. This has come to be seen as the official birth of video art. In New York, Paik was the first artist to start using the Portapack (a portable video camera). He made the first ever art video by filming the city from the taxi that was taking him to the café where the film (*Café Gogo, 152 Bleecker Street, 4 and 11 October 1965*) was then shown. Paik attended all the major Fluxus festivals, presenting a blend of video, music and performance. He then began to devote himself to video sculpture, creating a large body of installations. His sphere of activity gradually extended to the wider world of communications and in 1984, from the Centre Georges Pompidou, he created a tribute to George Orwell that consisted of the live transmission of events being held jointly in New York (with Cage, Cunningham, Allen Ginsberg and others) and Paris (where Beuys was performing an action). These elements were combined with images that had been pre-recorded in Cologne (with Dali, Stockhausen and the Argentinian composer Mauricio Kagel).

SELECTED WORKS

– *Zen for TV*, 1963.
– *TV Bra for Living Sculpture*, 1969.

- *Global Groove*, 1973.
- *Video Buddha*, 1974.
- *Moon Is the Oldest TV*, 1976.
- *Guadalcanal Requiem*, 1976.
- *TV Aquarium*, 1977.
- *Merce by Merce*, 1979.
- *Tricolor Video*, 1982.
- *Good Morning, Mr Orwell*, 1984.

TV Cello
Videotape, 1971

Paik's videos, performances and actions with the cellist Charlotte Moorman – wearing a bra consisting of two small television screens (*TV Bra for Living Sculpture*, 1969), playing either a real cello or a cello made up of television sets, or lying on a 'televisual' bed (*TV Bed*, 1972) – are canonical works of 20th-century art. They contain all the fundamental elements of video art: sculptural use of a television set, performance (involving the presentation of a living person), musical references and distortion of the image for artistic purposes. The performance aspect was based on a number of different systems; an image of those watching could appear on the screens of the 'cello', and the image itself could be modified by using a magnet or by using interference from the sound of the cello.

- *Beuys/Voice*, 1987.

BIBLIOGRAPHY

- Hanhardt, J G, 2, Guggenheim Museum, New York, 2000
- Paik, N J, *Nam June Paik: Video Works 1963–88*, exhibition catalogue, Hayward Gallery, South Bank Centre, London, 1988

against this adventurous, ever-changing and highly productive background that video art took off. Fluxus, being primarily a celebration of life, irony and protest, was suspicious of the word 'art'. It promoted the values of the moment – the ephemeral, the fortuitous, the everyday (as opposed to the 'noble arts') – and created an enormous melting-pot of objects, gestures, musical scores, communications, concerts, happenings, etc. This was an art that admitted the unforeseen, the banal and the derisory. Communications tools (train, telegraph, telephone, etc) joined in the activity, dragging in with them the new medium of television. The spirit with which the first 'video actions' of Paik and Vostell were imbued was thus very different from that of the later video installations of 1980–90. It was close to the spirit of Dada, seeing itself as anti-establishment and following in the footsteps of Marcel Duchamp, and indeed the history of video art is first and foremost the history of its opposition to the medium of television. Paik and Vostell excelled at hijacking what at the outset was no more than a mass-market communications tool. Paik organized happenings and gave 'concerts' long before turning to video. He started to think about the electronic medium in 1960–1. In 1963 he sold everything he owned in order to buy himself thirteen television sets and showed thirteen different versions of the same recorded programme at the Galerie Parnass in Wuppertal. This was before Paik could afford a video recorder and he had to work from 'ready-made' images provided by mainstream television programmes. He devised thirteen different ways of distending and distorting the image, working on the horizontal and vertical holds that control the appearance of the image on the screen. These television sets 'prepared' by Paik thus echoed the 'prepared pianos' of John Cage.

In May of the same year, Wolf Vostell realized his very first video 'dé-coll/age': a wall of six 'malfunctioning' televisions with fuzzy screens covered in splashes of paint, pierced with bullet holes, and so on. He recorded a number of images from a malfunctioning television set using 16-mm film (*Sun in Your Head*) and showed them at the Smolin Gallery in New York. He also made sculptures out of exploded television sets and various pieces of scrap material.

Video art was thus invented – in two different places almost

simultaneously. Vostell had already anticipated it to a certain extent by introducing a malfunctioning television wrapped in barbed wire into his 1958 work *Black Room*, an environment evoking the massacres of Auschwitz and Treblinka. The following year, he devised a project for a happening (unrealized), in which instructions would be shouted out at television viewers ('walk', 'run', 'kiss the TV', etc). In its earliest days, video art was based on the principle of subversion. Already, two distinct groups were emerging: the first, personified by Paik, was interested in the image, in the television as a unit and in the treatment of 'videographic material'; the second, represented by Vostell, made frequent use of scrap or salvaged materials and not only emphasized the ironic aspect (also present in Paik's work) but also succeeded in positioning itself sociologically and politically as a radical critique of the consumer society.

In 1969 the Howard Wise Gallery in New York organized an exhibition called 'TV as a Creative Medium'. In Germany in the same year, two more galleries, Galerie TV in Berlin and Video Gallery in Düsseldorf, embraced video art and set themselves up as distributors of limited-edition videotapes.

Happenings, performances and participation

'Using a television set to encourage the public to act ... Making the public act is a constant in my happenings and is where their real novelty lies. Until then, the public had never participated to such an extent in the creation of a work of art.'
Wolf Vostell

The happening was a feature of video art from the earliest days – in the work of Paik as well as in that of Vostell. Not having access to television stations at the beginning of the 1960s, Paik produced work that was designed to be shown in galleries; hence the development of what is generally known as the 'installation' (in which the artist takes over a space and introduces objects into it) and the happening. During happenings, artists put themselves in front of an audience – generally a collection of people similar to those that attended private views – and carried out an action whose aim was usually to surprise or shock the spectator.

Wolf **Vostell**

Born Leverkusen (Germany) 1932. Died Berlin 1998.

'My films are sequences of psychological experiences and pedagogical processes in which boredom, delay, repetition and distortion are considered analogous to the world around us.'

Vostell became interested in the artistic potential of electronics in 1954, when he was associated with the Electronic Music Studio in Cologne. He was a very active member of Fluxus, one of the pioneers of video art and

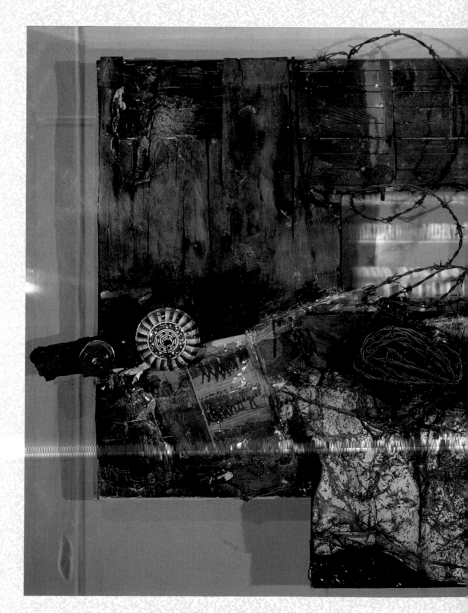

the inventor of the 'dé-coll/age' principle, which went far beyond the boundaries of video art. The inspiration for dé-coll/age came from the torn posters removed from walls by the Paris-based 'Affichistes' (Hains, Villeglé, Dufrêne). This action, consisting of unsticking an image from its support, had a deeper significance relating to the ideas of destruction, wearing away, misappropriation and even erasure. Applied to the medium of television, the aim of this principle was to disrupt normal programmes by interfering with the image and the way it was presented. This involved removing and replacing images one by one, editing images into a loop and erasing images.

Vostell sought to expose the different levels of the viewer's consciousness and psychology by revealing the ideological mechanisms on which use of the medium is based: 'Our accumulated prejudices are the psychological equivalent of posters stuck on top of each other.' The television set itself was made to malfunction, disrupted, damaged, riddled with bullets or tuned into a channel with nothing on it. At the same time, Vostell also created pictures of a highly material nature which incorporated television sets.

SELECTED INSTALLATIONS
– *TV Dé-coll/age*, Smolin Gallery, New York, 1963.
– *Electronic Happening Room*, 1968.
– *Endogene Depression,* video environment inhabited by live turkeys, 1975–80.
– *Media Plan*, realized in Cologne for the *Hamlet* directed by Hans-Günther Heymes, 1979.
– *Butterfly TV*, 1980.

BIBLIOGRAPHY
Vostell, W, *Wolf Vostell: Environment, Vidéo, Peintures, Dessins 1977–85*, Musée d'Art Moderne, Strasbourg, 1985

German View from the Black Room Cycle, assemblage with television set, 1958–9.

The subsequent history of performance was of video's interaction with it. Coming from a background of poetry, photography and film, Dan Graham held his first performances in the 1970s. Initially he used 16-mm film, but soon discovered the remarkable possibilities of video, in particular the phenomenon of feedback, which allowed for the framed interlocking of situations and for interesting space-time delays. In 1970, while crawling, rolling over and moving around on a platform facing an audience, he pointed a video camera at a TV monitor positioned at the back of the room, resulting in a succession of interlocking images – an expression of the subjective, 'restless' vision reflected in Graham's movements. The spectators, turning around, could not meet their own gaze on the screen, but could only see the backs of their heads; they could, however, see the faces of the other members of the audience as they looked into the camera.

Performance

Synonym for 'action'. A form of artistic expression involving the staging of acts or events that usually make use of the body of the artist and sometimes that of the spectator. Essential to an understanding of contemporary art, performance is where visual arts and performing arts meet. A large number of video artists have turned to performance. Performance art distinguishes itself from the installation or the environment in that it incorporates into its structure human participation and the development of an action in a specific, limited time and place. An action comes to an end, whereas an installation does not. This type of event was closely related to the development of Body Art at the beginning of the 1970s.

The characteristic features of video as a medium thus became quickly established – in particular a propensity for narcissism. The video camera functioned like a kind of electronic mirror with a slight delay and returning a slightly distorted reflection, thus allowing artists (or spectators) to play with their own image. Marshall McLuhan picked up on this straightaway: 'It is this continuous embrace of our own technology... that puts us in the Narcissus role of subliminal awareness and numbness in relation to these images of ourselves.' In a number of installations the monitor simply played mirroring games, reflecting and duplicating the elements of the installation. One such work was Catherine Ikam's *Identity III* (1980), in which the image of the artist's face was fragmented over several monitors. But the duplication of images was often disrupted and the image shown on the monitor corrupted or out of phase, as in *The Head of M* (1977), an installation by Jochen Gerz in which the figure 'reflected' in the television monitor curiously echoed a puppet (or statue) which was also equipped with a mirror and a sickle and fixed in the same pose.

For a long time, artists recorded their performances. Here, video served as a simple recording tool allowing archives to be created –

particularly important in the case of an art form as ephemeral as performance art. Performances that integrated video into the actual unfolding of the action form a quite distinct category. In 1968, *Iris*, a closed-circuit video installation by Les Levine, presented the viewer with three televisions and three video cameras. Viewers discovered that they were being filmed and their image instantly relayed in close-up, medium shot and long shot. Paik's *TV Buddha* (1974), in which the Buddha contemplates the playback on television of his own image, is the archetypal identity-within-an-identity work. Juan Downey took up the theme again in 1980 in *Venus and Her Mirror*, in which a video monitor rather than a mirror reflected the image of Velázquez's *Venus*.

Feedback

Action carried out by an information system on itself. In 1913, the term 'feedback' was first used to designate the regeneration of a shrill, modulable sound signal produced when a microphone is pointed at the loudspeaker to which it is connected. The same phenomenon is produced when a camera is pointed at the screen of the monitor to which it is connected: the image on the monitor is reflected into infinity. This procedure has been widely used by video artists. Varying camera position, camera angle or lens allows all kinds of interlocking, scrolling, split and multiple images to be generated. In 1978, Jochen Gerz used feedback as the main element of one of his installations, the frame of the television set reproducing successive, infinitely reflected images of the frame of the television set.

An international art form

'A miracle tool that allowed us to control our own work — live — by checking the monitor and immediately being able to view the recorded elements. The same procedure, in fact, as drawing or painting. That's what interested me about video.'
Ulrike Rosenbach

The beginnings of video art in Japan go back to 1968, when Yoshiaki Tono and Katsuhiro Yamaguchi showed their work *Say Something Now, I'm Looking for Something To Say* in Tokyo. Around this time, video collectives – such as the Toronto-based group General Idea – began forming all over the world. The year 1971 saw the emergence in Montreal of Vidéographe, a group that would play an important social role. Its aim was to enable everybody to make (and show) their own videos.

The first American videos were shown the same year in the Kunsthalle in Düsseldorf, and in 1974 an exhibition was held at Cologne's Kunsthalle showing videos by a hundred or so artists from different countries. This included video installations by Nam June Paik, Dan Graham and Peter Campus.

Video in France was essentially activist in origin. It went back to 1968 and its aftermath, and was informed by the political

Vito **Acconci**

Born New York 1940. Lives in Brooklyn.

'Television is a rehearsal for a time when human beings no longer need to have bodies. The way a movie projector shoots images onto a movie screen, the television set 'shoots' images into the viewer: the viewer functions as the screen.'

Vito Acconci, one of the major performance artists of the 1970s, is representative of those artists who used video to retranscribe and fix permanently performances that were essentially ephemeral. In such cases, video is a narcissistic or conceptual medium recording simple, almost banal acts. Merce Cunningham said he saw dance as an experiment, as a form of research, as a meditation on everyday movement, and the experiment that Vito Acconci patiently records (such as moving around, sitting down, lying down or walking along blindfolded) is a similar one. The point is to test the limits of endurance of the artist's body – and of the viewer's powers of attention.

Acconci also turned the video camera into a means of communicating with the viewer. He addressed viewers directly, hurled abuse at them, adopted their own stance by staring straight back into what was initially the camera but subsequently became the eyes of the viewers of the videotape. The body is at the centre of the scenario – Acconci's, presented in a variety of ways, but also the viewer's, who finds himself or herself caught in a game of mirrors or echoes, in a confrontation of the most disturbing kind.

Acconci does not see art as a self-contained universe but as a tool to help us understand and change the world around us. Artistic experience is something to be applied to real life. Acconci's art has a 'use value' and its medium of choice is the body. The themes it examines – identity, sexuality, the role of the viewer vis-à-vis the new media – turn the camera and the video monitor into a kind of indispensable artificial limb.

SELECTED WORKS

Installations and performances:
- *Air Time*, 1973.
- *The Object of It All*, 1977.
- *Head Capsule (for Mind and Body)*, 1984.

Video:
- *Red Tapes*, 1976–7.

BIBLIOGRAPHY

– Acconci, V, *Vito Acconci/Acconci Studio: Para-Cities, Models for Public Spaces*, exhibition catalogue, Arnolfini Gallery, Bristol, 2001

– Linker, K, *Vito Acconci*, Rizzoli, New York, 1994

– Shearer, L, *Vito Acconci: Public Places*, exhibition catalogue, Museum of Modern Art, New York, 1988

– Ward, F, Taylor, Mark C and Bloomer, Jennifer, *Vito Acconci*, Phaidon, London, 2002

Centers
Videotape, 1971

With his stare and his finger pointing directly at the viewer, Acconci faces the camera and fixes his gaze very precisely on the centre or focal point of the scene – that is, of the double scene where observer and observed are brought together and interact. The tape lasts 22 minutes and 28 seconds, during which time the only recorded changes are in Acconci's state of tension and a visible weakening in his physical stance. Two linked elements support and sustain each other: the intimacy of the relationship between viewer and artist and the unfolding of the work in real time.

struggles of the time. The user-friendliness of the video camera, its relatively low cost and the possibility of immediate playback made it a perfect tool for social comment. New ways of disseminating images were discovered and many alternative, militant organizations such as Video Out (1970) and Les Cent Fleurs (1973) sprang up. They became involved in actual acts of guerrilla warfare directed largely against the institutional media (newspapers, television, etc) and took a stance on issues of the day such as the Palestinian question, the Black Panther movement and the Attica Prison uprising.

Following closely on their heels, a number of visual artists turned enthusiastically to the medium of video – Robert Cahen, Dominique Belloir, Patrick Prado and Thierry Kuntzel all made their first videotapes around this time. Jean-Luc Godard also started making political videos.

In 1970, Edmund Alleyn exhibited *L'Introscaphe* at the ARC

Dominique Belloir (and Rainer Verbizh), *Flippers*, installation, 1974. General view and detail.

(Musée d'Art Moderne de la Ville de Paris). Visitors entered this egg-shaped cockpit-like object, sat down inside it and watched a medley of popular television programmes. But it was not until 1974 and the exhibition 'Art vidéo Confrontation 74', again held at the ARC and organized by Dany Bloch, that video art was officially recognized in France

This exhibition featured numerous videos (Nil Yalter), environments or installations (Paik, Dan Graham, Frank Gillette) and actions or performances (Fred Forest, Léa Lublin). Also shown and greatly admired was Roland Baladi's motorcycle video, shot from the back of a

motorcycle as it traces out the word PARIS on the streets of the city. In 1979, French television showed a series of five programmes documenting the work of video artists (*Vidéo 2*) that had already been seen on American television. This was followed – again on a state-owned channel – by *Juste une image*, a programme produced by the INA (Institut National de l'Audiovisuel, the French national radio and television archives). Video showings were also held at the American Center in Paris each month. This gave French artists the opportunity to discover the work of their US counterparts such as Paik, Dara Birnbaum, Bill Viola, Joan Logue and Gary Hill. In 1978, Robert Wilson created a series of short video works at the Centre Georges Pompidou entitled *Video 50*.

Special effects and collages

'For the rabbit-hole sequence in Alice in Wonderland, Averty wanted six thousand collages like those by Max Ernst! Dreamlike images infused with the spirit of a little Victorian girl's secrets, from Pre-Raphaelite eroticism to the horrors of Jack the Ripper. All in all there must have been fifteen hundred and they weren't even seen! He had a tower constructed in the studio, the collages were stuck onto the tower and the camera, on a crane, rotated inside. What's more, he superimposed *tournette* [optical disc] effects and lightning effects over the top of it all.'
Roger Dauvillier

Having joined Radio Télévision Française in 1952, Jean-Christophe Averty invented his famous, unclassifiable *écritures vidéographiques* (video writings) while working for the state broadcaster, producing a total of over five hundred programmes including variety shows,
dramas, documentaries, reports, jazz shows and stage productions. With his invention of the electronic collage, Averty was following in the tradition of ingenious craftsmen and special effects men such as Georges Méliès and Raymond Roussel, as well as Dadaist and Surrealist collage-makers such as Francis Picabia and Max Ernst. Many of the devices developed by Averty and his collaborators were originally manually operated and consisted of optical discs or *tournettes* that turned on their

Jean-Christophe **Averty**

Born Paris 1928.

'What I do resembles printing more than any other form of expression because I print images in several passes, just as colours are printed using the four-colour process... '

What is original about Jean-Christophe Averty is that he belonged not to the world of art but to the world of television, a new medium that he appropriated and deconstructed with devastating wit. He took a surrealist approach to television. For him it was a 'dissecting table' on which one could encounter fantastic objects and characters from the world of literature

(Apollinaire, Raymond Roussel), avant-garde art (Duchamp, Picasso), jazz, entertainment (Henri Salvador, Yves Montand) or fashion (for a long time he produced *Dim Dam Dom*, Daisy de Galard's popular magazine that was a mixture of different genres, allowing him to give free rein to his imagination). Averty invented

Impressions of Africa, after Raymond Roussel, 1977.

the 'electronic collage', which replaced the glue-and-scissors special effects he had previously developed with his colleagues. His images were liable to suddenly disappear, reappear and change. The use of cardboard scenery (containing 'windows' and cut-outs), backdrops (often animated by mechanical systems), rasters, shutters and masks made possible all sorts of ingenious and imaginative tricks. A pioneer of the televisual image, for which he invented a unique language that remains unrivalled today, Averty paid homage to his illustrious forerunners Méliès (the king of cinematic special effects) and Roussel (the inventor of an automatic 'painting machine' that seems to have anticipated electronic scanning). In his works, Averty's characters stand out against dark or fantasy-style backgrounds: they lose their heads, or find themselves straddling the moon or levitating in deep space. Element-within-element was the order of the day: Averty's figurines enter and exit the sets, but are just as likely to leave the screen and enter a theatrical world which, in turn, contains other miniature worlds.

SELECTED WORKS

– *Green Grapes*, 1964.
– *King Ubu*, after Alfred Jarry, 1965.
– *Alice in Wonderland*, after Lewis Carroll, 1970.
– *Impressions of Africa*, after Raymond Roussel, 1977.
– *The Breasts of Tiresias*, after Guillaume Apollinaire, 1982.

BIBLIOGRAPHY

– Duguet, A, *Jean-Christophe Averty*, Dis Voir, Paris, 1991
– Siclier, J, *Un Homme Averty*, editions Jean-Claude Simoën, Paris, 1976

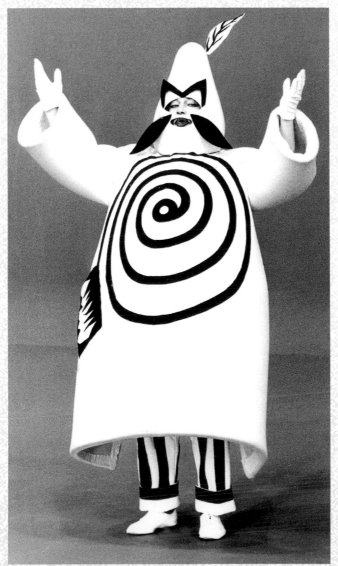

Ubu Enslaved, after Alfred Jarry, 1971, with Benoît Alemane as Ubu.

horizontal or vertical axes, causing elements of the scenery or background to change.

These complex, extremely graphic animated backgrounds allowed the juxtaposition or superimposition of different movements, and Averty played brilliant games with the effects produced in this way. Changes of scale, transitions from black to white (and vice versa), contrasts of form (horizontals/verticals, curves and straight lines, stars, check patterns, waves, clouds, etc), repetition of motifs, variations of speed in the scrolling of the image – all of these made possible the superimposition of numerous images, one layer on top of another.

These combinations of images sometimes led Averty to tamper with the work of the artists he was dealing with – this can be seen in a programme on Vasarely entitled 'Vasaverty', an example of what Anne-Marie Duguet described as Averty's 'visual dynamism'. The treatment of the image here is graphic and meticulous. It is based on the play of strong contrasts, on the systematic use of black and white and on well-delineated motifs. Averty also systematically exploited the vast field of popular imagery: playing cards, postcards, manufacturer's labels, illustrations, medallions, as well as the whole range of graphic signs such as waves, stars, checks, letters, numbers, clouds, diamonds, hearts, and so on. Special effects and the manipulation of the image are one of the main features of video art and a theme to which we shall return. For the moment it is enough to be aware of the special place occupied in this field by the creator of *Green Grapes*.

Cut-in

An electronic process involving the replacement of one part of a televisual image by another. This process, a form of 'electronic collage', is largely responsible for lending the video image the hybrid character that gives it its edge. The cut-in allows dissimilar images to be mixed and stitched together. Many artists have adopted this technique. Michel Jaffrennou used it extensively in works such as *Videoperettas*, *Videoflashes* and *Jim Tracking*, which are often reminiscent of the visual gags and poetry of the films of Méliès.

Tournettes

Pierre Trividic, Averty's assistant, described the way these little machines worked as follows: 'The first layer is a starry sky: a black, star-spangled disc is placed in front of a camera and turned by an assistant with all the forceful, lyrical slowness appropriate to the movement of the planets. This background of stars forms the base onto which other layers of images are later added...' Waterfalls banknotes... the whole thing builds up and blends together until eventually Dalida appears, singing 'Money Money'.

The first experiments with colour

'Colour complicated matters, especially for people like me who love abstraction and strongly contrasting images...'
Jean-Christophe Averty

Paik and Vostell's first work took as its starting point black-and-

Copy art

The electrography (or xerography) process was developed in the USA and Germany in 1938, and the first operational machines came into use in 1959. Copy Art, which uses the photocopier to create images, makes frequent use of the principle of reproduction or multiplication and plays on the process of transformation effected by the alchemy of light at the heart of the technology. It started to develop when the first photocopiers (such as the Xerox 914, dating from 1960) were made available to the public. In North America, Copy Art began to appear after 1970. An exhibition entitled 'Electroworks' was held in Rochester in 1979 and Canadian galleries organized further Copy Art exhibitions in the same year. Copy Art made its first appearance in France in 1975. In 1983, the exhibition 'Electra', held in the Musée d'Art de la Ville de Paris, devoted considerable space to it, showing work by Gudrun von Maltzun, Nicole Metayer, Paul-Armand Gette, Daniel Cabanis, Pati Hill and others. Pati Hill, in particular, excelled at using the shadows, grain, contrasts of black and white, textures and micro-textures (of subject matter such as feathers, flowers, fabric and plants) made possible by this technique. One of her most extravagant projects was to photocopy every possible aspect (visible, invisible, obvious or unexpected) of the Palace of Versailles.

Copy Art caught on strongly in Canada, where it continues to thrive. In 1982, the Centre Copie-Art was opened in Montreal. Its founder, Jacques Charbonneau, came across the technique in 1978 during a holiday in New York, when he noticed a group of artists jostling to use the colour photocopier in a shop in Soho. Copy Art also overlaps with Body Art, whose practitioners (for example, Amal Abdenour and Philippe Boissonnet) use the photocopier to reproduce different parts of their bodies, exploiting the variations of colour and effects of contrast and solarization that can be obtained, and experimenting with the overlaying of transparencies. Copy Art has inspired all kinds of magazines and fanzines (for example, *Palpable*, *DOC* and *Placid et Muzo*), which often originated in art schools (such as the École des Beaux-Arts in Dijon and the visual art departments of the Universities of Paris-I and Paris-VIII). In 1985, Klaus Urbons founded a museum of photocopying in Mülheim an der Ruhr in Germany which displays old machines, documentation and artists' work. In 1990, a major international museum of electrography opened in Cuenca in Spain.

BIBLIOGRAPHY
- *Copies non conformes*, exhibition catalogue, Le Centre Copie-Art Inc, Montreal, 1992
- *Copy Art*, exhibition catalogue, Media Nova, Dijon, 1984
- *Electra*, exhibition catalogue, Musée d'Art Moderne, Paris, 1984

Joan **Jonas**

Born New York 1936. Lives in New York.

'The mirror provided me with a metaphor for my investigations as well as a device to alter space... and to reflect the audience, bringing them into the space.'

Joan Jonas has been working with video since 1972, and has continually experimented with ways of integrating the public into her work. In her performance piece *Brooklyn Bridge* (1988), images of the famous bridge, pedestrians walking over it and the surrounding scenery were projected in a loop onto a screen and repeated three times. Each time they were shown, interference occurred between the unfolding of the performance and the projection of the images, causing the viewer to ponder the nature of perception and how it functions. In *Left Side, Right Side* (1972), the use of a mirror creates a rupture at the centre of the image, raising questions about the double or 'twin' identity of a body or face split into two by a central dividing line.

SELECTED WORKS
- *Organic Honey's Visual Telepathy*, 1972.
- *Glass Puzzle*, 1974.
- *May Windows*, 1976.
- *Double Lunar Dogs*, 1984.

BIBLIOGRAPHY
- Mignot, D, *Joan Jonas: Works 1968–1994*, Stedelijk Museum, Amsterdam, 1994

Left Side, Right Side, video (black and white, with sound, 8:50 min), 1972.

white television programmes. Colour television had not yet reached Germany. Hoping to work with colour, Paik returned in 1964 to Tokyo, where, over the course of four years, he constructed his first synthesizer with the help of the engineer Shuya Abe. In 1965 he moved to New York. The new device colourized and mixed black-and-white images, the colours being distributed according to the luminosity of the different areas of the image. The colourization is therefore highly idiosyncratic, following not the contours of a particular figure, but the borders between different areas of brightness. Paik systematically exploited this process, producing coloured, deconstructed portraits (of Allen Ginsberg, President Nixon, etc) that were highly three-dimensional and played with raster effects.

The synthesizer also allowed greater modulation of rasters. Images could be made to appear and disappear by operating the keyboard, leading Paik to conclude that he could play the synthesizer like a 'piano of light'. Images and sounds could be treated like individual fragments to be assembled and reassembled indefinitely, following the well-established principle of collage beloved of visual artists. This gave rise to the concept of 'electronic collage'.

The public had become used to black-and-white television. The appearance of colour television profoundly altered people's relationship with the small screen. By adding realism, colour gave the illusion of being closer to the external world. Artists adopted very different attitudes towards colour. Averty, for example, used colour in a non-realistic manner, turning to bright, often pure colours and strong contrasts, various reds, yellows, pinks, fuchsias and delicate greens.

Resistance to video art

'– Didn't any journalists come to see you in Grenoble?'
'– For them it was sub-cinema. Myself, I still like "France Tour Detour" a lot. When I made it I had a real belief in video, in the link between cinema and video.'
Jean-Luc Godard interviewed by Alain Bergala in 1985

Mass-market tools despised by the intellectual elite, video and video art were widely condemned in the early days. Their main

dctractors were the experimental directors who discovered the virtues of Super 8 (low cost, lightweight, good mobility) during the 1970s and could only conceive of the art of the moving image in terms of cinema.

However, criticism also came from visual artists and the many denigrators of the mass media in the aftermath of May '68, who were vehement in their criticism. Given this climate of widespread mistrust, it is remarkable that some artists and technicians did indeed discover the possibilities and distinctiveness of video at an early stage. An article that appeared in the *Chroniques de l'art vivant* in 1975 gives a good idea of the kind of humour deployed by the critics of video. The article's author, Julius de Farigoule, suggests some 'practical exercises for beginners in the art of video'. Here are just a few examples:

'**Action 3:** Cathode-ray hams. Ten monitors and ten cameras hanging from the ceiling are agitated from time to time by a specially programmed stream of air or shaken by the helpful hand of a female assistant. Some of them dance with pleasure, some produce feedback and others break down.

Action 5: Move a half-inch camera towards a quarter-inch monitor. What happens? Do they hum? Do they touch? Do they communicate with each other?

Action 6: Place a cow in front of a monitor showing a continuous film of a train passing.

Variant: try the same thing with a turbotrain and an elephant.'

BIBLIOGRAPHY

Battcock, G, *New Artists Video: A Critical Anthology*, Dutton, New York, 1978

Godard, J-L, *Jean-Luc Godard par Jean-Luc Godard*, Cahiers du Cinema, Paris, 1998

Goldstein, A and Rorimer, A (eds), *Reconsidering the Object of Art*, MoCA, Los Angeles, 1995

Hall, D, and Fifer, S J (eds), *Illuminating Video*, Aperture, New York, 1990

Youngblood, G, *Expanded Cinema*, New York, 1970

Holographic art

'With holography it is possible to record things invisible to the naked eye or turn space inside-out.'
Margaret Benyon

Dennis Gabor discovered the principle of holography in 1947, but it was not until 1960 and the development of the first laser beam that the technology could be taken further. In 1968, Stephen A Benton invented the transmission hologram, highly luminous and visible in white light. The hologram is an analogical image, a form of three-dimensional photography. It gives density to light and captures the three-dimensionality of the object, retaining no more than its blueprint in light. Holographic images therefore give objects and human beings a transparent, spectral look, not unlike the appearance of a jellyfish swimming in crystal-clear waters. Holographic images are generally rainbow-coloured, resulting from the breaking up of white light into its component colours, although it is also possible to produce achromatic, in other words black-and-white, holograms.

In 1969, Bruce Nauman exhibited portraits made using pulsed lasers at the Leo Castelli Gallery in New York. Holographic art developed mainly in the USA (Lloyd Cross, Mark Diamond), Great Britain (Margaret Benyon, Jeffrey Rob), Japan (Setsuko Ishii) and Canada (Marie-Andrée Cossette, Mary Harman, Philippe Boissonnet, Howard Gerry). Michael Snow used it in a famous installation (*Still Life in 8 Calls*, 1985). In the early 1980s, attempts were made in France to develop holographic cinema (Claudine Eizykman and Guy Fihman, *Flight of Birds*, movement synthesis, 1982, cinehology on a fixed plate, viewable by seven spectators at a time).

The hologram plays with the effects of superimposition (fluorescent sandwiches of shadows, light, grids and rasters) and presents an unsettling image on account of its three-dimensionality (in the same way that stereoscopic photography did in the 19th century). Ghostly, yet extremely realistic, holography is of obvious interest to museums, which can use it to show hologram 'doubles' of certain fragile exhibits.

BIBLIOGRAPHY

- 'Archives of Holography', *Leonardo* 25 (5), 1992
- 'Holography as an Art Medium', *Leonardo* 22 (3,4), 1989
- *Through the Looking Glass*, exhibition catalogue, Museum of Holography, New York, December 1976–February 1977

Michael **Snow**

Born Toronto 1929. Lives in Toronto.

Known as an experimental film maker (his 1967 film *Wavelength* is famous for its 45-minute forward zoom) and visual artist, Michael Snow used the hologram in a number of installations in 1985–6. This experimentation can be seen as the continuation of his investigations into transparency (super-imposition of images using photography or film) and light (objects created with a candle, as in *Midnight Blue* [1973–4], or lamps, as in *Light Blues* [1974]).

Michael Snow emphasizes in particular the hallucinatory and spectral character of the hologram, but regards the technique as a continuation of the traditional disciplines of painting, drawing and photography. He therefore sees his holographic installations as 'pictures' to be studied from the front. What is radically new about his work, however, is its visual power, which allows it to go beyond a mere illusion of three-dimensionality: his holograms seem to belong to real space.

SELECTED HOLOGRAPHIC WORKS

- *In/Up/Out/Door*, 1985.
- *Egg*, 1985.
- *Maura Seated*, 1985.
- *Redifice*, 1986.

BIBLIOGRAPHY

- Shedden, J, *Presence and Absence: The Films of Michael Snow 1956–1991*, Art Gallery of Ontario/A A Knopf, Toronto, 1995
- Snow, M, *The Collected Writings of Michael Snow*, Wilfrid Laurier University Press, Waterloo, Ontario, 1994
- Snow, M, *Michael Snow: Almost Cover to Cover*, Black Dog/Arnolfini, London/Bristol, 2001

Still Life in 8 Calls

Installation with holograms, 1985

The installation is divided up into eight apparently identical scenes, each of which is structured around a hologram suspended in space. The hologram is set up as though on a table opposite a chair and apparently depicts the same arrangement of objects, including a telephone, keys, a pair of glasses, a lamp and a cup and saucer. Each hologram differs from the next, however, in terms of its treatment. These differences relate to colour, lighting, the organization of the scene and the duplication of the image. Michael Snow uses this installation as a way of re-examining the history of art: the eight holograms offer varying ways of seeing objects. From a version showing the everyday appearance of ordinary objects we move on to a Cubist, deconstructed version of the same objects in wood, and from there to a 'skeletal' version showing the abstract modelling of these objects, and so on. The focus of the installation is on the variations and internal transformations of a new kind of still life – banal, artificial and a complete illusion.

'The different art forms are merging: video and literature, graphics and music.'
Nam June Paik

The parallel development of video and video art has significantly changed the visual arts scene. Although video art took some time to become recognized, it has now taken off as an art form and can be found in many galleries, museums and art fairs. Video brought with it movement, fluidity, a certain lightness and an ease of use. In this sense, it has enabled artists to break with the heaviness and academicism of the past and to establish direct contact with the most ordinary and ephemeral of events. It thus represents a tool for the decentralizing and opening up of the closed world of the traditional arts (painting, sculpture, drawing). It has given a tremendous boost to the development of the action and the installation. Allied somewhat belatedly (since the beginning of the 1990s) with digital technology, video is now an option not only for professional artists but also for amateurs, as today's home computers allow everyone to process and manipulate images.

Technical recap

'A tool is only ever a tool. But there's nothing to stop us pondering the sometimes unforeseeable consequences of certain tools...'
Jean-André Fieschi

The video image results from the conversion of electrical variations into light data. The camera's pick-up tube explores the image that forms on the sensitive plate point by point and line by line. The definition of the image varies according to the number and sharpness of the scanned points. In the case of a black-and-white image, these points display varying degrees of brightness on a scale ranging from black to white, passing through a large number of intermediate greys. The video image is an electronic transcription, each point of the image being characterized by an electrical intensity corresponding to the brightness of the area in question.

In the next phase of the process, this information is then transferred to the cathode-ray tube of the video monitor. Here it is analysed and retranscribed by means of the electron beam that travels over the surface of the screen. This scanning is done line by line. The image is created by the variation in luminous intensity

Tom Wesselmann,
*Bedroom Blonde
with TV*, 1984–93.
Painted panel and
television set.

of the beam striking the screen. With a black-and-white image
there is a single beam, whereas in the case of a colour image the
screen is swept by three different electron beams.

The simplest video system consists of a camera linked to a
monitor, forming a closed-circuit system. This is the set-up for a
surveillance camera. Introducing a video recorder between the
camera and the monitor allows the images and sounds to be
recorded and retranscribed onto magnetic tape. (For a long time,
the various systems in use were defined by the width
of this tape – half-inch, three-quarter inch, and so on.)
To these elements can be added a video mixing desk
(allowing the images to be processed and mixed),
colourizers (for adding chromatic nuances) and a video
synthesizer (which generates abstract shapes and
allows pre-recorded images to be edited).

As is generally the case with the so-called
'technological' arts, research, experimentation and technical
considerations have played an important role in the development
of video art. Artists have frequently enlisted the help of
technicians. It was in conjunction with an electronics specialist,

Red, green, blue

Colour television is based on the
principle of the 'additive synthesis'
of colours. Each 'dot' of a video
image is made up of a combination
of the three colours red, green and
blue. The eye combines these three
colours, perceiving them as a
uniform whole.

Shuya Abe, that Paik developed his first synthesizer at the beginning of the 1970s. At that time, video art had much in common with DIY (it is worth remembering the extraordinary function attributed to DIY, or 'bricolage', by Lévi-Strauss in his book *The Savage Mind*). Max Debrenne, one of Jean-Christophe Averty's special effects men, has explained how a lot of visual discoveries were initially the result of chance or the technicians' attempts at 'do-it-yourself' solutions. This playful aspect never totally disappeared and was even underlined by the development of the light video system – camera, video recorder and monitor in one. A parallel development was that of specialist editing and post-production facilities.

The Paluche

Developed by Jean-Pierre Beauviala at the end of the 1970s, the Paluche is a miniature cylindrical video camera weighing 300g. Its ease of use revolutionized video art. It was famously used by Jean-André Fieschi (*The New Mysteries of New York*, 1975–9), who described it as follows: 'The lens screws onto the end of the cylinder, which is about twenty centimetres long. You hold the tube in the hollow of your hand like an electric torch or a microphone. It scans and captures images. It is literally an eye at the end of your fingers. It's a strange, novel feeling when the image materializes – as if you've had an organ transplant or been split into two. Your hand moves almost in spite of itself, approaching objects on the table, moving round them, sweeping over them in order to look at them.'

Proximity to the object; a tactile rather than merely a visual experience; the ability to move around at will; lightness of the camera, which has often been compared to a type of electronic pen – it is possible to see here how technology can influence art by favouring the adoption of a particular style.

The video image

'The electronic image... is unique... It's liquid, it's shapeable, it's clay, it's an art material, it exists independently.'
Woody Vasulka

The main characteristics of the video image are its brilliance and extreme luminosity, its fragmented, pixellated nature and its tendency to break up – all of which extend to the installations themselves, allowing them to become complex iconic ensembles. These ensembles, such as Paik's enormous *Tricolor Video* (consisting of 384 television sets laid on the ground with their screens facing the ceiling, Centre Georges Pompidou, 1982), can be read microscopically (down to the infinitely small detail of the raster) as well as macroscopically (taking into account the effect of the whole).

The recorded image is subjected to all kinds of modifications – for example, stretching, distortion, the cutting of one image (or a portion of an image) into another, and the deliberate use of interference, static or screen noise. In *Still* (1980), Thierry Kuntzel overlays the image with specks of static. Dots of light loom up like pearls against the blue background and gradually take over the whole screen before merging with the picture. Objects and figures

Yang Fudong,
Tonight Moon,
video installation,
2000.

tend to dissolve and fade away in a never-ending play of forms. *Kaleidoscope* (1988) by the Japanese artist Mineo Aayamaguchi is an installation featuring 25 monitors whose pictures are reflected – and distorted – on the shiny floor. Bill Viola plays with systems of reflections in a similar fashion by using reflective materials in his installations (*Stations*, 1994).

It is worth remembering that live video has possibilities other than feedback. In live video the filming of the image and its playback to the viewer are instantaneous. This allows artists to monitor their images. They can also use live video to incorporate the viewers into the action of their tape or installation. Coupling a camera with a monitor in this way creates an autonomous system in which the recording feeds off the projection.

This explains the large number of installations functioning as closed-circuit systems. Viewers entering these 'optical chambers' come face to face with a version of themselves produced by clever time-space distortions. Dan Graham, Bruce Nauman and Peter Campus are past masters in these games, which update the *camera obscura* or optical chamber invented centuries ago by Brunelleschi. In these systems the viewer is subjected to all manner of optical games and illusions. In *Face/Ings* (1974) by Taka Iimura, visitors enter an environment in which screens project their image from the back only: they are only able to view the one

Bruce **Nauman**

Born Fort Wayne (USA) 1941. Lives in New Mexico.

'The closer you try to get, the further you get from the camera, the further you are from yourself. It's a very strange kind of situation.'

Bruce Nauman started recording his performances in 1968. He very soon discovered the possibilities of the medium, systematically varying the composition, filming himself from behind or in such a way that his body appears to be parallel to the ground, and so on. He constructed systems in which the viewer is the key element. His installations are often based, with minor variations, on an empty corridor in which a closed-circuit video system is installed. The pictures captured by the camera appear immediately on the monitor. Visitors can therefore observe their own image (or images of other visitors) on the screen, but Nauman positions the camera in such a way that they can only see themselves from behind. He interferes with our normal, expected field of perception, creating an imbalance between real space and the space of the picture, both of which, however, belong to the same time-frame. In *Live/Taped Video Corridor* (1969–70), Nauman places one monitor on top of another. The one underneath shows a picture of the corridor while the one on top shows a closed-circuit image filmed by a camera positioned at the entrance to the corridor. After entering the corridor, the closer visitors get to the monitor, the further they are from the camera. As a result, their image on the screen becomes smaller and smaller and they seem paradoxically to be distancing themselves from themselves. In other installations, Nauman uses a surveillance system whose two elements (camera and monitor) are located in two separate rooms (A and B). He also twins a system of this kind with one in which a second camera and monitor are located in rooms B and A respectively, forming a criss-crossing system. Even a simple surveillance system is thus thrown into disorder.

SELECTED INSTALLATIONS

– *Performance Corridor*, 1969.
– *Wall Floor Positions*, 1968.
– *Video Corridor Piece for San Francisco*, 1969–70.

BIBLIOGRAPHY

– Brundage, S (ed), *Bruce Nauman, 25 Years*, Rizzoli, New York, 1994
– Nauman, B, *Please Pay Attention Please: The Words of Bruce Nauman*, MIT Press, Cambridge, MA, 2003
– Simon, J (ed), *Bruce Nauman*, Walker Art Center, Minneapolis, 1994

screen linked to the camera that (at any given time) films them from behind. The use of mirrors and reflective surfaces has meant that video effects have become even more complex. Many environments, such as those of Peter Campus or Dan Graham, contain mirrors or glass surfaces. These installations make extensive use of optical games and games with light as well as transparency, shadows and reflections. Faced with their own image but with a slight time lag, visitors lose a sense of their own bodies and identities. Many of the systems that have been dreamed up for video installations seem to be a continuation and extension of the optical boxes and optical games of past centuries. The use of liquid crystal screens in small television sets and, at the other extreme, the use of enormous screens that cover whole walls allow more and more varied settings to be devised.

Installation

An individual spatio-temporal arrangement; a set of elements constituting a work of art or providing the framework in which a work of art can unfold.

Video installation

The rectangular shape of the television set and the special features of video technology (feedback, near real-time projection, etc) favour the construction of video installations featuring walls, towers, pyramids and multiple screens (as in works by Nam June Paik and Marie-Jo Lafontaine, for example). Feedback and real-time playback also allow the creation of interlocking and element-within-element effects. Video installations can exploit the slight time lag between the time of recording and the time of projection, and can also involve the construction of optical 'boxes' or 'chambers' containing curious mirror effects (for example, the installations of Dan Graham or Peter Campus).

The surveillance camera

'We are no longer able to gaze upon mystery and silence. Today's images consider themselves very superior to things. This is what strikes me every time I see a video.'
Michaël Klier

Many of the features of video art derive from the medium's everyday uses. Artists have discovered new narrative styles by using the type of surveillance system installed in banks, public buildings and shopping centres in unusual ways. In 1984, Michaël Klier unveiled his video *The Giant*, which is composed entirely of clips taken from surveillance cameras.

What are the characteristics of the seeing eye of the surveillance camera? It is neutral, indifferent and films everything – at a distance. *Hotel Tapes* (1986) uses the same technology, but in hotel rooms. This time Michaël Klier uses actors, but retains the angle of vision (low-angle shot from a corner of the room) and 'neutrality' of the camera. This is what the film-maker calls 'surveillance fiction', the technology eliciting a certain type of behaviour from the actor and resulting in a certain type of image.

It is quite possible to imagine the technology multiplied and the results shown on several screens: 'We would simultaneously see rooms in which something was happening and others in which nothing was happening. A bit like *The Thousand Eyes of Dr Mabuse* or *Rear Window.*'

Another tribute was paid to *Rear Window* by Pierre Huyghe in his video *Remake* (1994–5). This takes the form of a home-movie remake, filmed over two weekends, of Hitchcock's classic film, following the scenario of the original shot by shot, replaying and recreating its oppressive atmosphere. Everything hinges on the knowledge of the viewer, who cannot help but compare the new film with its model. In *Arrangement Stasi* (1990), Ange Leccia had already used surveillance technology to make a political point. Two Stasi (East German secret police) 'surveillance units' – in other words, two cameras connected to two monitors – were placed against a wall. Symbols of bureaucratic absurdity, the cameras observe each other and the two monitors display the single image of the two lenses.

Sound and music

'A video camera is closer to a microphone in operation than it is to a film camera: video images are recorded on magnetic tape in a tape recorder. Thus we find that video is closer in relationship to sound, or music, than it is to the visual media of film and photography.'
Bill Viola

Nam June Paik's inaugural exhibition at Galerie Parnass in Wuppertal in 1963 was called *Exposition of Music/Electronic Television*. Based on figurative images recorded from commercial television stations, he created abstract images by interfering with the paths of the electrons inside the cathode-ray tubes of thirteen modified television sets. From the outset, therefore, video had the look of a new form of painting – electronic, luminous, fluid.

Many video artists (including such prominent figures as Paik, Viola and Steina Vasulka) have been practising musicians or have had a strong interest in music, and there are indeed strong links between music and video. Paik, who frequently referred to his television sets as 'pianos of light', was for a long period a regular

visitor at Stockhausen's Electronic Music Studio in Cologne and claimed that making his videotapes was like composing sonatas, with themes, counter-themes and a set tempo. 'The connections between music, sound, architecture and visual proportion were important for me... I would say that the larger phenomenon of sound had the deepest effect on my work as an artist.' (Bill Viola). We are dealing here with extremely technical art forms, influenced to a great extent by the possibilities and limitations of the equipment (which can, of course, be put to positive use). In this context it is important to mention the probably decisive influence of an instrument called the oscilloscope. The oscilloscope allows us to visualize sound and to track changes in volume and frequency in the form of oscillations. The small step between visualizing sound with the oscilloscope and seeing this as a way of actually generating visual forms was made by video artists in the early 1970s. The fundamental principle here is that of the luminous, visible signal. This had a profound influence on the work of Woody Vasulka. By causing a sound to pass from the realm of the invisible into the realm of the visible, we are entering a new universe.

Many of the early video-makers trained initially in electroacoustics, moving on from there to the creation of images that are basically the visual manifestation of sounds, noises and acoustic signals. The television set was perceived as a source of light and sound, an acoustic box as well as a visual one. Artists like Paik and the Vasulkas, or video-makers such as the Canadian Jean-Pierre Boyer (*The Magnetic Field*, *Phonoptic*, *Video-Cortex* 1973–4) played with the distortion and deformation of the image, manipulating it as one manipulates acoustic material. By connecting sound to the circuit that controls the scanning of the screen and by using an oscilloscope, Jean-Pierre Boyer generated distorted images and floating faces. Nam June Paik's circular electronic magnet allowed him to transform the movement and oscillations of the waves on the screen. The image is conceived of and manipulated in terms of 'phases', 'waves', 'rasters' and 'scanning'.

Violin Power, a work by Steina Vasulka spanning a period of several years (1970–8), represented a systematic exploration of the distortion of electronic images. Using various electronic interfaces (synthesizers, colourizers, signal processors), she

Steina and Woody **Vasulka**

Steina born Reykjavik (Iceland) 1940; Woody born Brno (Czechoslovakia) 1937. Based in Santa Fe (New Mexico).

```
'When I first saw video feedback, I knew I had seen the cave
fire. It had nothing to do with anything, just a perpetuation
of some kind of energy.'
Woody Vasulka
```

Multimedia artists and the founders in 1971 of The Kitchen, a space dedicated to multimedia arts, Steina and Woody Vasulka are both regarded as important pioneers in the field of video and the electronic arts. Their work has focused in particular on the interactions between sound and image. Steina trained as a musician and started out as a professional violinist. Fascinated by the medium of video, she constructed a 'vision machine' comprising rotating cameras and spherical mirrors and used it to make many experimental videos both in the studio and on location. Her interest in the use of reflections and complex spatial overlapping led to the creation of installations such as *Allvision* (1982). Here, two rotating cameras provided multiple viewpoints as well as a 360-degree field of vision. In *The West* (1983), Steina used a telescopic device to explore and systematically catalogue the structures in the landscape that she was filming. In doing so, she exposed the internal geometric system of the site while practising a kind of electronic land art.

Violin Power (1978) was a performance that evolved over a number of years. It was based on the interactions and interference between the playing of the violinist (Steina Vasulka) and the audio signal relayed by the television set. This resulted in formal distortions of the image on the monitor.

SELECTED WORKS

Woody:
- *The Commission*, 1983.
- *The Theatre of Hybrid Automata*, 1992.

Steina:
- *Allvision*, 1982.
- *The West*, 1983.

BIBLIOGRAPHY

- *Pioneers of Electronic Art*, exhibition catalogue, Ars Electronica, Linz, Austria, 1992.
- Vasulka, S and Vasulka, W, *Steina and Woody Vasulka: Machine Media*, Museum of Modern Art, San Francisco, 1996

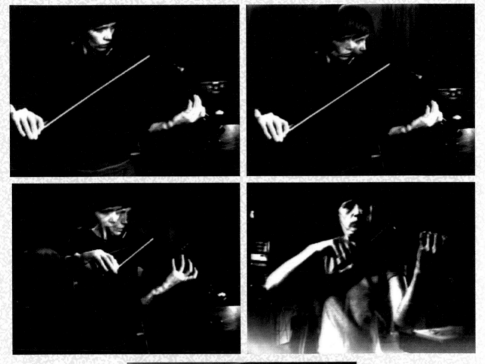

Steina Vasulka, *Violin Power*, interactive performance with videotape (black and white, stereo sound, 10 min), 1978.

transformed her violin into a tool for the generation of visual forms. The scanning of the image onto the screen corresponded to the movements of the bow. The audio and video signal generated each other. In *Voice Windows* (1986), Steina Vasulka worked with landscapes which she subjected to distortion and superimposition using the frequency and pitch of the sound waves produced by Joan La Barbara's vocalizing. Ernest Gusella also used the oscilloscope to generate a video signal from a synthesized sound. This made it possible to play with images as one played with frequencies, manipulating video waveforms, the scanning process, rasters and phases. Woody Vasulka is fascinated with video as a frameless picture – fluid, immaterial and lacking in any substance other than light. He has used pixilation, raster effects, intentionally superflous effects and distortions (*The Commission*, 1983) to great rhythmic effect.

Installations

'The video art of tomorrow is the installation, the art of absolute time and space, and in order to be able to read this new art we will need to know the code.'

Nam June Paik

The installation space

Installations are shown in dedicated spaces in galleries or museums. Virtual installations reinforce the feeling of delocalization or ubiquity that any type of show creates. The virtual space, the opportunity to act and react (in real time) and the ability to exert some kind of influence over an extremely remote space – these alter the viewer's relationship with the work of art. Increasingly, works of art form a part of real space. But this space expands and becomes a representative space, allowing the viewer to experience virtual objects or people, absent or invented, and to interact with them.

With Paik, as has already been seen, video art developed out of the action and the happening. While it is true that the action and the happening lived on, with artists continuing to use performance as an art form and making their own bodies the centre of the action (as in the case of Marina Abramovic), the installation started to gain in importance from the beginning of the 1980s. As usual where video art was concerned, Paik and Vostell were at the forefront of these developments. Paik's *Video Fish* (1979), with its five aquaria twinned with five television sets, remains the archetypal installation.

Each aquarium forms an extension to its corresponding television set, and real fish swim about surrounded by a moving, multiform, coloured image so that viewers cannot be sure whether they are looking at the back of the aquarium or the artificial reality of the

Marina **Abramovic**

Born Belgrade 1946. Lives in Amsterdam.

'I am not often in tune with the spirit of the times... I don't drive a car, I don't have a computer and I don't take photographs... All this gives me a highly personal approach and I frequently make use of very basic technology.'

Becoming Visible,
video installation,
1993.

Marina Abramovic collaborated for a long time with the artist Ulay (born in Germany in 1943). They spent many years travelling the world, an experience which furnished them with the material for their 'Continental Videoseries', in which each continent provided the starting point for a video work. Corresponding to each video (and continent) is a secret trunk or chest. There are twelve (a mythical number) of these 'reinvented' continents.

City of Angels, one of the videos in the series, was made in Bangkok in 1983. It attempts to paint a portrait, through their rites and traditions, of the Thai people, who are filmed in the temples and ruins of their country. Marina Abramovic subsequently pursued a career as a solo artist. She remains known mainly for performances of a social or political nature, some of which use video. Many of these performances play with the idea of the passage of time. *Cleaning the Mirror III* (1995) was performed in a museum of ethnography. The artist spends a long time contemplating the objects presented to her by the curator (a medicine box, a mummified ibis, aboriginals' shoes, etc). Suspended above these objects, her hands capture the energy emanating from them. Abramovic also created a large number of often humorous and surrealist installations and sculptures which also incorporated video (*Becoming Visible*, 1983), thus allowing her to include fragments (or memories) of earlier performances in her new works.

Video is just one ingredient of an output in which the main role is played by the human body – alive or dead. Abramovic's actions and performances are often violent. At the heart of the installation *Cleaning the Mirror I* (1995), five video monitors show the artist washing and scrubbing a human skeleton at great length.

SELECTED WORKS

– *AAA... AAA*, 1978.
– *City of Angels*, 1983.
– *The World is My Country*, 1984.
– *China Ring*, 1987.

BIBLIOGRAPHY

– Abramovic, M, *Marina Abramovic: Cleaning the House*, Academy Editions, London and New York, 1995
– Abramovic, M, *Marina Abramovic: Artist Body*: Performances 1969–1998, Charta, Milan, 1998

screen. The live turkeys in Vostell's installation *Endogene Depression* (1975–80) move about among a collection of television sets encased in concrete and arranged in a semi-enclosed space. The scene is observed from the outside as through a shop window.

Installation time

Using speeds which vary from extreme slow motion (Douglas Gordon's *24-Hour Psycho* (1993), which expands and stretches Alfred Hitchcock's *Psycho* to over 24 hours) to extreme acceleration (often modelled on the rhythm of an advertising film), video or multimedia installations force the viewer to enter a world lasting a specific time and unfolding at a certain tempo.

While some of these installations (Paik's *Video Fish*, for example) are viewed solely from the front, others are accessible on all sides, thus bringing the viewer into the heart of the installation, as with the circular arena of Marie-Jo Lafontaine's *A las cinco de la tarde* ('At Five in the Afternoon'; 1984) or Dara Birnbaum's *Will-o'-the-Wisp* (1985), the second part of her *Damnation of Faust* trilogy. Here, Birnbaum includes video projections in a space occupied by large photographs arranged in a circle. The video monitors are either placed here and there amongst the photographs or else set into the images themselves. Other installations that use circular arrangements

Wolf Vostell, *Endogene Depression*, installation, 1975–80.

include Michel Jaffrennou's *The Great Forest Merry-Go-Round*, which features a 'forest' of monitors whose screens face the ceiling.

Dominique Belloir also creates installations in which this idea of sensorial envelopment is pronounced. *Nymphaeum* (1991, a 'video architecture for 36 screens') plays with reflections, transparency and the effects produced by multiple images which join together, break apart and combine like the multicoloured glass shards of a kaleidoscope. The modular function of the different television sets

Marie-Jo **Lafontaine**

Born Antwerp 1950. Lives in Brussels.

'Faced with an installation, the viewer is caught in a seductive relationship. He is in the same situation as when confronting a picture: he is in the presence of something, he can stay for hours should he wish... if he wants to let himself be seduced... '

Using arena-like spaces or spiral spaces (*Victoria*, 1988) in which the viewer is caught up in a swirling mass of images, Marie-Jo Lafontaine's work generally involves circular installations or walls of screens. *A las cinco de la tarde* ('At five in the afternoon'; 1984) recreates the circular arena of the bullring. Finding themselves trapped inside, viewers witness a strange *corrida* of forms, alternating between bullfights and flamenco demonstrations. The installation is rigorous in structure, while its images are baroque and flamboyant. The sensuality of the images and the forcefulness of the circular arrangement make a direct appeal to the visitor's senses. The visitor finds himself or herself completely engrossed by the *corrida*, almost becoming another element in the artist's installation.

The Swing (1997–8) is a more diffuse installation comprising seventeen columns positioned here and there throughout the exhibition space. The screens of the video monitors set into the columns face in different directions, forcing the viewer to move continually around the installation space.

SELECTED VIDEO INSTALLATIONS

– *La Marie-Salope*, 1980.
– *Round around the Ring*, 1981.
– *A las cinco de la tarde* ('At Five in the Afternoon'), 1984.
– *The Metronome of Babel*, 1984–5.
– *Les larmes d'acier*, 1985–6.
– *Victoria*, 1988.
– *The Swing*, 1997–8.

BIBLIOGRAPHY

– Lafontaine, M, *Einzelgänger*, Salon, Cologne, 1998
– *Où va la video?*, Cahiers du cinéma, Paris, 1986

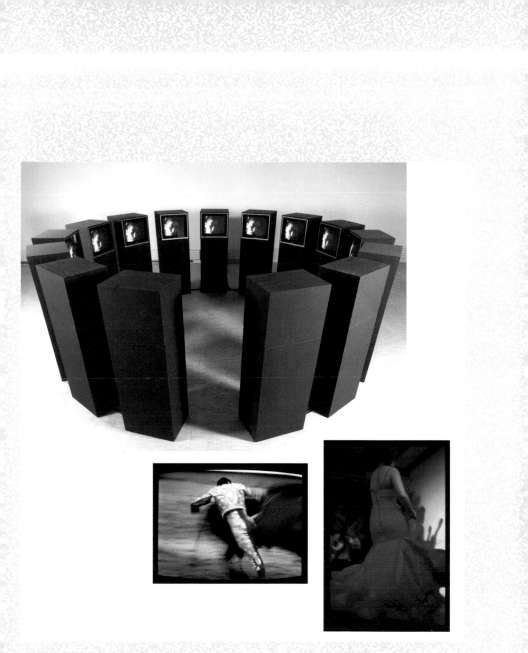

A las cinco de la tarde ('At Five in the Afternoon'),
video installation, 1984. General view and details.

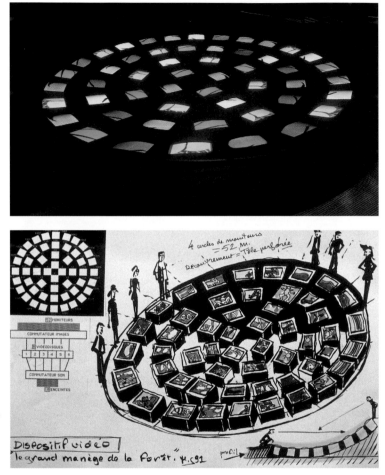

Michel Jaffrennou,
*The Great Forest
Merry-Go-Round*,
video installation,
1991. General
view and
storyboard.

is particularly effective, the various sets making the creation of luminous structures possible. The same feeling of sensorial immersion is created by the Chinese artist Yang Fudong in *Tonight Moon* (2000), a multi-screen installation recreating the various phases of a performance whose theme is water.

The installation was born of the fusion of a number of different disciplines and genres. An eminently three-dimensional form, it incorporates elements of theatre, architecture and stage design. It is a form of live production, taking place in space and over time, that requires precise, meticulous regulation – hence the widespread use of computer technology to control complex installations involving such elements as multiple screens, changes of scenery and turntables.

The installation also remains 'open-ended' – open to infinite possibilities, as elements or objects can always be added to

installations that have already been shown. This may explain the success enjoyed by this art form in the closing years of the 20th century.

Video sculpture

'When I combine a television set with a sickle or a pile of shoes, I am not obeying some formalistic or aesthetic principle... What results is the birth of both a plastic reality (a sculptural event) and a psychological revelation closely connected with the televised programmes.'
Wolf Vostell

The overturned or upended television sets shown by Nam June Paik in Wuppertal in 1963 at the inaugural exhibition of video art showed only simple distorted images or occasionally just a single line. The sets functioned as luminous units that could be piled, stacked and built up into pyramids, crosses (Nam June Paik, *TV Cross*, 1966), and so on. Gary Hill created an allusive, hollowed-out crucifix: video monitors delineated the cross shape at its four extremities (*Crux*, 1983–7). Head, feet and hands were rent asunder in the darkened room.

Some artists approached the television as they would any other object or material: as something to be turned into a sculpture or incorporated in a picture. Early on in his career, Nam June Paik collected a number of television sets and exhibited them together with a magnet or a piece of copper wire (*Magnet TV*, 1965) or at other times scooped out their insides, retaining just the shell. In *Wrapped Television* (for Nam June Paik; 1970–6), Christo subjected a television set to the treatment he normally reserved for monuments and similar objects. Roland Baladi sculpted television sets in marble and Pipilotti Rist placed a television (whose screen is covered by a plastic screen divided into multiple light-diffracting facets) on a pedestal.

The principle of video sculpture clearly derives from the television set's specific characteristics as an object and as a unit that is easy to move around. As we have already seen, televisions can be used in multiple formations and are stackable. This allows artists to create video walls and friezes and to split an image over several

screens, allowing its various elements to move, slide or jump from one screen to another. The video sculpture retains a basic frontality, which in many cases gives it the appearance of a bas-relief or painting. This is true of Tom Wesselmann's *Bedroom Blonde with TV* (1984–93), an assemblage (reminiscent of plywood or sheet-metal advertising signs) that incorporates a real television set. The piece is viewed strictly from the front, enabling the viewer to enjoy the flickering picture on the TV that is framed by the protective figure of the platinum blonde. But video sculptures can sometimes be approached in the same way as sculptures that can be walked around or walked under (as in the case of Paik's *Arc de Triomphe*). *HardCell* (1994), an installation by Judith Barry and Brad Miskell, is based on this principle. Through the holes and cracks in the sides of a badly damaged wooden crate (marked with black letters that make up the title of the work), switched-on television sets, computers and miscellaneous materials can be glimpsed. As early as the end of the 1950s, Wolf Vostell had created pictures in a similar style that were designed to be hung on the wall. These works use a wide range of materials, consisting to a large extent of scrap objects, and include working television sets (*Dé-coll/age/Object*, 1958–9). There is a stark contrast in these works between the brightness of the television images and the matt appearance of the scrap materials.

In a wide frieze called *Grasshoppers* (1968–70), Vostell combines large-scale photographs (images of an embracing couple and Soviet tanks rolling into Prague) with twenty video monitors showing pictures of war, variety shows and advertisements. A camera connected to a monitor captures and plays back live images of the viewers of the work, who therefore find themselves involved in and incorporated into the frieze. This work is a cross between a video sculpture and an installation. Instead of contenting itself with the dimensions of the object and with frontal vision, the work is spread throughout (and incorporates) the space in which it is shown.

Born in Japan and living in New York, Shigeko Kubota has adapted the work of Marcel Duchamp in many of her installations, embedding her video monitors (showing images of a naked woman) in the steps of a staircase (*Nude Descending a Staircase* [Duchampiana series], 1975) or recreating Duchamp's window

Shigeko Kubota,
Nude Descending a Staircase
(Duchampiana series), video sculpture, 1975. 4 monitors, 1 video recorder, 1 videotape, 1 plywood structure.

(*Window Flowers, Window Snow and Window Stars* [Meta-Marcel], 1976). The television cabinet can also be hollowed out and reduced to a carcass, thus providing the framework or window for a miniature theatre. Paik once replaced a television screen with an outline of Mount Fuji or a picture of his own face.

The video wall has also played an important role in video sculpture and has occasionally perhaps resulted in overkill in terms of the number of screens used. Paik's *Tricolor Video* (1982) brought together 384 monitors at the Centre Georges Pompidou in Paris. In 1988, he built a tower of 1,003 monitors (*Tadaikson*) in Seoul and created his *Venus*, a monumental sculpture in the form of a spiral, in Düsseldorf in 1990.

The movement of images as they pass from one monitor to the next can create a variety of rhythms and complex optical effects. Vostell also created large-scale video walls. His *Requiem* (1990) consists of 20 juxtaposed photographs, retouched with paint, of extermination camps and the ruins of German cities. At the centre of each photograph is a video monitor.

Many of Fabrizio Plessi's works (*Horizontal Sea*, 1976; *Videoland*, 1987) also fall into the category of video sculpture (or video architecture) in that they too take the form of objects, assemblages and constructions – massed televisions that can be stacked and piled like bricks or rubblework. Video has thus been used in all sorts of three-dimensional combinations – walls, pyramids, diagonals – and monitors have been upended, tilted and suspended. However, as soon as spaces open up between the different elements of a work, a place is created that can be inhabited by the viewer, and one is in the territory of the installation.

Space, time, speed

'Video represents a progression from movement to the movement of movement. In terms of speed, the interesting limit here is the limit of our conscious awareness of the image – in other words, 60 images per second.'
Paul Virilio

It appears, it disappears, it metamorphoses – the video image is constructed (or deconstructed) dot by dot. Images which become fluid to the point of ceasing to be images as such, and appear instead as mere form and outline, are at the basis of Thierry Kuntzel's work. *Nostos 1* (1979) presents just the outlines of an image that fades away, seeking constant transformation.

In these artworks, time appears to take the place of space. Western aesthetics have traditionally been centred on space, but a major revolution has occurred in the visual arts and priority is now often given to time. Time even structures the installation spaces themselves.

Hence the distorted space-time relationship in Paik's depiction of the lunar phases (*Moon is the Oldest TV*, 1976), the intimate space-time relationship of the *corrida* in Marie-Jo Lafontaine's *A las cinco de la tarde* ('At Five in the Afternoon'; 1984) or the extraordinary compression of time achieved by the visual artist Giulio Paolini in the videotape he made in the 1970s consisting of slides of all his various works. To view the tape is to witness a speeded-up procession of fifteen years of the artist's life. Video

can employ slow motion and fast motion, but it can also reproduce the pace of real life at a normal tempo.

The proliferation of television images and the great rapidity with which they are pumped out are radically altering our way of perceiving images. Nowadays, we are confronted with a visual and aural kaleidoscope which we absorb at top speed. Advertising films, promotional clips, growing urbanisation and the increasingly sophisticated use of advertising tools have all contributed to this. The early video artists' use of ready-made images from commercial television led to overload – an accumulation of visual elements in which speed played a major role. The flow of images became stronger and stronger. These images interpenetrated, overlapped and merged into each other. The legibility of the image (or message) assumed secondary importance. What was absorbed was the noise, the flicker and the permanent flux of images. Artists added to this process and took it to extremes. A three-dimensional, 'musical' dimension to video dominated the early development of the medium, and has never completely disappeared – it can be found in the most recent work of Bill Viola and Gary Hill, for example. Different layers of images (corresponding to superimpositions and cut-ins) can be seen as a mixing of different timeframes.

Chantal Du Pont explained this in relation to one of her works (*The Love Market*, 1990) by emphasizing the 'fictional dimension' introduced through the mixing and bringing together of these disparate timeframes.

The careful management of time and the strict timing of the image allow artists to exert control over the sequence of events and to create specific effects. Michel Jaffrennou's *Videoflashes* (1982), short televisual gags, make use of a split-second timeframe. In 1975, Ernst Caramelle presented his work *Video Ping-Pong* at the Massachusetts Institute of Technology. This combined two ping-pong players and a real table with an image of the players in the process of playing. He thus created a curious effect of ubiquity and a kind of doubling in time of the action. Fascinated by the passing of time and attempting to find a way of 'reversing' its inexorable flow, Piotr Kowalski lined up 36 screens in *Time's Arrow* (1990). A camera films the passing visitor and freezes the

Fabrizio **Plessi**

Born Reggio nell'Emilia (Italy) 1940. Lives in Venice and Majorca.

'My work can be enjoyed as an image can be enjoyed. I don't want the viewer to change the way he looks; he should look at my work in the same way that he looks at a work by Giotto.'

Influenced by the Italian Arte Povera movement of the 1960s, Plessi embodies the alliance of two extremes: nature (considered in terms of its 'purest' elements – water, soil, fire, marble) and technological artifice. Many of his performances and installations involve games with water and feature videos that could be described as 'liquid'. From 1975 onwards, Plessi could be seen walking on water or sawing the calm waters of a lake into two equal parts. In 1978, he used a pair of scissors to cut and divide the water flowing from a tap. He also played on the complementary nature of contents and container (*Liquid Piece*, 1975) and the distortion of bodies in water (*Underwater*, 1982). In 1996, he constructed an 'electronic aqueduct'. In his installations he shows a fondness for creating complex structures, some of which come under the category of video sculpture while others – shown in prestigious architectural locations – have more in common with an environment: he has projected digital images of water and fire onto the façade of the Museo Correr in Venice. *Raw Material* (1989) comprises monitors and slabs of rough-hewn marble. Plessi has taken care to maintain his distance from technology and to treat television as a voiceless object. In another installation, 'electronic' water is combined with fire and elsewhere with other materials such as soil (*Liquid Centre of Gravity*, 1982) or marble (*Marble Sea*, 1985). Water and video, declared Plessi, 'are both full of movement' – like fire and energy.

SELECTED INSTALLATIONS
– *Horizontal Sea*, 1976.
 Water Wind, 1004.
– *Videoland*, 1987.
– *Vertical Sea*, 2000.
– *Waterfire*, 2001.

BIBLIOGRAPHY

– Plessi, F, *Fabrizio Plessi: Guggenheim Museum SoHo*, New York, exhibition catalogue, Chorus-Verlag, Munich, 1998

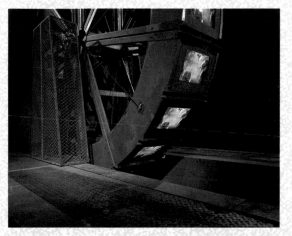

Liquid Time II

Video sculpture, 1993.

An iron structure with a motor, a movement, a water pump, running water, 21 monitors, 2 VHS tapes and sound. Based on the principle of the paddle wheel, this work by Fabrizio Plessi plays delightful games with the hybridization of real elements (such as water under the wheel or the movement of the wheel) and artificial elements (the images which appear on the video monitors that are fixed to the wheel and that move as the wheel turns). Plessi thus highlights a principle at the heart of all his work: the fluid nature of video. The flow of images turns the medium into a kind of luminous water capable of falling and running.

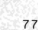

resulting image, which is gradually enlarged from one screen to the next until it fills the screen in close-up. Multiple screens, often arranged in a bold layout, can allow perspective-based viewpoints to be reintroduced into the installation space. *The Terror and Possibility in the Things Not Seen* (1997) by Judith Barry is an installation of this type. It gives the visitor a sense of moving around inside a world of great depth.

Judith Barry, *The Terror and Possibility in the Things Not Seen*, video installation, 1997. 5 video projections, 1 five-sided structure, 5 sets of loudspeakers. General view and diagram.

Light, grain, raster

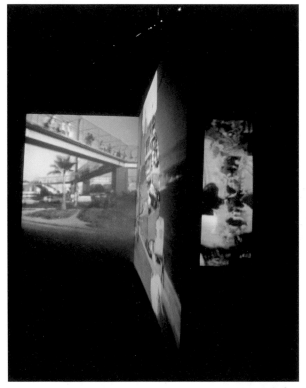

'A sketch that can never be completed. The fluidity that precedes the picture... A crazy desire like wanting to make light visible.'
Thierry Kuntzel

Whether used in an abstract, figurative or narrative context, the video is first and foremost a powerful tool for the orchestration of light, and artists were quick to understand this. Whether in the work of Nam June Paik, Bill Viola, Gary Hill, Thierry Kuntzel or Pipilotti Rist, raster and luminous scanning effects can now be found in museum and gallery spaces everywhere.

Alongside video works that told stories (and were able to deal with criticism), the abstract use of the medium also developed into an important art form. Today, the abstract images of Ernest Gusella (1974) – reduced to luminous, sonorous, malleable video material – are being rediscovered. The duo Graf/ZYX

created amusing abstract sculptures incorporating video elements (*T for 2*, 1987), Ingo Günther suspended monitors and objects in space in Düsseldorf Museum (*Eleven Waiters Vertical*, 1982) and Claire Roudenko-Bertin, both a sculptor and a video artist, used a system of shutters to refine the image and to experiment with dark patches of varying sizes.

Indeed, what would the video image be without darkness – darkness that allows it to burst into light and life? Dark rooms are needed for Paik to be able to deploy his flickering images (*Global Groove*, 1973) or Ko Nakajima his coloured cubes (*Mount Fuji*, 1985) and for the 'light brushes' of Gary Hill's projection devices (*I Believe It Is an Image in Light of the Other*, 1991–2), the tender, attenuated frames of Robert Cahen's videotapes (*Just Time*, 1983) or the fields of colour of Thierry Kuntzel's installation *Winter* (1990) to be shown. Video can produce dramatic effects of light, but also of scale. Paik's installation *Tricolor Video* (1982), an installation at the Centre Georges Pompidou that featured 384 television sets, is enormous. Joan Logue's *The Homeless* (1990), in which four minuscule televisions are set into a wooden triptych, is an example of miniaturization. Extreme simplicity (and another mystical reference) is present in the three panels assembled by

Nam June Paik
Global Groove,
video (colour,
sound, 28:30 min),
1973.

Thierry **Kuntzel**

Born Bergerac (France) 1948. Lives in Paris.

```
'Time takes hold of the surface, of the surfaces... the side
projections vary imperceptibly in intensity and colour while
at the same time the central panel takes on the appearance
of a relief... A surface between two surfaces whose colour
also dissipates, fades, and vanishes.'
Thierry Kuntzel on Winter.
```

Kuntzel's universe is constructed around soft forms. In all his work, contours and outlines appear and change, ever ready to return to the nothingness from which they arise. Viewers are never required to submit to the power of televisual imagery, but simply to let all that is floating, fluid and imprecise about the medium wash over them. This imprecision is designed to reveal the aura in which the visible world is enveloped. As in *Time Smoking a Picture* (1980), images are to be 'smoked' and consumed, their immateriality 'listened to', because time erases images, gives them a patina and sublimates them. Echoes of this can be seen in the folds of the sheet in which Robert Walser is wrapped – an immaculate shroud along which the camera glides in a movement resembling a long caress – in *Winter* (1990). All of Kuntzel's work displays this tactile quality. In *Cubist Painting* (1981, co-created with Philippe Grandrieux), a solarized hand invites us to discover the world of objects. In *Summer (Double View)* (1989), the viewer's gaze has to swing back and forth between two screens, each at the end of a vast room, in order to relate the grain of one image to the body shown opposite and the close-up to the view of the whole. Video, it has often been said, is light. It is also matter – hazy, grainy and elliptical.

SELECTED WORKS
Videos:
– *La Desserte Blanche, Echolalia, Still, Time Smoking a Picture*, 1980.
Installations:
– *Summer (Double View)*, 1989.
– *Winter (The Death of Robert Walser)*, 1990.
– *Spring (No Spring)*, 1993.

BIBLIOGRAPHY
– Kuntzel, T, *'Été'* and *'Hiver'*, exhibition catalogue, École régionnale d'art de Dunkerque, 1991
– Kuntzel, T, *Thierry Kuntzel*, exhibition catalogue, Galerie nationale du Jeu de paume, Paris, 1993

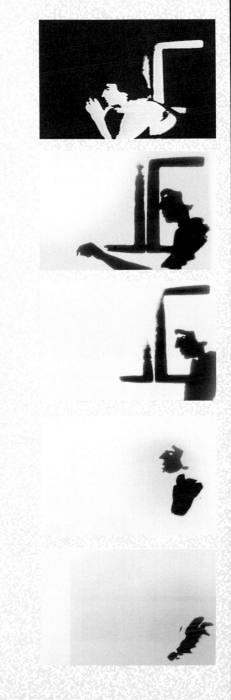

Nostos 1

Video (colour, 43:30 min), 1979

'*Nostos 1* weaves a unique video recording out of multiple time systems: the time of the outline (different frequencies make the image flicker at different speeds), the time of materialization and erasure (mobile projections are used like brushes of light), the time of chromatic variations (in which colour literally 'fades' from white to blue, from blue to black, from black to blue and from blue to white) and the time of repetition.' (Thierry Kuntzel)

The working title used by Kuntzel for a long time while working on *Nostos* was *Wunderblock* (Freud's 'magic' writing pad). Shifting lines in the process of appearing or disappearing, the lines of force of the figures, the modulating of the halation – everything is based on a system of ellipsis and on the insubstantiality of certain lines.

Dan **Graham**

Born Urbana (Illinois) 1942. Lives in New York.

> `'Public Space/Two Audiences` effects an inversion: the spectators, instead of contemplating an art production... are themselves placed on display.'

During the 1970s, Dan Graham was one of the pioneers of performance and video art, and as such he experimented with all the possibilities offered by video circuitry in its early stages. He attached ever-greater importance to exploring ways of integrating the public into systems consisting of live camera and immediate playback of the video image. Along with many other artists, he also experimented with time-delay techniques and the mild feeling of alienation created by short time lags. Graham subsequently became interested in the integration of his installations into public and architectural spaces, using devices such as windows, two-way mirrors and systems that allow one to see without being seen or to be seen with a slight time lag. Dan Graham's work thus follows in the tradition of the optical devices that fired people's imaginations from the Renaissance (Brunelleschi's *tavoletta*) right through to the 19th century (slide shows, phenakistoscopes, etc). He uses similar techniques to create a sense of magic and to blur people's normal points of reference. These techniques allow us to penetrate into a world of reflections, artifice and pretence.

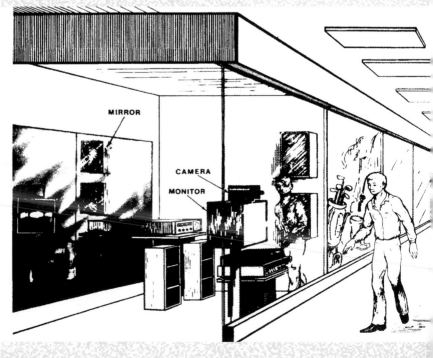

SELECTED WORKS

- *TV Camera Monitor Performance*, 1970.
- *Time Delay Room 1–7*, 1974.
- *Mirror-Window-Corner Piece*, 1974.
- *Present Continuous Past*, Centre Georges Pompidou, 1974.
- *Public Space/Two Audiences*, 1976.
- *Performer/Audience/Mirror*, 1977.

BIBLIOGRAPHY

- Alberro, A (ed), *Two Way Mirror-Power: Selected Writings by Dan Graham on his Art*, MIT Press, Cambridge, MA, 1999
- Graham, D, *Rock My Religion*, MIT Press, Cambridge, MA, 1993
- Graham, D, *Dan Graham: Works 1965–2000*, Richter, Düsseldorf, 2001
- Pelzer, B, *Dan Graham*, Phaidon, London, 2001

Video Piece for Showcase Windows in Shopping Arcade

Video installation, 1976.

Designed for a shopping arcade, this installation comprises two monitors, two cameras and two mirrors. The two mirrors are placed opposite each other at the back of two shop windows on either side of the walkway. The mirrors reflect the contents of the shop windows as well as the exterior of each shop.

Shoppers approach from the back, as seen in the picture here. In the window on the shopper's left is a monitor with its screen turned towards the central walkway. In the right-hand window another monitor faces the mirror at the back of the shop. The camera installed above the monitor on the left is focused on the mirror, while the other camera is turned towards the shop front and the central walkway. The camera on the left transmits its images live to the monitor on the right, while the camera on the right transmits its images to the monitor on the left with a five-second delay.

It is not difficult to imagine the interplay of complex reflections and delayed images produced by this type of set-up, with the shopper moving around at the centre of a visual trap that is both familiar and unfamiliar. The installation is all the more effective as it takes into account the peculiarities of each site: the windows can be empty or full, the public can walk between the shops or enter them, and so on.

Christian Boustani in homage to the Old Masters of Flemish painting (*Bruges Triptych*, 1990). Video has reinvented the light-filled painting as a kind of portable stained-glass window and Paik, as we have seen, considers video installations to be 'pianos of light'. The group of Italian artists known as Studio Azzurro create installations in which video fills the whole space (*Two Pyramids*, 1984; *Views*, 1985). Some of their installations are bathed in a blue light, creating atmospheric artificial worlds. This was later enhanced by the glistening, metallic character of the digital image. In 1999, James Turrell took the concept to its limits by inviting people to sit on a seat in front of a screen and then presenting them with nothing more than coloured light pulsing from the monitor. All other information had been eliminated, and the medium of video was reduced to mere light.

A tactile dimension

'Holding the image at the end of one's arm. Abnormal. Artificial... Perhaps it was this: the sudden appropriation of animal vision, the vision of a feathered creature or a thing that crawls'
Hélène Chatelain

When a video image is projected onto a large screen – or indeed onto multiple screens – its tactile dimension becomes more and more important as does the sense of closeness. Bill Viola has repeatedly explored these particular properties of the medium. Taking place in a narrow corridor and thus forcing the viewer to get as close as possible to the screen, *Passage* (1987) is one work which emphasizes this tactile dimension of the video image, which looks to the viewer, close up, like skin or flesh. Also worth mentioning here are the highly organic videos and installations of Tadasu Takamine: a body floats in water (*Water Level* and *Organ Sound*, 1998), another struggles against weightlessness and is pushed in every direction (*Onyx Dreams*, 1998). Pipilotti Rist goes one better in installations such as *Sip My Ocean* (1996). Here, mirror images meet and join in the corner of the room as the same video is projected simultaneously onto two adjoining walls. Curious anamorphoses and doublings, or couplings of similar, unexpected

objects, occur at the point where the images meet. A body is swimming in a swimming pool. Everything is an intense, sensual blue, with reflections like those in an aquarium.

The song on the soundtrack, which plays over and over again like a ritornello, envelops the viewers, lulling them with its rippling sounds.

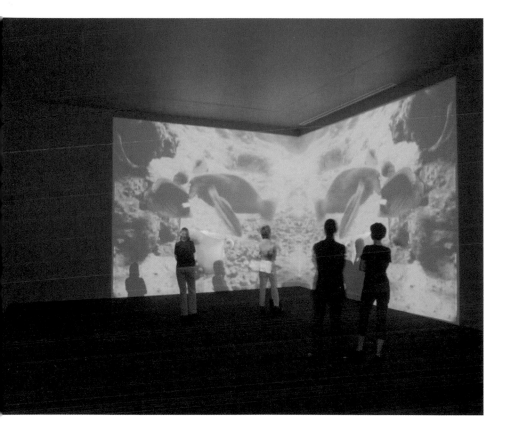

Pipilotti Rist, *Sip My Ocean*, video installation, 1996.

The narrative image

'Images turn into human characters almost. It is as though they have a destiny (they are born, they die, they mate) and adventures. We are intrigued by their stories.'
Jean-Paul Fargier

In addition to three-dimensional and occasionally 'abstract' video art, the distinctive properties of video – duration and continuity – have favoured the development of a narrative dimension. These

Peter **Campus**

| light | camera | viewer | shadow | image |

screen

Born New York 1937. Lives in New York.

'The video camera makes possible an
exterior point of view simultaneous
with one's own.'

Known for his sophisticated optical installa-
tions and devices, Peter Campus plays with
transparency, mirrors, reflections and distor-
tion. These visual illusions are set up in opti-
cal chambers, where visitors are confronted
by time-lapse images of themselves in the
time and space frames of various environ-
ments.

camera

SELECTED INSTALLATIONS
– Double Vision, 1971.
– Kiva, 1971.
– Interface, 1972.

BIBLIOGRAPHY
– Campus, P, *Peter Campus: Analog+Digital
Video+Foto 1970–2003*, Kunsthalle Bremen/
Walther König, Bremen/Cologne, 2003

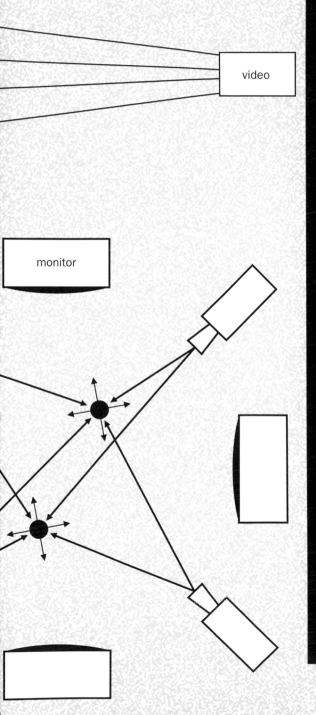

video

monitor

Shadow Projection
Installation, 1974

Two types of images meet and are superimposed on the screen at the centre of a room: the shadow of the viewer and the recorded and projected image of the same viewer captured by a camera located in front of the light source.

Optical Sockets
Installation, 1974

This installation comprises four cameras (in the four corners of a square space) and four monitors (in the centre of the four walls). The information from the video cameras is mixed by an image synthesizer and projected onto the screens. This arrangement encourages visitors to move around in order to appreciate the distortions and mixing effects until they discover the precise central point where the four images coincide.

videos tell stories, present real or fictitious characters, or incorporate documentary elements (as, for example, in the videos of Nam June Paik, who uses television programmes as raw material and regularly includes sequences showing Richard Nixon, Allen Ginsberg, Fidel Castro and other political leaders). Video art of this kind can assume a saga-like quality: occasionally lyrical, flirting with critical discourse and feeding like a palimpsest off its own superfluities – as in the work of Jean-Paul Fargier (*The Arch of Nam June*, 1980; *Sollers in Paradise*, 1983; *Digital Joyce*, 1984). Video art enabled this narrative dimension, which the tendency towards abstraction, formalism and minimalism had displaced, to re-enter the visual arts during the period 1970–80. The humorous playlets of William Wegman filming his dog (named Man Ray) at the end of the 1970s, the videotapes and romantic sagas of Patrick de Geetere and Catherine Maes in the 1980s (*Clouds of Glory*, 1984; *Johnny*, 1985), the tapes and installations of Marcel Odenbach, which use a system of horizontal and vertical picture strips and are dedicated to a particular form of historical memory (*1,000 Murders*, 1983; *In the Peripheral Vision of the Witness*, 1986) – all display this narrative element.

Since then this tendency has grown stronger and the telling of stories and the presentation of characters and situations has represented a substantial category of installation works at the end of the 20th century and the beginning of the 21st. Often there is a strong leaning towards autobiography in these works. Pierrick Sorin, for example, presents himself as a character confronting the petty lunacies of everyday life. *The Showers* (2001) is an installation with a mirrored background in which small characters (in the form of video projections dotted around the space) take a shower in the real water of a built-in fountain. Tony Oursler creates numerous short dramas in which the talking heads of his televisual pods inhabit environments filled with old-fashioned fabrics and floral cushions.

Feminist video

'I travel everywhere with my Portapack on my back like a Vietnamese woman carrying her baby... My Portapack and I travel all over Europe, to the land of the Navajo and to Japan – all without a male companion.'
Shigeko Kubota, 1978

A significant amount of video work, particularly during the medium's early years, was activist in character, created by artists who were involved in the social and political struggles of their day. Feminist video was an important strand. The new, accessible technology encouraged its spread, but not to the extent that it became an over-exposed artistic medium. In Germany, Ulrike Rosenbach worked with closed-circuit systems. Recorded and projected images made up a closed system that allowed her to explore the distortions or near-similarities between reality and its immediate representation. An active feminist, she created a number of video performances in which she herself is the centre of the action. In *Reflections on the Birth of Venus* (1976), she examines the process of fracture and the bodily collage imposed on the female figure as she emerges from her shell.

In 1980, Nicole Croiset and Nil Yalter performed an action at the ARC (Musée d'Art Moderne de la Ville de Paris) entitled *The Rituals*. The space was divided into two equal zones, each containing a video monitor and a camera. The set-up was based on the interlinking of the two spaces, with each camera connected to the monitor in the opposite space.

Nicole Croiset and Nil Yalter operated within their own spaces, but were confronted with the images filmed in the other space or pre-recorded for the other monitor. This resulted in a constant exchange of two types of ritual: masculine and feminine, warrior-like or relating to motherhood.

Female artists have placed great emphasis on the role of the body. Mona Hatoum, for example, who was born in Lebanon but lives in London, has created many actions and performances based on her own body (*Corps étranger*, installation, 1994) and also frequently includes autobiographical elements in her work. *Measures of Distance* (1988) 'enacts' letters from her mother in

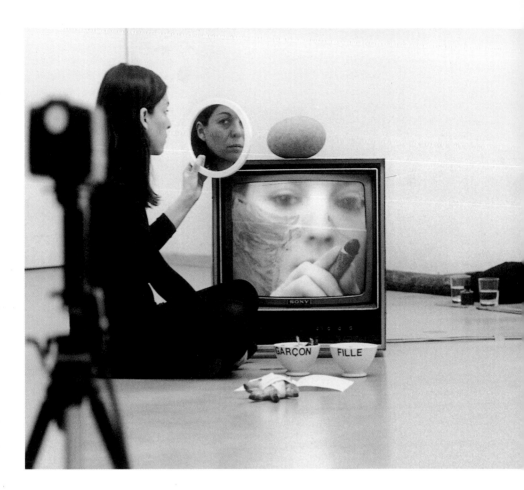

Above and opposite:
Nicole Croiset and
Nil Yalter, *The
Rituals*, action,
1980

which she writes of the war and daily life in Lebanon. Zhou Xiaohu, a Chinese artist born in Changzhou in 1960, is continuing this tradition of feminist video. *Beautiful Clouds* (2001) juxtaposes the artificial image of a young child with pictures (in the form of projections shown behind the child) of mushroom clouds and other images of the wars and catastrophes that regularly afflict our planet.

A significant proportion of the video work produced by women is activist in character. As a tool of social and political struggle, this falls largely outside the sphere of art. It is nonetheless worth remembering that questions of social and political identity form the background to many of the performances of artists such as Joan Jonas, Dara Birnbaum and Marina Abramovic.

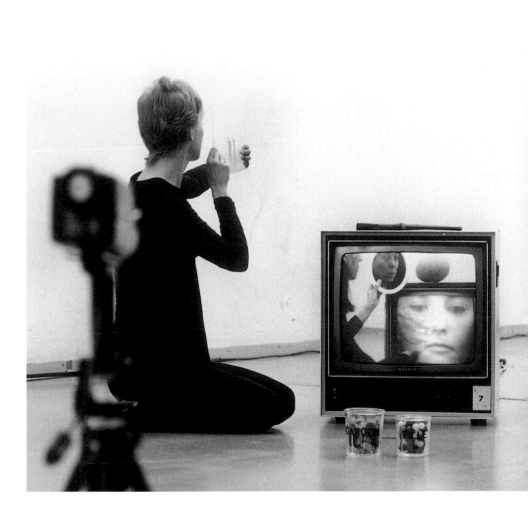

Zhou Xiaohu,
Beautiful Clouds,
video (colour, 4:48
min), 2001.

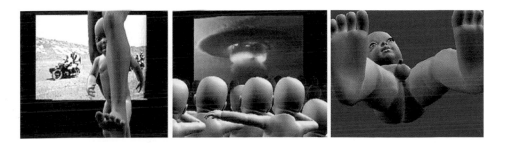

Bill **Viola**

Born New York 1951. Lives in Long Beach (California).

'In video a still image does not exist. The fabric of all video images, moving or still, is the activated, constantly sweeping electron beam... the video image is a living, dynamic energy field.'

There are three main components to the complex art of Bill Viola: the artist's attention to nature and material textures, a deep understanding of installations and an obsession with everyday human actions and rituals (birth, death, walking, swimming, sleeping, breathing, and so on). The four elements (water, air, earth, fire) are present throughout his work. The representation of light and heat and the distortions to which they give rise form the basic premise of *Chott el-Djerid (A Portrait in Light and Heat)* (1979), a video that experiments with the mirages of the Sahara Desert. His later installations all exhibit the same fragmentation and dilution of the image that is to be found here, with video assuming the form of a fluid, watery medium that takes the images to the very limits of decomposition and disappearance – as, for example, in *The Crossing* (1996), where water and fire intensify and merge as the silhouette of an approaching man takes shape. Viola's installations frequently unfold in darkness, reinforcing the rigour of the scenic arrangements that confront the viewer. The function of these is to immerse the viewer in images, to plunge him into a bath of light as if into a tank of water. In *The Messenger* (1996), the image of a naked man rising and sinking in a pool of water was projected onto a screen at the centre of Durham Cathedral. For *The Veiling* (1995), Viola employed a series of translucent screens on which images were refracted and dissipated. Two projectors, one on each side of the screens, projected the images (and faint shadows) of a man and a woman whose outlines meet (and separate) at the centre of the screens.

SELECTED WORKS

– *Room for St John of the Cross*, 1983.
– *The Theatre of Memory*, 1985.
– *Passage*, 1987.
– *Nantes Triptych*, 1992.
– *Stations*, 1994.
– *Pneuma*, 1994.
– *The Messenger*, 1996.
– *The Crossing*, 1996.

BIBLIOGRAPHY

– Sparrow, F (ed), *Bill Viola: The Messenger, The Chaplaincy to the Arts and Recreation in North-East England*, Durham, 1996
– Viola, B, *Reasons for Knocking at an Empty House: Writings 1973-94*, edited by Robert Violette in collaboration with the author, Thames and Hudson, London, 1995
– Walsh, J (ed), *Bill Viola: The Passions*, John Paul Getty Museum in association

Heaven and Earth
Video installation, 1992.

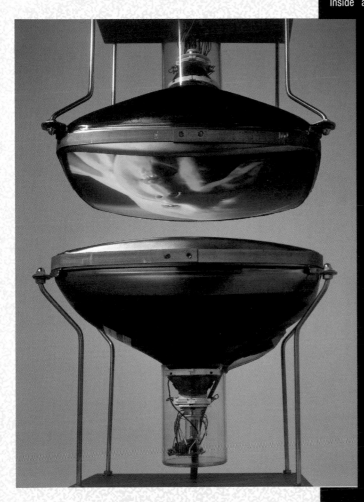

Inside an alcove, a wooden column extends from the floor to the ceiling. A section has been cut out of it at eye-level and two black-and-white video monitors without cabinets have been inserted face to face (looking like two enormous light bulbs). The monitors are separated by a gap large enough to allow people to see the images on their screens. The upper screen displays the image of an old lady dying. The lower screen shows the face of a newly born baby, just days old. Reflected in the glass of each screen is the image being shown by the other. These two stages of life, beginning and end, are thus fused and interwoven. The work is dedicated to Bill Viola's mother, who died in 1991 and whose final moments the artist filmed, and to one of his sons, who was born nine months later.

with the National Gallery, London, Los Angeles and London, 2003
– *Bill Viola*, exhibition catalogue, curated by David A. Ross and Peter Sellars with contributions by Lewis Hyde et al, Whitney Museum of American Art in association with Flammarion, New York, 1997

The medium as subject matter

'You can get the feeling when watching TV that it is not reality you are seeing but waves of reality... With its rasters, speed and colours, television brings home to us this transformation of reality into waves. Reality is being transmitted.'
Paul Virilio

In addition to the marked development of video as three-dimensional art – video being more and more frequently combined with other techniques and assuming a hybrid function – artists of the end of the 20th century also used the medium in order to 'talk about the medium'. They did this either in a neutral way or in a critical way.

In 1967, Martial Raysse incorporated a video monitor into one of his pictures (*Identity, Now You Are a Martial Raysse*). Connected to a camera, this monitor showed those viewers who lingered in front of the picture their own image, thus instantly turning them into a part of Raysse's work.

When Michel Jaffrennou creates his comic operas and circus scenes, he is exploiting the technological possibilities of video; the subject of his work is the medium of television itself. For Pierre Huyghe and Fabrice Hybert the subject is the technical aspects of video. Huyghe erected a television transmitter outside the Nouveau Musée in Villeurbanne and Hybert created a working television studio for the French pavilion of the Venice Biennale in 1997. The work of art and the medium thus become perfectly fused and confused. Technology (and all the procedures that go with it) takes the place of the work of art and is exhibited in the same way that a painting or sculpture might be.

BIBLIOGRAPHY

De Oliveira, N and Oxley, N, *Installation Art*, London, Thames and Hudson, 1994

Raysse, M, *Martial Raysse*, Stedelijk Museum, Amsterdam, 1981

Passages de L'Image, Paris, Centre Georges Pompidou, 1990

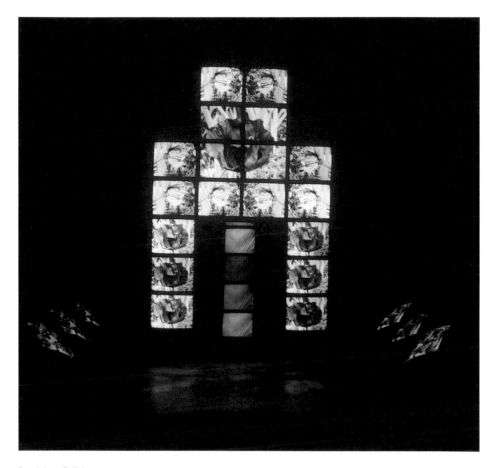

Dominique Belloir,
Nymphaeum, video
architecture for 36
screens, 1991.

'Computer science has opened up a new perception of space. The same phenomenon is taking place today that must have occurred during the Renaissance, when the invention of perspective ushered in a form of architectural representation. Computer science is more than just a tool: it involves a whole system of thought and a way of looking at things.'
Nasrine Seraji, architect.

Because of its scientific, technical and military origins, the image created by a computer can be very precisely controlled. This total control and the resultant pressure from various kinds of stereotyping have meant that computer art has had some difficulty in gaining acceptance in the art world. Many of the first computer artists were technicians and information scientists who ventured into the field of art. It was thought that art and science, or art and technology, would be united in a new, innovatory genre. The 'artificial' image has borne (and continues to bear) the burden of its origins and has struggled to free itself from its technical constraints. It was only by combining with other art forms (such as dance, cinema, theatre, architecture or video) and playing a role in installations that the digital (or 'artificial') image became truly interesting. This was also the moment when it became a simple tool once more, integrated into a larger ensemble, the confusion over territorial limits (art and science, art and technology) having succeeded only in subjecting art to academic procedures. François Molnar observed this same phenomenon in 1981: 'Artists are learning to use computers... technicians are discovering the possibility of creating art, of producing combinations of shapes and colours... These computer technicians are invading the "art market". Their work, it is true, resembles genuine works of art, but something fundamental is lacking...'

As the architect Nasrine Seraji has noted, digital imagery also involves a specific mode of thought – one based on a constructional system, on the spatial and temporal development of interwoven figures and objects that can be walked through and traversed. Manfred Mohr describes this new system as 'statistical thinking'. According to him, the rigour and precision of this mode of operation – based as it is on numbers and on the repetition of the same numbers and same forms – should enable us to 'see the visual in a new light'. By using models we can now anticipate how a form is going to turn out. This form, along with its own set of unknowns, becomes entirely controllable.

We need here to clarify certain items of vocabulary. The use of the terms 'artificial image' and 'digital image' (by artists, critics and theoreticians) is somewhat vague and subject to shifts in meaning, which is not surprising, as the development of new technologies is often accompanied by semantic uncertainties. The analogue image

results from the 'capture' of reality in the form of continuously varying intensities of light. The digital image is based on numbers or abstract signs. The so-called 'artificial' image is an image that has been calculated and constructed. These last two terms are often used interchangeably.

The recent appearance of digital cameras and photographic equipment has changed the situation considerably. The digital representation of previously analogue data (such as images and sound) allows for standardized processing of this data by computer. The quality and definition of digital images are steadily increasing and indeed are starting to match those of analogue images. Now that image (or sound) data can be infinitely manipulated, there is a tendency towards what is known as 'all-digital' technology. Seen from this perspective, therefore, artificial images constitute a sub-category of digital images.

Analogue, digital, artificial

Analogue. Relating to the representation, processing or transmission of data in the form of continuously varying intensities.
Digital. Describes systems or devices using binary signals only.
Artificial. Calculated from beginning to end on the basis of mathematical or abstract models. The artificial image is thus digital.

The digital 'diagram'

'The real raw material is not the camera and monitor, but time and experience itself, and... the real place the work exists is not on the screen or within the walls of the room but in the mind and heart of the person who has seen it. This is where all images live.'
Bill Viola

With the dominance of the computer we are approaching what Bill Viola described and hailed in 1984 as 'the end of the camera'. This would also be the end of an aesthetic dominated by natural light ever since the appearance of the camera obscura. In future, images will be artificially created, calculated and programmed rather than captured with due regard to lighting conditions.

The image then reverts to the form it took before the Renaissance and the development of illusionist perspective; in other words, it becomes a mental image – which (according to Viola) it never ceased to be in the East.

The use of algorithms, curves and mathematical plans, together with a system of random variations, constitutes a language of considerable graphic flexibility. Many images of computer art (for example, those produced by Manfred Mohr,

Artificial light

Unlike the video image, which results from the physical recording of light, the artificial image belongs to a world in which light values, shadows, reflections and objects are determined mathematically. The computer artist decides on the shapes, textures and colours of objects and then (using rather simplified optical laws) adds light to the scene (in terms of localization, intensity and colour). The job of the software is then simply to work out the image.

Michael Noll, Torsten Ridell and Vera Molnar) are effectively the result of systematic or random distortions introduced into the development of a system of calculation.

The digital image is governed by a rigorous semiotic system involving rasters, grids and sequences of numbers, letters and abstract signs. Computer art often bears the stamp of this strict encoding. The works of Michael Noll, Torsten Ridell, Jacques Palumbo and Roger Vilder play with numbers and introduce multiple variations and graphic and coloured partitions. Torsten Ridell develops a structure in a three-dimensional space and varies the viewpoint. Of his *Permutations of Lines in Three Dimensions* (1979–83) on flat surfaces, he has said: 'I select the angles that I judge to be interesting for both me and the viewer and stress those that seem to me to be fundamental.'

The digital image breaks with the traditional analogue image. With the analogue image – obtained from the recording of data and fundamental to the development of photography, cinema and video – the viewer became accustomed to considering the natural world as a reservoir of images to be captured and recorded. Closer in terms of the way it functions to drawing, painting and sculpture, the digital image is a mathematized and pre-calculated image that can be controlled right down to the infinitely small detail of its textures. 'Since 1973,' explains Manfred Mohr (*P-522/D*, 1997), 'my work has been based on rigid systems (cubes and hypercubes) that I regard as a catalogue of elements to be used in the development of signs.' The artist works with mathematical entities that he combines and organizes by using a language that remains totally formal.

This does not mean that the artificial image can exist without a model. Like drawing and painting, it can take 'nature' or perceived 'reality' as its model. The famous teapot that served as a model for the teapot digitized by Martin Newell is now displayed in a gallery next to its double. Realism and naturalism, as we shall see, were to become two goals that computer graphics would strive to achieve. Attempts were made to perfect the way in which different materials were rendered and to smooth out the image and cover it with a realistic-looking 'skin'. Computer modelling allows for the extremely precise (and increasingly precise) pinpointing of, and control over, the various components of the

information (image or sound) that are to be processed. This begins with the analysis and breaking up into component parts of the different elements of the target object or image, followed by a point-by-point, element-by-element artificial reconstitution of them.

Manfred Mohr, *P-522/D*, digital artwork, 1997.

Let us take as an example Leonardo da Vinci's famous *Mona Lisa*. Once all its information has been turned into simple dots or pixels – atomic, elementary signs – the model painted by Leonardo can be reconstituted, transformed, colourized, doubled up, multiplied, and so on. In the series of pictures created by Jean-Pierre Yvaral in tribute to *Mona Lisa (Synthesized Mona Lisa*, 1989), the artist applies to Leonardo's painting this strict digitization of the different elements of an image. Digitized into many discrete, geometrical elements, the resulting picture is then manipulated, transformed and used to create the illusion of a kind of open-sided cube or a room viewed in perspective. The artist plays with rasters, grids, associations, repetitions and colours. In a work like this, an important role is played by cultural stereotypes, which the viewer can get pleasure from identifying. Images of Brigitte Bardot, Mao Tse-tung and others have been given the same treatment. Léa Lublin, meanwhile, uses the computer to examine the history of art. She deconstructs, reframes and reworks quattrocento images of the Madonna and Child, recycling the works of Dürer, Andrea del Sarto and Parmigianino, for example, as electronic images (*Memory of History Meets Memory of the Computer*, 1983).

Creating digital images

'In what way can the computer be of 'service' to the artist? From an intellectual point of view, the computer is an amplifier of ideas; from a mechanical point of view, it possesses unequalled drawing skills. The computer's contribution to art is thus perfectly clear. It forces the artist to be rigorous: it raises precision to the dignity of art'
Manfred Mohr

Léa Lublin,
Memory of History Meets Memory of the Computer,
digital artwork,
1983.

The computer is a tool that brings precision to art and that facilitates the management of visual material. It is therefore easy to see why, following the example of specialist computer graphics artists, video artists also embraced the computer enthusiastically: it makes the process of editing and timing images far easier. Objects in space can be analysed in a number of different ways: for example, as surfaces or volumes, in terms of facets, two- or three-dimensionally, or as animated or static. For the construction of an artificial 3-D image modelled on a real object, the object needs first of all to be optically simulated using mathematical models. One of the methods used for modelling three-dimensional objects is to redefine the surface of the target object as a series of small subordinate planes. This forms the basis of a technique

known as wireframe modelling – a technique widely used during the early days of artificial images when the rendering of objects involved long calculation times. This wireframe structure functions as a kind of blueprint for the form or figure that is to be recreated. Based on this skeleton, the image then has to pass through the final stages of smoothing out, creation of texture, addition of colour and calculation of shadows, reflections and, where necessary, areas of transparency. This is slow, painstaking work requiring multiple calculations every step of the way.

The deconstruction and analysis of the image (possibly an object chosen as a model) by reducing it to a set of 'atoms' or discrete dots (pixels) enable it to be subsequently reconstructed. Every imaginable form of correction and manipulation is possible during the course of this reconstruction. Similarly, the digitization of a photograph obtained by analogue means allows it to be improved or restored. Shadows and contrasts can be removed or modified, the photograph made crisper and details added or eradicated. When the whole thing has been 'smoothed out', the corrections are invisible.

Once the form or figure has been constructed and inserted (in gossamer-like form) into its three-dimensional space, it needs to be 'dressed' through the addition of textures. For this the computer graphics artist has a wide range of materials to choose from. Textures (water, veins, grooves, etc) can be simulated and constructed using algorithms of varying degrees of complexity, or photographs featuring different materials (sand, rocks, fabrics, skin, marble wood, etc) can be scanned in. Here the artist comes up against the ancient question which has preoccupied painters for so long, of how to render these materials. Like them (but using different means), computer artists search for the best way of portraying velvet, the complex interplay of veins running beneath the skin, the silky texture of a particular fabric, and so on.

A linear dimension

'I describe my work as "generative" because all my art is generated from algorithms (logical procedures) established by me in advance... My work is essentially linear. The exclusive use of black and white as visual components allows the elaboration of a rigorous system of binary decisions.'
Manfred Mohr

Initially, much computer art was linear. In the beginning this was because it was closely linked to technique, but it subsequently developed into a style and was claimed as such by artists. We have already mentioned the wireframe structure – this is used mainly with figurative constructions, but also in the creation of volumes and geometrical compositions. The surfaces of forms created in such a way can be either covered up or left 'naked' and transparent, as is often the case in Vera Molnar's work (*Quadrilateral Structures*, 1986). Some of Tina LaPorta's linear outlines (*net.works + avatars*, 1999) certainly count as wireframe structures, but they are not simply 'topographical' or stereometric résumés of the human body: her figures are well and truly 'drawn' – in the manner of watermarks or working drawings.

Some works of art explore the possibilities inherent in the simple creation and distortion of a line. Many of Manfred Mohr's works are like melodic linear variations (*Random Walk*, 1969) presented in series form; or else the line transmutes into signs or symbols, the artist lining these up as if they were words on a page of writing (*Meta-Language II*, 1974). Making use of this same type of linear construction (*Permutations of Lines in Three Dimensions*), Torsten Ridell would later describe it as 'sculpture'.

Below and right: Tina LaPorta, *net.works + avatars*, digital artwork, 1999.

It is, of course, a programmed sculpture based on computer

language – sparer and more economical than the sort of sculpture one is used to seeing on pedestals. When all is said and done, it is the 'idea' of sculpture; sculpture that can be varied or turned in any direction.

Also using this technique of stripped-down perspective, Vera Molnar produced a series of variations on the lines of force of the Sainte-Victoire mountain landscape immortalized by Cézanne.

Franck Scurti (*The Line*, 2002), presents the adventures of a line (and a little cartoon-like character created from it) whose moods and adventures follow the fluctuations – also linear – of the stock market.

Simulation

'The artistic technique of simulation consists of creating worlds that refer continually to reality and also extend it, establishing a dialectic between memory and creation, the real and the virtual.'
Jean–Baptiste Barrière

Simulation is at the heart of synthesis, which is still haunted by the old dream of mimesis – imitation and reproduction. The digital

works guided by aesthetic choice, and as such contrast strongly with those of Noll: they are interpretations that take up certain motifs rather than simulations.

The computer functions as a kind of triple tool, allowing analysis, creation and simulation. As regards artistic creation, however, most existing software is of limited use, being designed for technical and scientific purposes. While it allows the programming of shapes, colours and precise volumes, it is, by its very nature, restrictive and not always very well suited to the subtleties of visual experimentation. Artists therefore have to be extremely resourceful in finding ways of introducing random factors.

Fluid and dynamic shapes

'Computer rendering is a new medium in which pictures without paint of objects that do not exist are created: in effect ghosts of sculptures.'
William Latham

In addition to geometric forms, the world of artificial imaging soon became interested in soft, organic forms based on new and more complex programming systems. The Japanese artist Yoichiro Kawaguchi (*Ocean*, 1986; *Embryo*, 1988; *Flora*, 1989) has developed a dynamic morphology heavily inspired by the organic world. Living creatures, and undulating aquatic environments in particular, are the models for his work. William Latham sees his organic images and quasi-surrealist life forms (*The Conquest of Form*, 1988; *The Evolution of Form*, 1990) as a kind of digital sculpture. A program called Mutator allows him to generate and program complex forms that are then preserved on a film or photographic support or else abandoned.

Karl Sims' animated particle waterfalls and genetic creations (*Panspermia*, 1990; *Primordial Dance*, 1991; *Galapagos*, 1997) carry this tendency further in interactive installations that allow his forms to take different-coloured twists and turns.

Louis Bec's invented creatures and species (*Upokrinomène Vulgaris*, 1993) also present an evolving fantasy flora and fauna based on lithe, supple forms.

Based on GPS (global positioning) technology, Masaki Fujihata's

William Latham,
Computer Artworks,
digital works.

Impressing Velocity (1992–4), which takes Mount Fuji as its theme, generates a whole series of complex forms. Fujihata starts by constructing a digital model of Mount Fuji. He then alters the shape of the mountain by increasing its height to twelve times its 'normal' size.

Visitors can then use a joystick to transform the image of Mount Fuji's summit by manipulating the GPS data (speed, height, latitude, longitude and time) obtained from an actual ascent and descent of the mountain. The delicate graphic forms created in this way are reminiscent of ideograms.

The development of fractal images enabled improvements to be

Karl **Sims**, *Galapagos*

Interactive installation, 1997.

This installation comprises twelve graphics stations connected to a central server. The work is a double homage: to Darwin, the father of evolutionary theory, and to the Galapagos Islands (the remote archipelago that is home even today to an extraordinary fauna). Twelve television monitors are connected to twelve pedal-operated sensors. By activating a selection of sensors with their feet, visitors can choose the type of 'living' form that will gradually invade all twelve screens. Black or coloured, vegetable or animal, serpentine or rounded, these 'organisms' selected by the visitor will evolve, reproduce and mutate, to the visitor's delight and amusement.

General view and detail

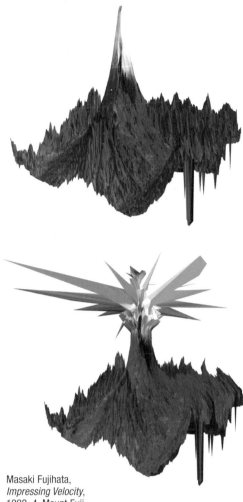

made in the management of complex forms. Artists such as Carlos Ginzburg, Ève Larramée and Miguel Chevalier have used fractals in order to manipulate forms. The resulting works are a mixture of a fairly laboured geometricism and an intricate, baroque style. However, when not informed by serious aesthetic intent, the use of fractals simply involves a process of interlocking forms and forms-within-forms which results in a somewhat academic end product.

Fractals can also be used as an analytical tool. For example, they have made it possible to schematize Jackson Pollock's works, and his dripped works in particular, following the revelation that they contain fractal structures. This procedure consists in marking out a painting in successively smaller and smaller squares in order to determine the trajectory of each line. The problem is that this runs counter to the whole action painting concept of gestural dynamism and thus misses the essential point about Pollock's method.

Masaki Fujihata, *Impressing Velocity*, 1992–4. Mount Fuji 'undistorted' (top) and 'distorted' (bottom).

Fractals

Certain natural forms (such as coastlines, the contours of clouds, the structure of snowflakes, the branches of trees or bronchial tubes, and hydrographic networks) display an irregular, fragmentary character which can only be understood through the application of a specific mathematical process. As theorized by Benoît Mandelbrot, fractals (images or objects) are based on repeated subdivisions of a base form that are framed by and repeated (or reproduced) within themselves.

'Fractals formulate a geometry that perpetuates, from anamorphosis to metamorphosis, a new tension between form and formlessness, figuration and dis-figuration.' (Miguel Chevalier)

Realism

Computer images 'have a tendency to be visually excessive in some way... excessively schematic, excessively geometric or, at the opposite extreme, excessively realistic in an all too perfect way'.
Françoise Holtz-Bonneau

One of the functions of the digital image is the modelling of reality, and this is how it originally

developed in the aviation industry, with the production of flight simulators designed to enable pilots to learn their craft in an entirely artificial environment. Today, this function is becoming more and more integrated into the real-time flying of aircraft, which is done with the help of screens that connect the pilot to the real world. Actual vision has been replaced by the manipulation of digital data and the representation of an artificially reconstructed landscape. Forms, figures, objects and landscapes have been taken over by increasingly perfect simulations.

The ultimate in realism, however, is the successful modelling of the human being and the main ways in which humans express themselves. The computer graphics artist creates a three-dimensional diagram based on the average measurements of the human body. This is a skeletal, filigree, so-called 'wireframe' figure, hollow and transparent, that can then be dressed – covered with skin and clothes – and eventually animated. As a pioneer in this area, Rebecca Allen worked her way through all the stages, from wireframe structures (which provided her with a skeleton with which to work) to the covering of volumes and surfaces. *Steps* (1982), an animation based on artificial images, includes a structural, animated, moiré human figure. If we analyse the way *Music Non Stop* (1986) was made, we can follow the gradual modelling of the face from the creation of the squared mesh structure to its covering.

Keith Waters' work is based on a system of progressive covering involving three levels: bones, muscles, skin. It is not until right at the end that he adds folds and wrinkles, gradually styling and 'humanizing' his characters. The modelling of the face is often achieved using a close-knit mesh, a kind of raster or very narrow grid which allows the flat surfaces, ridges and surfaces of the different volumes (nose, cheekbones, dimple in the chin, arch of the eyebrows, etc) to be digitally defined.

Tony de Peltrie (1985), the creation of the Canadians Philippe Bergeron and Pierre Lachapelle, was given facial expressions (in particular a smile) copied from the face of a young woman. The expression of human feelings is what has fascinated computer graphics artists most of all. *The Other* (1992), by Catherine Ikam and Louis Fléri, is another example of this simulation of what is human. It also has an interactive dimension, the aim of which is to

establish a dialogue between the installation's gigantic artificial face and the visitor. *ELLE and the Voice* (2000), by the same artists, offers a more refined, more realistic version of a face and its expressions despite the fact that its colours are unreal – fluorescent and completely artificial.

The crowning achievement, as regards realism, is the creation of artificial actors (the doubles of deceased real actors) that can then act out new scenes. In Nadia and Daniel Thalmann's *Rendez-vous in Montreal* (1987), for example, Marilyn Monroe and Humphrey Bogart act out a scene that was never filmed during their lifetimes. However, it is not simply a question of bringing Hollywood legends back to life: computer graphics artists have now developed original artificial actors of astounding realism. These, of course, can appear in an entire series without ageing.

3-D: a world in relief

'A distinctive characteristic of artificial images is "the visit"; all they allow us to do is to visit forms... The digital image is a form of endoscopy.'
Paul Virilio

At the outset, digital images were two-dimensional. Gradually, the representation of volume was achieved, allowing viewers to move around inside the image and explore it from every angle. This has found a use, for example, in architectural software which enables agencies to offer their clients virtual visits of planned buildings.

The notion of virtual space comes into its own here, letting people move around in artificial worlds, fly or fall through the air, or climb over entire landscapes – all the while experiencing the appropriate kinaesthetic sensations.

This representation of volume and movement within a space that can now be contemplated from every point of view (above, below, underneath, etc) is often achieved by plunging into the heart of a transparent image. This transparency allows the eye to 'move' in every direction, over the different layers or sub-layers of the object or landscape represented.

To this has been added a 'relief' effect, which differs from a simple perception of volume in that it provides an extra dimension:

Above and below:
MVRDV,
Metacity/Datatown,
digital 3-D image,
1998.

landscapes and objects appear jagged or with highlights. During the 19th century, stereoscopic vision was all the rage. This is coming back into use today with the virtual reality goggles that visitors to many installations and environments are required to wear. This pleasure in depth, increasing our perception of objects, is making a comeback, opening the door to what is now described as a virtual world or 'enhanced reality'. Such worlds are perceived as possessing a relief that ordinary vision does not let us see. Here too there is surplus, an excessive representation of a reality more real than nature itself. In conjunction with the representation of movement, this new dimension is changing everything –

developments in digital imaging are indeed creating a new way of experiencing space.

George Coates's installations, for example, allow visitors to move within a three-dimensional image that transforms itself in real time. In 1994, he gave a performance in Tokyo entitled *NOWHERE NOW HERE*. Throughout the action, digital images and film projections underwent all kinds of transformations. On stage, actors appeared and disappeared, passed through walls or metamorphosed into virtual characters. Wearing 3-D goggles, the public witnessed the unfolding of a magical, childlike world inhabited by extraordinary animals and plants.

The representation of movement

'I am dealing with two highly technical systems, each with their own technical language and frames of reference — that of the human body on the one hand, and that of computer technology on the other hand.'
Thecla Schiphorst

George Coates, *NOWHERE NOW HERE*, 1994. 'A girl dreams of becoming a magic bird.' Multimedia performance and environment.

One of the biggest challenges for computer artists was the representation of movement. There were two essential stages in

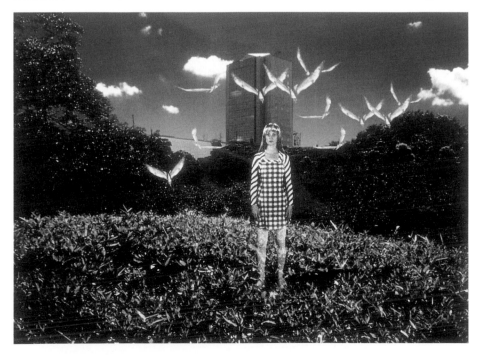

its development. The first was the artificial modelling of movement, which was based on calculations and depended greatly on the internal clock speed of the computer, a severe constraint that resulted in the creation of jerky, schematic movements. It was a matter of analysing and deconstructing people's movements in order to recreate them as accurately as possible. Based on the modelling of forms and the human body in particular, the computer (using 'continuity equations') took into account the various parameters that had to be altered at each step to match the movement to be performed. The second stage was the progression from artificial modelling to the capture of real movements. A great leap forward was made in around 1992–3, when researchers succeeded in capturing movement in 'real time', followed by the processing and recreation of that movement, again in 'real time'. This gave immediate access to the world of virtuality and interactivity and allowed the artist (whether dancer, visual artist or performance artist) to interact with his or her double for the first time.

For a long time the complexity inherent in the representation of movement led to tasks being broken up into individual operations – some focused on the representation of walking, others on hand movements, others still on the extremely complex movements of the face, and so on. Lillian Schwartz and Ken Knowlton deconstructed the movements of a famous sportsman in this way (*Olympiad*, 1971), analysing the effects his successive movements had on the surface of his body. Some time later, Omura Fukomoto's mechanical tiger (*Bio-Sensor*, 1984) and the giant ants of the New York Institute of Technology (*The Works*, 1983) took their first steps as artificial animals. Coupled with sensors and interactive devices, data relating to the representation of movement would also play a role in choreographic education and the development of dance performances. Dancers' movements would be broken down, minutely analysed and reintegrated into the bodies of virtual dancers.

Rebecca Allen also gives her artificial characters a range of different movements and expressions, from basic facial mechanics to more complex movements. In *RABL* (1985), eyebrows move up and down and mouths open and close. When she made *Kraftwerk* (1986), she used casts of the heads of real people (the members

of the German electronic music group of the same name, for whom she also designed an album cover). These casts were photographed and then analysed from all angles. The subsequent animation was based on the reference points thus identified. Today, however, the computer's contribution to the various art forms goes much further. Dance (as we shall see) has benefited greatly from computer-generated movements. The movements of real dancers can be captured and analysed (and then transferred to a virtual dancer or puppet), but dancers can also be asked to reproduce a set of movements generated by the computer or members of a dance troupe can be asked to add their movements to a piece of virtual choreography.

Colour: a digital code

'What would be of interest to the geographer would be not so much the exact shade of dark green of the Brazilian forests, perhaps, or the cerulean of the sea, but the admission once and for all that the green forests really are green, the sea really blue and the sand really yellow. This would amount to the construction of a "diagram of colours" as precise as that used by the cartographer.'
Abraham Moles

For a long time, the work produced on graphic tablets was either black and white or was coloured later using one of a number of different screen-printing techniques or photographic filters. The arrival of colour on the computer terminal at the end of the 1970s changed things completely. No longer was form – which had dominated the work of the pioneers of computer art – the only element that could be taken into account.

Henceforth, manipulation could be done using a colour palette with a vast range of gradations: as many as 16 million available (and displayable) nuances of colour. The use of paint programs led to increased artificialization and the use of colours in a schematized way. The precise shade of a tree, flower or specific material was no longer reproduced from nature, but chosen from the available colour code. This code was written into the software and able to produce automatically the gradations of colour and shadow needed

to create a degree of verisimilitude. The same process occurs in medical imaging and satellite photography. In both cases, the information recorded is monitored, manipulated and corrected, resulting in images that are more vivid and 'perfect' than the originals. As Abraham Moles explains, the effect is actually to improve on reality, rendering it in a way that can be easily understood. Thus birches become yellow and fir trees blue. The tissues and fluids of the human body are rendered with the help of a conventional colour scheme, as in the case of thermographic imaging. This records the temperature of the body's various organs, tissues and fluids and portrays them in a range of colours.

Yoichiro Kawaguchi, *Cytolon*, digital image, 2002.

Digital colour is based on the principle of additive synthesis, which involves the blending and mixing of red, green and blue in the viewer's eye. Digital imagery of the 1980s is characterized by its use of vivid, contrasting colours and a kind of chromatic glow. It is not difficult to see what Françoise Holtz-Bonneau meant when she spoke at the time of vivid colouration and of the 'tendency towards excess' of the digital imagery aesthetic.

Yoichiro Kawaguchi, *Nebular*, digital image, 2000.

The intensity of this colouration was often accompanied by geometrical severity and a realism verging on parody. This explains why artists later attempted to do exactly the opposite by adopting pastel or neutral colour schemes. Nevertheless, it is easy to imagine the appeal to artists of this palette of artificial colours that could be infinitely adjusted and shaded.

Interfaces

'The possibilities of virtual realities, it appears, are
as limitless as the possibilities of reality. It provides
a human interface that disppears - a doorway to other
worlds.'
Scott Fisher

An 'interface' is a device that forms a connection between two
systems using different languages, thus enabling information to flow
between them. Interfaces are particularly important in the virtual
sphere as they provide communication between one type of element
and another. The first interfaces were 'graphic' – styluses (electronic
pens) connected to graphics palettes – but they later became more
varied. Vertical screens and the use of visual interfaces is currently
the norm; however, researchers have experimented with various
interface systems. These can be tactile and horizontal, such as the
special game of table tennis developed by Hiroshi Ishii and the
Tangible Media Group. Whenever the ball comes into contact with the
table, which has been transformed into a digital 'sea', small white
waves radiate out from the point of contact, accompanied by a range
of sounds. Another interface system developed by the same group
involves musical bottles: three small bottles play tunes when they
are uncorked. Each stopper is wrapped in electromagnetic tape
which instructs the computer, as soon as it detects that the bottle
has been opened, to play the appropriate melody (piano, strings or
percussion).

The current trend is for the control interfaces that allow users to
establish contact with a machine to become smaller, lighter and
less physical. The hand-controlled keyboard or mouse is being
supplanted by the voice, the eyes and soon, perhaps, even by
thought – research has been carried out into the visualization and
monitoring of brainwaves. Pierre Henry's *Corticalart* (1971) was
already based on this principle: electrodes attached to the
musician's head allowed him to 'conduct' sounds with his
thoughts. The same waves were also converted into visual,
coloured form and displayed on screens.

Tactile interfaces with a high entertainment potential have also
been created in the form of robots and puppets equipped with 3-D
sensors. 'The Monkey' is a 30cm-high puppet connected to its
double on the computer. When the real puppet is manipulated its

on-screen double adopts the same positions. One can also manipulate an artificial puppet moving within a virtual world, or play with a virtual sculpture that – thanks to a system of tactile retroaction – responds by communicating a whole range of sensations to the player (suppleness, resistance, and so on).

The computer and its double: painting machines

'In addition to random chance preventing the machine from painting the same picture twice, improvised interventions are also possible. Colour blocks, objects and scraps of fabric are interposed between the jets and the support. The work produced by the machine can thus end up full of signs, torn to shreds, or broken into pieces and reassembled by assistants.'
Victor Grillo

Like video, whose narcissistic character has already been described, the digital universe was soon influenced by the tools being used to create it. In *Bend II* (2002), Annika Larsson brings an artificial character face to face with his artificial double whom he can watch on the screen of his computer. The world of the artificial image takes us straight into what used to be regarded as the world of science fiction. The methods of the artist Miguel Chevalier are a good example of this particular type of approach, which includes in the artistic process elements that reveal and represent the technology used. In much of his work, Chevalier is influenced by depictions of computer (and smart card) circuits and networks, which he reproduces and explores in all sorts of forms: paintings, videos, installations and CD-ROMS.

He even gave one of his works, dating from 1989, the revealing title *Binary State*. Other works refer directly to the various ways of creating digital images (*Fractal Natures 1, 2, 3, 4*, 1994; *Outline Landscape*, 1000). The fantasy of a painting machine had been a permanent feature in the history of art; the computer now seems to have revived it. Plotters and other forms of graphics palette that have allowed artists to be in some way connected with the computer have already been described. However, the computer and visual artist Victor Grillo was not content with the purely optical and digital nature of the works produced in this way. Hoping to

rediscover the physical, tactile dimension of the painting process, he actually designed a painting machine. In 1988, he used it to create his *Homage to Yves Klein*. The model is filmed with a camera before lying down on a large stretcher. Covered in a kind of shroud, his body becomes the support for the painting machine, which then prints the pre-filmed image of his own body onto him.

BIBLIOGRAPHY

Moles, A, *l'Art et l'ordinateur*, Paris, Casterman, 1970

Paul, C, *Digital Art*, Thames and Hudson, London, 2003

Popper, F, *Art of the Electronic Age*, London, 1993

'The hybrid or the meeting of two media is a moment of truth and revelation from which new form is born.'
Marshall McLuhan

Video and computers were originally two distinct technologies producing different kinds of images – one analogue and the other digital – and this initially gave rise to two highly contrasting art forms. However, the two technologies quickly merged. Here again it was technicians who took the initiative by improvising new devices. A range of tools began to emerge from 1969 onwards: Eric Siegel's *Electronic Video Synthesizer*, Thomas Tadlock's *Archetron*, Earl Reiback's *Aurora* and Joseph Weintraub's *AC/TV*. In the end, digital technology has come out firmly on top. The introduction of digital photography, the development of digital camcorders and the digitalization of the cinema have led to the concept of 'all-digital' technology, where artists can use video together with computers and take advantage of many different technical devices.

Multimedia art

Multimedia art is art that involves a number of media or technical supports (painting, photography, sculpture, digital imagery, etc). There are two possible approaches to multimedia art: artists either smooth over and obliterate the joins and meeting points between the different media, or they do the exact opposite and exploit the shock value and dissimilarity of the various techniques employed. Installations and environments frequently make use of a range of different supports and can thus be considered the focal point of multimedia art. The 1990s were characterized by work of this kind. There was a 'merging of the arts', with new technology adding a fresh dimension to the notion of 'total art' as formulated by avant-garde movements at the beginning of the 20th century (such as Constructivism, Futurism and the Bauhaus)

As we have seen, the computer became a key player in art, particularly in the work of Steina and Woody Vasulka. An electronic era had begun in an electronic universe where nature and artifice were grafted onto each other. Artists were systematically exploring the properties of the medium, hence the proliferation (within the arts themselves) of a form of 'metalanguage' – in other words, one form of discourse that subsumes another and encompasses another language.

In 1970, the World Fair held in Osaka (Japan) gave artists an opportunity to engage with the computer. Environmental sculptures were designed for various pavilions. Following in the footsteps of the 'total theatre' project conceived by the French director and designer Jacques Polieri and created by the Mitsui Group, Katsuhiro Yamaguchi produced an impressive installation consisting of three rotating, ascending platforms which lifted the public heavenwards (*Journey into the Cosmos and Creation*). Projected onto a 360-degree screen, computer-controlled lights, images and sounds invaded the whole space. At a very early stage, artists were involved by industrial firms and large stores in a process that had enormous economic consequences. In 1985, the Science Expo held in Tsukuba was another opportunity for grandiose technological statements.

While the 1970s saw the invention of the electronic collage, in the 1990s a new type of relationship developed between the various forms of expression. Artists began to master technologies such as video or the computer, and art schools started turning out young

artists trained in their use. The tools, moreover, were within everybody's reach. This resulted in a proliferation of installations that combined the different media so closely that video art and digital art merged and started to develop jointly. Multimedia installations and the blending of art forms was soon followed by the development of new modes of communication and information storage: artists' CD-ROMs, art on the Net, and so on. From then on, artists took advantage of new gadgetry as soon as it came onto the market.

One of the characteristics of video and the new digital images was that it allowed artists to accumulate images and pile them up one on top of the other. Following a complex system of layering, images (which could come from a wide range of sources) could be superimposed until a global image was obtained that was almost illegible.

'All-digital' art

'I am interested not so much in the image whose source lies in the phenomenal world, but rather the image as artefact, or result, or imprint, or even wholly determined by some inner realization.'
Bill Viola

'All-digital' art tends to emphasize programming, editing and special effects. More and more, images are constructed and manipulated and based less and less on reality. As McLuhan explained, the media are translators. As such they allow all natural material or reality to be transformed into a system of interchangeable elements which can be controlled mechanically and subjected to infinite permutations in the networks of our information systems. What we have here is a genuine material transformation, the age of automation making it possible to translate and transform any given material reality into another. Reality is thus transformed into images and images are transformed into other images, with all the various technologies rubbing shoulders.

The image has started to take precedence over, or even to supplant, reality. As McLuhan observed, we are now capable of 'transferring the whole show [the world] to the memory of a computer'. The dramatization and staging of the real world takes place today by means of tools (video, computer, optical fibres and

Gary **Hill**

Born Santa Monica 1951. Lives in Seattle.

'You can't sidestep the mechanics of the medium, but it's not what makes something... If a piece really works for you, your response goes beyond a question about how it was made.'

In Gary Hill's complex installations viewers are confronted with spaces or

corridors through which they are drawn by the appearance and disappearance of characters whose size, presence or words create feelings of disturbing strangeness.

Using the fragmentation of human body parts, the play of superimposed images and strong contrasts of light, the sliding and shifting of an image in perpetual

I Believe It Is an Image in Light of the Other, video installation 1991–2. Seven modified black-and-white monitors, hanging tubes, sound system and books.

anamorphosis (*Beacon*, 1990) and texts whose letters undergo transformations, Gary Hill's video installations explore time, language, sound and perception. Fragmented, dissociated, often reduced to small details, his images shift from one monitor to another.

Gary Hill's first installations conformed to rigid geometric structures such

as the cross (*Between 1 & 0*, 1993). But his images soon liberated themselves from their frames and supports, assuming increasingly ethereal forms and appearing to be suspended in space: luminous, moving projections of texts and images which undergo a process of strange anamorphosis in the

corners of dark rooms or when they come into contact with supports or objects (*I Believe It Is an Image in Light of the Other*, 1991–2).

SELECTED INSTALLATIONS

– *Crux*, 1983–7.
– *Disturbance (among the Jars)*, 1990.
– *Tall Ships*, 1992.
– *Circular Breathing*, 1994.
– *Viewer*, 1996.

BIBLIOGRAPHY

– *Gary Hill: In the Light of the Other*, exhibition catalogue, Museum of Modern Art, Oxford and Tate Gallery Liverpool, Liverpool and Oxford, 1993
– Hill, G, *Gary Hill: Imagining the Brain Closer than the Eyes*, Cantz, Ostfildern, 1995
– van Assche, C et al, *Gary Hill*, Éditions du Centre Georges Pompidou, Paris, 1992; Stedelijk Museum, Amsterdam and Kunsthalle, Vienna, 1993; IVAM Centre del Carme, Valencia, 1993

Inasmuch As It Is Always Already Taking Place

Video installation, 1990

16 modified monitors, 16-channel video, NTSC, black and white, sound, synchronizer, niche.

The monitors (removed from their cabinets) are arranged like a group of stones, facing outwards from a niche 120cm wide and 50cm high. Ranging in size from very large to very small, the screens show images of different parts of the human body. The piece is a kind of anatomy lesson revised and updated by audiovisual technology, a realist (or hyperrealist) 'still life' in which some of the recognizability of individual body parts is sacrificed to close-up detail. Here we have a scattered, fragmented body reminiscent of the theory of the divided body of which psychiatry provides many examples. Or is this a detailing of the body parts of Christ as evoked by Gary Hill in a previous installation (*Crux*, 1983–7)? Displayed here are the folds and wrinkles of the naked body: skin, thumb, elbow and knee joints, the bumps of the vertebrae, the furrows of the brow and the diagonal groove of an eyelid.

The soundtrack plays a variety of rustles, whispers and murmurs, and sounds made by the rubbing of hands and the pages of a book being turned. These images are as much about the image as they are about the body, which they both show and conceal.

waves, networks and digital programming) that transform diverse
textures and materials into a kind of single visual currency
corresponding to what Paul Virilio called 'the image bloc'. Digital
technology has thus come to mask the analogue, to smooth it out,
civilize it and dematerialize it.

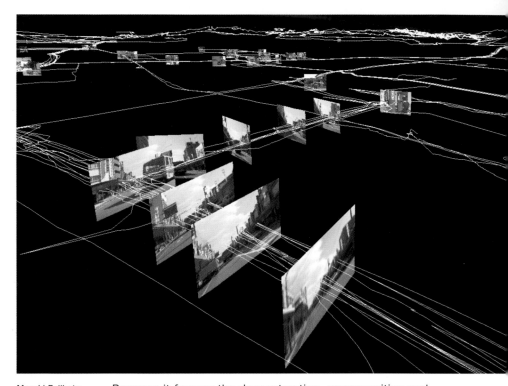

Masaki Fujihata,
Field-Works –
Tsumari,
'cyberspace' based
on GPS data and
video images, 2000.

Because it favours the deconstruction, recomposition and
manipulation of the visual, the artificial image has become the
main focus for hybridization. This is a method that reconnects with
the well-established principles of decoupage, collage and
transformation, and sometimes touches on unadulterated kitsch
as it revisits deep-rooted clichés. Working with the monumental
cultural cliché that Leonardo da Vinci has become, Lillian Schwartz
demystifies our image of him, joining one half of the Mona Lisa's
face to the other half of Leonardo's (*Mona/Leo*, 1986).
In another of her works she progressively transforms Rembrandt
into Einstein by means of a whole series of calculations and
intermediate images. The analysis and digitization of two different
images allows her to engineer a series of encounters between
them, a technique she also applies to the faces of Elizabeth I and
Shakespeare in *The Mask of Shakespeare* (1992).

Nature and artifice

'... a hybrid portrait, a kind of semiotic chimera, the astonishing fruit of a variable-geometry crossing between two "genetic donors".'
Edmond Couchot on a work by Lillian Schwartz

There are different categories of 'hybrid'. The first concerns the hybridization of different types of image. This involves grafting an analogue image onto a digital image in order to achieve a synthesis or fusion between different art forms – traditional photography, analogue video, digital images, and so on. *Television, the Moon* (1992–5), an installation by Nil Yalter and Florence de Mèredieu based on video and 3-D imagery, belongs to this category. Here, images have been grafted onto one another, braided, woven together and intertwined in such a way that it is impossible to tell which are 'real' (video recordings) and which are 'artificial' (digital images and video montage). 'Twelve television screens', wrote Jean-Paul Fargier about this installation, 'depict a powdery universe of sand. It is difficult to distinguish the real sand, filmed with a camera, from the sand created by computer... An artificial golden light blows across these bodies of sand, which fragment into corpuscles and float through the air before coagulating once more into semblances and transparencies' (*Le Monde*, 14 June 1994). There are a huge number of hybrids and grafted images today, thanks to technology that has made it easier to perform transformations of this kind. *Morphoscopy of the Transient* (2000–2) by Tania Ruiz, plays with a system of after-images. Pictures curl up, get out of phase, and are replayed, while retaining traces of the form they took the moment before, thus resulting in strange, attractive anamorphoses.

The second category of hybrid results from a form of 'symbolic transformation' of the real. This is also brought into being by means of the image (which connects it from a technical point of view with the first category). But here the real world and nature are revised and amended by digital technology. So, for example, the artist Orlan re-sculpts her face with the aid of digital modelling. She describes her art as 'carnal art' (in order to distinguish it from other forms of Body Art which are essentially based, she believes, on suffering). Initially, Orlan's aim was to alter her body by means

Nil **Yalter** and Florence **de Mèredieu**, *Television, the Moon*

Video installation and 3-D images, consisting of a variable number of modules, each containing two monitors positioned one on top of the other, the top one slightly recessed. Excerpt from the text Television, the Moon *(1985) by Florence de Mèredieu.*

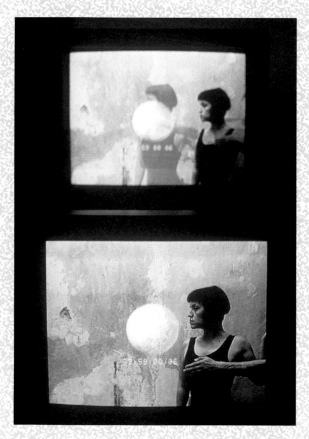

'The current interaction between the image and reality makes itself felt in the increasing influence that audiovisual tools have on our behaviour and daily lives. The world of the image is taking on the appearance of a composite universe, blending together images from different sources and with different origins. *Television, the Moon* superimposes and grafts artificial, machine-generated material onto material from the real world. The static of the video screen, artificial sand, particles and pixels blend with real sand, whose slow flow lends a rhythm to the whole. Hybrid combinations of images are produced by the superimposition of layer after layer of images. The joins and splices of these different orders of image are more or less visible, the origin or source of the images more or less identifiable. The result is a strange world – semi-natural and semi-artificial.'

of cosmetic surgery – albeit by cosmetic surgery diverted from its true purpose, as it was a question not of making herself 'beautiful' but of mutating and transforming herself. This was a far more violent practice, and went considerably further than her simple digital graphic manipulation, which was no more than symbolic. Orlan's *Self-Hybridations* led in 1999 to her interest in the canons of beauty as codified by different civilizations, and she subsequently applied to her own photographic image the cranial deformation practised by the Mayans and Olmecs and the false noses and strabism (squinting) popular among Mayan dignitaries. The hybridization is visible here: Orlan's aim is not to achieve a harmonious and imperceptible blending-in of these modifications but to highlight the freakish, scarred results. She ends up looking like Frankenstein's bride after an electronic makeover.

The third category of hybridization involves grafting the flora or fauna of the living world onto the artificial world. The interweaving of the two can occur at a variety of levels. Paik's installation *Video Fish* 'grafts' five aquaria filled with live fish onto five television sets displaying images taken mainly from the mass media. Another hybridization between the natural and artificial worlds occurs in Katsuhiro Yamaguchi's artificial gardens. His *Future Gardens* (1984) comprise six installations with a total of forty or so monitors doubled up with mirrors. Arranged horizontally or vertically and duplicated in numerous reflections, the images they display – including carp gliding around a 'pond' consisting of eight monitors laid flat on the ground – are blatantly unreal. In 1986, Yamaguchi created his *Galactic Garden* in Kobe. Here, metallic spheres suspended in space added their reflections to his usual compositions. As a counterpoint to the artificiality of the digital garden and as a stark contrast to it, raw materials in the form of stones and bundles of straw were strewn around the centre of the installation. At the end of the 1990s, some rather more disturbing developments started to take place, involving robots, artificial limbs, mutant-like creatures and transgenic animals. Symbolic action was no longer enough; neither was the gentle domestication of the living world. The challenge now was to operate directly on the living world through implants, the fitting of prostheses or the use of genetic modification, as in the case of Eduardo Kac's

Tony **Oursler**

Born New York 1957. Lives in New York.

'My main focus is the position of the individual in relation to the mass of information we are fed and the manipulation we undergo by the powers that be.'

Tony Oursler's installations and small-scale theatre pieces are based on marionettes that are generally human-sized. The bodies of these marionettes are made of rags, wood or straw, and their faces are brought to life by video projections that could be described (without fear of stating the obvious) as animated, vibrant and mobile. This makes the puppets, whose faces are often dominated by a huge eye, disturbing and strange. The discrepancy between the technological realism of their faces and the tattered nature of their bodies give Oursler's installations a quality reminiscent of Beckett's plays – more precisely, they resemble a childlike version of Beckett reworked using video and transposed into a world that juxtaposes cutting-edge technology (video, light projections, sound environments) with old bric-à-brac in the form of floral hangings and beaten-up furniture. The use of a set (furniture and other objects), actors and sound turns these scenes into quasi-theatrical performances. Oversized, moon-like or inflatable, imprisoned in boxes (*Guard Booth*, 1997) or aquaria (*Drowning*, 1995), suspended in mid-air (*F/X Plotter*, 1992), half buried in the soil (*In/Out/Out/In*, 1997) or lurking beneath a bed (*Guilty*, 1995), these heads observe the viewer and laugh, speak, yawn and generally behave as any person might. But they can also swarm through space (*Molecule, Méliès*, 1997) like the bodies or disembodied organs in the paintings of Hieronymus Bosch. The video is sometimes projected onto a kind of sculpture made out of loose rectangular blocks, so that the heads are fractured into numerous shards (*Digital*, 1997) or end up as fragments in glass bowls or aquaria (*Bull's Balls*, 1997).

Tony Oursler belongs to a generation of artists that grew up during the audiovisual age and was thus entirely comfortable with the new technology right from the start. In 1992, he started using liquid crystal supports for his projections (*F/X Plotter*), a system which allowed him to free his characters from the constraints of gravity. More recently he has been using plexiglass projection screens whose distortions give the faces displayed on them the floating, fluid appearance of creatures trapped in pharmacists' jars.

SELECTED INSTALLATIONS

– *Spheres of Influence*, 1985.
– *The Watching*, 1992.

– *Judy*, 1994.
– *Metro Pictures*, 1995.
– *Horror Show*, 1996.
– *Composite Still Life*, 1999.

CD-ROM

Tony Oursler, *Fantastic Prayers,* 1997.

BIBLIOGRAPHY

– Janus, E and Moure, G (eds), *Tony Oursler*, Ediciones Poligrafa, Barcelona, 2001

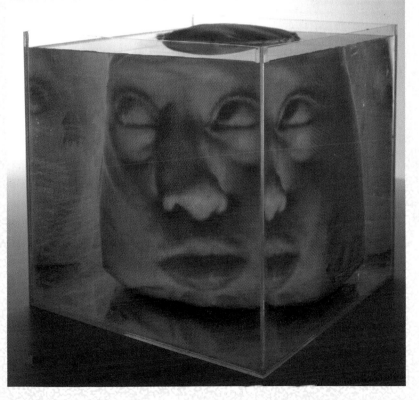

Drowning, video installation, 1995.
Performer: Tracy Leipold.

– Oursler, T, *Tony Oursler: The Influence Machine*, Artangel, London, 2002
– Rothschild, D (curator), *Tony Oursler: Introjection, a Mid-Career Survey 1976–99*, exhibition catalogue, Williams College Museum of Art, Williamstown, MA, 1999

Jean-Charles **Blais**, *Double View*

DVD, 2001.

Works that only 'take shape when they are looked at'.

At the opposite extreme to the attention-grabbing hybrid images of the last few decades, the painter and visual artist Jean-Charles Blais creates minimalist art using DVD as a medium. His work generally involves a number of forms (here two circles or ovals) resembling luminous ectoplasm, fireflies or dancing shapes that move, grow, change shape and then disappear. The geometry at play here is a supple, informal geometry verging on insubstantiality. *Double View*'s black-and-white moving images threaten to dissolve into complete formlessness, to become blank patches of pure black or pure white with no recognizable form. As in any other piece of video art, the main substance of the work is its movement. The forms below need to be imagined mutating, gliding and gradually disappearing.

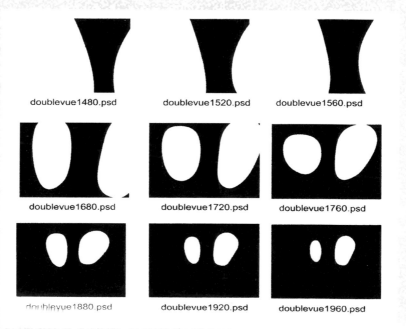

doublevue1480.psd doublevue1520.psd doublevue1560.psd

doublevue1680.psd doublevue1720.psd doublevue1760.psd

doublevue1880.psd doublevue1920.psd doublevue1960.psd

whose memory capacity is even larger and which functions as a kind of 'super CD-ROM'.

Multimedia installations and projections

'Video installations can contain everything, just like a handbag: painting, technology, language, music, movement, ugly and flowing pictures, poetry, commotion, premonition of death, sex and friendliness.'
Pipilotti Rist

The installation was the prototype of hybrid artwork and the place where multimedia art was born. In installations any type of encounter is possible, any form of collusion between different media, different objects and different genres. Joan Jonas's work – from the 1970s through to the present period – belongs to all three categories of theatre, video and performance. The term 'multimedia installation' started to be used at the end of the 1980s. More than ever before, the artist seemed to be assuming the role of director or stage manager, taking a space over and filling it with a variety of people and objects.

The corridors, video walls and highly architectural installations of the Italian group Studio Azzurro also sprang from the same sort of experimentation (*Relief of the Visible Part*, 1988; *Celestial Trajectories*, a video sky with 40 screens and a weather satellite link, 1990). *The Swimmer* (1984) is one of their most successful installations: 13 monitors are arranged in a line at the centre of an empty space resembling a swimming pool. The screens are perfectly synchronized, allowing the swimmer of the title to pass slowly and rhythmically from one to the next. This impeccable horizontality is interrupted by the falling of small items within each screen. The vertical intrusions punctuate and articulate the installation's narrative intent.

The installation is one of the key elements of art today. It represents a kind of interface that allows the multiplicity of experiences conveyed by new technology to connect or disconnect, reunite or break up. The Japanese group Dumb Type create excellent examples of the kind of installation that brings together all the different forms of expression – music, dance, theatre,

Marie-Jo Lafontaine, *The Swing + Kinder*, video installation, 1997–8.

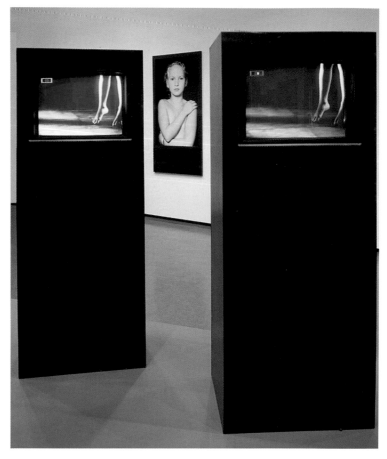

electronics, and so on. Their work is becoming less and less tangible and often consists merely of films, videos or photographs projected onto multiple or very large screens. These screens form environments in which the visitor feels thoroughly immersed.

The same is true of Krzysztof Wodiczko's video and photographic projections. These works are strongly anti-establishment and are usually projected onto public monuments. One example is the image of a woman talking to her dead child, which was projected onto the Bunker Hill memorial in downtown Los Angeles. Another is his projection on the façade of the Hirshhorn Museum in Washington during the 1988 presidential election.

Wodiczko's installations are often narrative in form. They tell a story or criticize our turn-of-the-millennium society – our interactive, open, watered-down, globalized society that manages nevertheless to shun any global project that is not of an economic or commercial nature.

The CD-ROM

'... the structure of the disk, cut up into "zones"... Each one of them in its turn matches up with other zones which are so many islands or continents of which my memory contains descriptions, and my archives the illustration... But my fondest wish is ... that the reader-visitor could come to replace my images with his, my memories with his...'
Chris Marker on 'Immemory'

There are two types of CD-ROM. The first type is used for documentary and information purposes and is produced by the major museums (for example, the 'Grand Louvre' CD-ROM) or published to coincide with exhibitions like a kind of artist's monograph. The CD-ROM devoted to Orlan is a good example of a well-produced, comprehensive visual monograph that gives a chronological account of the artist's career to date (1947 to 2000 in this case), describes in detail the different phases of the artist's work, reproduces a selection of key texts and includes bibliographical information. Such CD-ROMs are veritable retrospective catalogues.

Alongside these CD-ROMs – whose aim is to preserve and present essential elements of the collections of major institutions – there are also artists' CD-ROMs which are conceived as artworks in themselves. They are interactive, entertaining works that play with the idea of interlocking systems and the unveiling of numerous, carefully interwoven elements connected with each other via a series of bridges or computerized links. When part of their aim is also to offer a retrospective of the work of this or that artist, this type of CD-ROM can also prove highly informative and useful from a documentary point of view. This is true of the CD-ROM by (and about) Antoni Muntadas in the 'Anarchives' series: *Media, Architecture, Installations* (1999). Users are presented with a menu of options from which they can choose. The value of the CD-ROM lies in its ability to offer, succinctly and in compact form, a large amount of information and a large number of images and sounds from a variety of sources.

Muntadas' CD-ROM presents itself as an imaginary space. It comprises four levels or superimposed platforms: the *observatory*

CD-ROM
A system allowing access to, but not alteration of, text on a compact disc (Compact Disc Read-Only Memory).

Dumb Type

*Artists' collective founded in Kyoto in 1984 by Teiji Furuhashi (died 1995).
Today the group operates internationally.*

'Technology has created a network covering the globe, making
the world smaller and sending information tens of thousands
of miles, from point A to point B, in just a few seconds. In
reality, however, when we try to communicate, for example,
the few words "I love you", just these words, we are forced
to realize the vast distances that lie between us.'
Teiji Furuhashi

Between them, the members of the Dumb Type collective cover all genres
and modes of expression (choreography, video, theatre, electronic music,
etc). This results in hybrid installations (strongly influenced by the concept
of multimedia art) which display a predilection for projections of jerky or
smoothly gliding images, the play of shadows and the use of doubles. Dumb
Type's dance troupe is often naked and stripped down to the basic language
of movement, as in *Lovers* (1995), an interactive installation by Furuhashi,
or the performance *pH* (1991). The group's work features strident visual
and acoustic effects, pools of light, screeching noises and strange ges-
tures, lending their shows a powerful dreamlike quality. Jerky rhythms and
flashes of light and sound bombard the audience with 'electrical' stimuli.
Images shoot into view and disappear again so rapidly that it is sometimes
impossible to make them out.

Other shows (such as *OR*, 1997) are extremely austere, even clinical. It is
as if the actors, dancers, performers and musicians are continually seeking
to push back the frontiers between the different genres and worlds and are
literally leaping, feet together, into the unknown. In *Memorandum*
(1999–2002) a Paluche (miniature video camera) films the stage from the
ceiling, transmitting its images to a screen facing the audience. Suddenly,
the camera descends towards the dancer on the floor. She grabs it and han-
dles it like a microphone, filming her eye (which appears in enormous close-
up on the screen), her mouth, her ear, and so on. The camera then starts
to swing like a pendulum. The image on the screen spins and sways. The
dancers' silhouettes stand out against the creamy background of the
translucent screens as in a shadow show.

SELECTED WORKS

– *pH*, 1990–1.
– *S/N*, 1992–4.
– *LOVE/SEX/DEATH/MONEY/LIFE*, 1994.

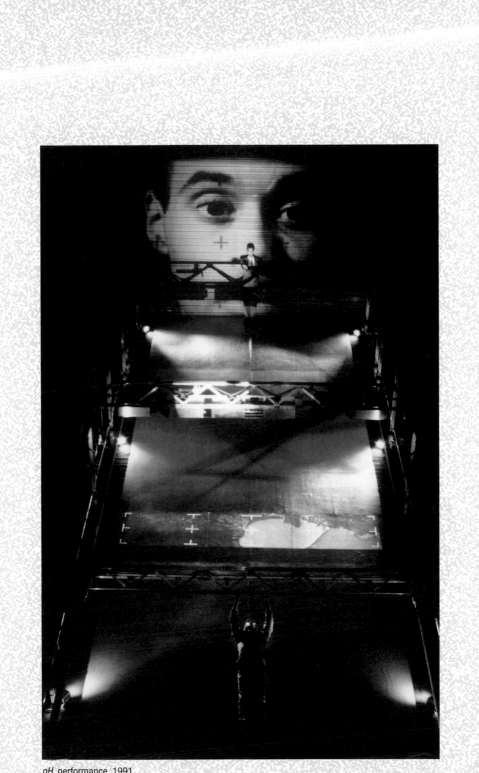

pH, performance, 1991.
Visual creation by Shiro Takatani.

Antoni **Muntadas**

Born Barcelona 1942. Lives in New York.

`'Now we use the term "interactivity", while in the sixties`
`we talked about audience "participation"... In terms of`
`meaning, the real force is the generosity of audiences.'`

Muntadas's work looks at the social, political and economic aspects of the media from a critical perspective. What does the corporate conference room have in common with the Church? One answer is: mystical, media-savvy leaders. In *The Board Room* (1987), we see a conference room with a collection of politicians' portraits on the walls. Where the mouth of each figure should be, there is a video monitor playing speeches and snatches of newsreel. *The File Room* (1994) consists of an archive library of the most traditional, bureaucratic kind and an Internet database of censorship throughout the ages. The installation is interactive: visitors are invited to contribute to the database by adding to it any examples of censorship they might have spotted. *Haute CULTURE* (1983) is a video sculpture made up of two seesaws with video monitors at each end. One of the seesaws was installed in a gallery, the other in a shopping centre, allowing Muntadas to establish an ironical, critical link between two spaces, one dedicated to culture, the other to mass-market culture.

SELECTED WORKS
– *The Last Ten Minutes (Part II)*, 1976–7.
– *Generic TV*, 1987.

BIBLIOGRAPHY
– *Antoni Muntadas: personal/public information*, exhibition catalogue, Vancouver Art Gallery, Vancouver, 1979
– *Antoni Muntadas: Trabajos Recientes*, IVAM Centro del Carme, Valencia, 1992
– *Muntadas: On Translation: The Museum*, ACTAR and the Museu d'Art Contemporani de Barcelona (MACBA), 2002

CD-ROM
Antoni Muntadas, *Media, Architecture, Installations*, Centre Georges Pompidou, 1999.

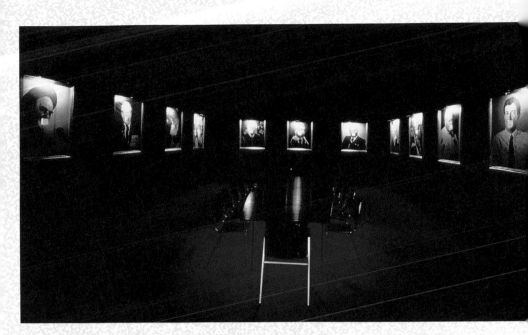

The Board Room, video
installation, 1987. General view
and details.

(the blue, Internet level that allows hybridization and encounters between images), the *auditorium*, the *library* and finally the *airport* (the red, yellow and green levels respectively). The *auditorium* provides access to drawings and models that subsequently serve as icons for the various works presented. In the *library*, seven keywords (archetype, context, archives, media, project, in/visible, montage) allow the user to navigate their way through the artist's work. The CD-ROM encourages hybridization and is based on the possibilities created by a whole network of links. It is like an enormous spider's web through which users pick their way, following the vital leads provided by Muntadas. The *airport* (or green level) allows users to see the artworks in the context of the cities in which they have been exhibited.

Each link leads to other links that lead to still further links and intersections. The icons send users incessantly to other icons which in turn lead to still more icons. Image feeds image, and images are in turn fed by words, concepts and definitions. The user thus approaches the artworks in a kaleidoscopic, fragmentary way based on a layered system of superimposed images that uncover each other little by little. A similar procedure is adopted by Chris Marker in probing the functioning of memory: one image continually conceals another, which in turn evokes yet another. This shifting and sliding of images becomes a metaphor for the slipping away and covering over of memories. In his CD-ROM entitled *Immemory* (1997), Chris Marker's memory is that of an image-maker and traveller who derives sustenance from poetry and who navigates his way through illustrations, old books, postcards, works by famous artists, Proust's madeleines, effigies of Hitchcock, war photographs, cartoon strips and familiar faces. Users can thus wander from room to room of Chris Marker's 'gallery' by clicking on one of his favourite artworks – a painting by Ingres, say, or the *Mona Lisa* – which are shown as faces of an open cube.

In *Puppet Motel* (1995), Laurie Anderson has created a CD-ROM that bears a closer resemblance to illustrated books (both for adults and children) of tales of the supernatural. It is a collection of restrained, landscape-filled images featuring dark, nocturnal colours. The landscapes contain small windows that, when clicked

on, open onto other worlds, landscapes or more intimate spaces – among them rooms and artificial environments populated by fictional characters, where Laurie Anderson herself also pops up. The system allows users to change their viewpoint, thus opening up a whole map of the landscape. The CD-ROM offers all the attractions of travel: it presents the user with numerous different spaces, all of which seem strangely familiar.

Pixelismus (1996, by Nil Yalter, David Apikian and Nicole Croiset) also takes the form of a picture book. Taking its inspiration from the Byzantine mosaics of the Chora Church in Istanbul as well as

from the work and writings of Malevich, this work combines images and texts from a wide variety of sources. Images reworked by computer, sounds and video sequences are united by the metaphor of pixels – discrete dots of colour that echo the thousands of coloured units making up Byzantine mosaics. *Opium* (2000) by Tom Drahos takes up the Baudelairean theme of the artificial paradise. Drahos plays with rasters and coloured, melodic, musical textures as if playing the piano. Users navigate their way around the site by clicking on squares or patches of coloured buttons. The work of Stéphan Barron, who specializes in a kind of ecological art (*Earth Art*, 1999), is cleaner-lined and poetic.

Chris **Marker**, *Level Five*

Film, 1997.

'While writing a video game on a little-known episode of the Second World War during the Battle of Okinawa, Laura meets informants and witnesses through a parallel computer network ... so many "levels" that will allow her to reconstruct the different elements in this collective tragedy.'

In *Level Five*, a woman named Laura consults her computer: images appear out of nowhere and merge together. Chris Marker delivers a profound meditation on the tragedy that occurred in the spring of 1945 on the island of Okinawa. Forced back by the Americans, more than 100,000 Japanese (including many civilians) died. Most of them committed suicide, some by jumping off the island's cliffs. Others killed their own children. Chris Marker uses new technology as a tool to analyse, deconstruct and reconstruct the existing documents. The multiplication and hybridization of images, the combining of archive footage with digital images, the omnipresence of the camera and the choice of a very conspicuous style of editing reinforce a feeling of voyeurism – a voyeurism that is being taken even further by today's proliferating, powerful media.

Artificial limbs and biological art

'The body must burst from its biological, cultural and planetary containment...'
Stelarc

The artificialization of the environment is affecting the whole world, and contemporary art is taking an ever keener (and ever more immediate) interest in biotechnological development – whether in the field of robotics, artificial limbs and organs, implants or (more disconcertingly) genetic engineering. Living matter has become another material available to artists.

More and more sophisticated prostheses are becoming available to the artist: virtual-reality helmets and gloves covered with sensors that simulate sensation and allow the manipulation of distant objects, to name just two examples. The Australian artist Stelarc, for example, attached an extra hand to his body in the form of an electromechanical artificial limb (*The Third Hand*, 1992). In 1996, he gave a performance in Sydney entitled *Ping Body*, in which he connected his body directly to the Internet, turning the latter into a gigantic extension of his own body with which he could then interact. The artist Lee Bull has created video installations (*Live Forever*, 2002) using karaoke-based cyborg armchairs – a different kind of technological extension of the body. Many artists take a keen interest in the research conducted by high-tech laboratories. Some experiments with robotics, particularly those conducted in Japan (and more especially in Tsukuba), have given their participants a curious feeling of dislocation from reality. One example of this – involving duplication, ubiquity and a distorted sense of identity – is the experiment in which the body of researcher Howard Rheingold was 'twinned' with a double of himself, locked away in another room, whose movements followed and copied his own to such an extent that he eventually started to question who he was and where his body was.

Among the most recent artistic manifestations of new technology are the research and the experiments conducted by artists into the manipulation and 'embellishment' of the living world. These include not only Eduardo Kac and his fluorescent rabbit (which has already been described) but also dolls with cultured human skin,

Christa **Sommerer** and Laurent **Mignonneau**

Born Gmunden (Austria) 1964 and Angoulême (France) 1967. Both live in Japan.

'It is the spectators, through their interaction, who give form to the artistic process. Our installations are not, therefore, static, predefined and predictable, but are more like the visible manifestation of a living process.'

Playful and poetic, the interactive installations of Sommerer and Mignonneau require visitor participation. Visitors are invited to immerse themselves in the environments created by the artists, to influence them, and to play a part in the production and genesis of images designed to resemble living creatures that come to life, evolve and mutate. These virtual worlds are inhabited by the visitors. Their movements – caught by hidden sensors – make birds appear on the screen opposite them (*Life Spacies*, 1995). Contact between the visitors and real plants (ivy, cactus, etc) causes a drawing of the same plant to appear on the screen (*Interactive Plant Growing*, 1993). A text can also be transformed into an image through the magic of networks and codes (*Verbarium*, 1999). Contact by touch again makes forms and abstract worlds appear on the train window in *HAZE Express* (1999), and words (the sound of the voice) cause the corresponding images circulating on the Internet at any given time to appear on the screen (*Riding the Net*, 2000). This might call up, for example, all the 'moons' or 'tulips' of cyberspace, among them quite possibly a dog named 'Tulip'.

In 1996, Sommerer and Mignonneau developed the idea of a 'genetic manipulator' (*GENMA*), a sort of 'dream machine' that makes possible countless combinations of form, leading to the creation of weird and wonderful hybrid creatures. Looking into a kind of optical box, visitors can watch the movements of the life forms which they can generate by pressing buttons on the outside of the box. In 1997, they extended this concept to the manipulation of forms on the Internet, creating their first website, *Life Spacies*. Encoded and transcoded, the messages of visitors to the site are transformed into complex creatures with their own specific histories. When one of these creatures dies, a message is sent to its 'progenitor'. No longer do artists dictate the nature of the message: they simply create the conditions in which things are made possible.

INTERACTIVE INSTALLATIONS

- *Interactive Plant Growing*, 1993.
- *Intro Act*, 1995.
- *Life Spacies*, 1995.
- *Verbarium*, 1999.
- *HAZE Express*, 1999.

BIBLIOGRAPHY

- Sommerer, C and Mignonneau, L, 'Art as a Living System', in *Art@Science*, Springer Verlag, Vienna and New York, 1998.

A-Volve
Interactive installation, 1994.

This installation takes the form of a game underpinned by reflections on life and artificial environments. By touching the surface of the 'pond' (the horizontal blue screen creates an illusion of three-dimensionality), visitors can make little coloured creatures appear which seem to surge up from the depths of the screen. The object here is to create Cartesian divers or small artificial creatures that visitors can play with as if with living fish. These creatures, however, are liable to metamorphose and disappear. The work is created and developed through constant interaction with the visitors, who give 'life' to the shapes generated on the basis of pre-programmed algorithms. Each creature brought to life by the visitor's touch can live for a minute at most before being replaced by a potentially infinite number of other forms which are also subject to random transformations brought about by the movement of the visitor's fingers over the surface of the screen. The installation even imitates the evolutionary process, with new creatures outliving their parent forms and thus 'carrying on the line'.

Behavior of creatures
6. Evolution
Birth of child - Decay of parents

1

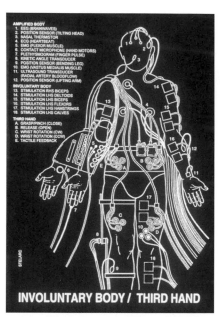

Stelarc, *Involuntary Body/Third Hand*, 1976–80. Technical diagram.

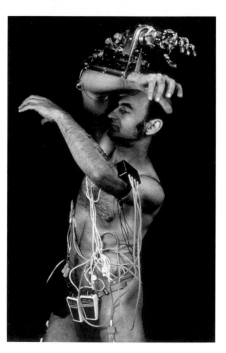

Stelarc, *The Third Hand*, performance, 1992.

created by the Australian group of artists known as Symbiotica (Oron Catts, Ionat Zurr and Guy Ben Ary). These dolls were created in collaboration with a research laboratory specializing in the culture of organic tissue.

The growing artificialization of human society is leading to a world of simulated reality. 'An artificial, virtual reality arrived at through global immersion', wrote Polieri, 'could easily, in the near future and in certain contexts (simulations, weightlessness, etc), become an amazing, strange reality, which is nevertheless as intense as everyday reality...'. What is astonishing at present is the rapid growth in artificial worlds that could conceivably supplant nature one day. Nature would then continue to exist only in a reconstituted form, re-manufactured and modified by man.

In 1991, Stéphan Barron created a self portrait entitled *Autoportrait*, using data communications technology. This self-portrait consists of a telephonic robot (constructed with the help of a home automation engineer) that indicates eight different directions in response to different frequencies. The artist moves

around outside the exhibition space, informing the robot of his location by making calls from telephone kiosks. In the exhibition space, an automated arrow indicates the artist's position in response to each call. The artist is thus visible and present only through the intervention of a machine that reacts to the information transmitted to it: a body of flesh and blood has been replaced by a well-oiled mechanical prosthesis. In 2002, Krzysztof Wodiczko designed and created *Dis-Armor 2*, an interactive outfit constructed at the Massachusetts Institute of Technology and intended for schoolchildren with learning difficulties. It is a kind of 'communications armour', consisting of a helmet (with microphone, camera and rear-projection device) and two video screens worn on the back which allow others to see the eyes (and thus the expressions) of the wearer. The idea behind the device is to improve the schoolchildren's sense of communication.

Cyborg

A cyborg is a cybernetic being created from a mechanical model. It is designed to act like an extension of the human body, enhancing our sensory, physical or cognitive abilities.

Exhibitions such as *Posthuman* (an international exhibition first held at the Musée d'Art Contemporain in Lausanne in 1992) and *Foreign Body* (Whitney Museum, 1995) helped popularize the concept of the prosthesis in art. Science fiction has played its part, making us familiar with mutants, clones, cybernetic bodies and talking robots. One such highly sophisticated machine is Chris Cunningham's love-making dummies, shown at the 2001 Venice Biennale – all gleaming moving parts and connecting rods (*All is Full of Love*, DVD, 1999). There seems to be no end to the current procession of video and computer-generated mutants in the work of Orlan, Mariko Mori and others. Coiled up in their world of vinyl and inflatable, transparent materials, their eyes covered with optical lenses that make them look like wild cats, the clones that spring from the imagination of Mariko Mori in the video *Miko no Inori* ('The Shaman Girl's Prayer', 1996) play with similarly transparent glass or plastic balls in which an artificial universe is reflected ad infinitum.

One of the works that take this creation of virtual bodies, twinned bodies and avatars the furthest is *Bodyscan* (1997) by Eva Wohlgemuth. The artist has digitized the different parts of her body using a 3-D scanner and converted the resulting data into a

Eduardo **Kac**, *Uirapuru*

Multimedia installation, 1999

Uirapuru is the name of a real Amazonian bird that has attained mythical status over the course of time. Located in the real space of a gallery, this installation combines elements of virtual reality and telepresence, visitors being able to manipulate the virtual images and also interreact with other 'visitors' who are connected via the Internet. Six flying fish – non-rigid dirigibles that are controlled by means of a local interface – float above a 'forest' of 20 artificial trees while singing.

Sensors record the movements within the gallery space of the remote-controlled fish and transmit this information to a server. The movements of the fish in the virtual space of the Internet thus correspond to those of the fish in the gallery. The forest is inhabited by birds whose song is dictated by the rhythm of the Internet activity. Another interface and video screen allow visitors to the gallery to 'pilot' one or other of Uirapuru's avatars in the virtual world.

language that can be manipulated via the Internet.

Her body is thus transposed into numbers from which three-dimensional sculptures can be created using stereolithography. Perhaps this is an indirect homage to another – this time scientific – project involving the precise cataloguing of the 1,878 body parts of a prisoner executed in Texas. These body parts were extracted, frozen, digitized, recorded on CD-ROM and then made available on the Internet (*The Visible Man Project*, 1994). Another interactive artistic experiment involved the creation of a gigantic mutant body *(Body without Organs)*. Internet users were invited to video different parts of their bodies in order to provide the pieces for a gigantic puzzle.

In 1994, Eduardo Kac and Ikuo Nakamura collaborated on an installation entitled *Essay Concerning Human Understanding*, which studied the remote actions and interactions between humans (whose presence alone affects the whole environment), animals (represented by a canary in Kentucky) and plants (a philodendron in New York). An electrode attached to the plant and connected to a computer allowed its reaction to the birdsong to be studied. The two artists used pre-recorded electronic sounds to play back the plant's reaction, but the order and duration of the different sequences are nevertheless a function of the plant's 'response' to the birdsong. The canary and the philodendron communicate between themselves; by influencing the frequency of the birdsong, the human presence also influences their communication.

Building on this communication between species and the extension of the powers and limits of the human body, computer programmes allow for the creation of avatars, clones and mutant bodies of which one can choose the gender, skin colour, texture and many other parameters. This means we can now turn ourselves into members of a different species or even into inhabitants of a different galaxy. The remarkable progress being made in the field of genetics will no doubt lead artists to adopt genetic techniques as well. How long will we have to wait before we see the self-cloning of a human being? In 1993, Vito Acconci created his *Virtual Pleasure Mask*, a kind of caricature of the virtual-reality helmets used by visitors to artificial worlds. It takes the form of a helmet sporting a mouth, a long, protruding red nose and cables for every imaginable type of connection.

Glorification or criticism of the new media?

'The televisual image is an unremitting flow of images
and sounds that swamp the world; it's a kind of overflow
pipe. People feel crushed by the power of the image. What
we can do is offer some sort of resistance to this.'
Bertrand Gadenne, multimedia artist

Since 1995, art has borrowed increasingly from a variety of different media (video, photography, painting, cinema, etc). The image elevates the most ordinary actions of everyday life and artists are not afraid to make the world around us the subject of their work. When Sam Taylor-Wood tackles the theme of still life and the vanitas, she uses the medium of the moving image. *Still Life* (DVD, 3:22 min, 2001) shows the speeded-up putrefaction of a bowl of fruit and recalls certain scenes from the Peter Greenaway film *ZOO* (1985). When she depicts the Virgin with the dead Christ (*Pieta*, DVD, 1:57 min, 2001), she herself plays the role of Mary and Robert Downey Jnr that of Christ. Painting serves as her model, as it does in most of Bill Viola's recent work (*The Passions*, 2003).

The new media are updating the great art of the past, with video and computer art taking over from the traditional materials of painting. An example of this is Bill Viola's triptych consisting of three screens on which three DVD sequences are projected. Characters in a forest move slowly and repetitively from one screen to another, their silhouettes disappearing behind the tree trunks and then reappearing – all this in indirect tribute to a painting already itself revised and updated by Magritte (*The Blank Signature* [1965]). Mark Wallinger's series of installations entitled *Third Generation (Shanghai), Third Generation (Ascher Family)* (2003) also refers to painting and other systems of representation (notably theatre and cinema). In this work there really are three generations of images: a person inside a frame looks at a picture inside a frame while at the same time being observed from the outside by viewers of the work.

The work of other artists constitutes a critique of the growing power of the image and the media. No longer is it the message alone that is being criticized; it is the medium itself, the whole supposedly communicative machinery in place at the start of the

21st century. Vincent Tordjman and Olga Kisseleva's *digi-cabin* raises questions about the role of spectator and participant and about the stance adopted by visitors during their journey through a work that combines drawings, projections, networked video games, and so on (*Flying on Instruments*, 2004).

BIBLIOGRAPHY

Wallinger, M, *Mark Wallinger at the British Pavilion*, 49th Venice Biennale, British Council, London, 2001

Taylor-Wood, S, *Sam Taylor-Wood*, Stedelijk Museum, Amsterdam, 2002

Walsh, J (ed), *Bill Viola: The Passions*, John Paul Getty Museum in association with the National Gallery, London, Los Angeles and London, 2003

ARTISTS' CD-ROMS

Laurie Anderson, *Puppet Motel*, Gallimard, 1995.

Nil Yalter, David Apikian and Nicole Croiset, *Pixelismus*, 1996.

Chris Marker, *Immemory*, Centre Georges Pompidou, 1997.

Stéphan Barron, *Earth Art*, École Régionale Supérieure d'Expression d'Arts Plastiques de Tourcoing, 1999.

Antoni Muntadas, *Media, Architecture, Installations*, Centre Georges Pompidou, 1999.

Tom Drahos, *Opium. Artificial Paradises*, Tom Drahos Média, 2000.

Orlan, multimedia monograph, Jériko, 2000.

Miguel Chevalier, 2000.

ARTISTS' DVD-ROMS

Michael Snow, *Digital Snow*, Centre Georges Pompidou/Epoxy, 2002.

'As our proliferating technologies have created a whole series of new environments, men have become aware of the arts as anti-environments or counter-environments that provide us with the means of perceiving the environment itself.'
Marshall McLuhan

A rt has always had a close relationship with the world of the imagination – subjecting what we call reality to all kinds of transformations and interpretations. Whether realist or abstract, works of art have always constituted 'counter-environments' characterized by an (admittedly varying) discrepancy with the real world. Today, this relationship is very different, however – for the artist and even more so for the public. A threshold is being crossed as today's technologies create an increasingly 'true' image. One of the dreams of technicians as well as artists has been to rival reality, to be able to produce a kind of clone or double that resembles reality perfectly and is able to be substituted for it. In many installations, the real is thus experienced as a kind of mirror or hallucination. Or as what Paul Virilio described recently as 'stereo reality': reality that – as with stereo sound – comprises an extra dimension in relief. The old world of our perceptions then comes face to face with itself in a permanent system of echoes or mirrors.

Art is also subject to this process, permanently duplicating, reduplicating, cloning and repeating itself. In fact, when surfing art sites on the Internet, one can get the impression that one is dealing with a Hydra with multiple, superfluous heads or a collective, anonymous, multiform work with numerous twisting branches that divide into more and more branches ad infinitum. In presenting a collection of works created by fictitious artists, Yoon Ja and Paul Devautour are the perfect embodiment of this tendency towards the total artificialization of art. It is only logical that among these invented artists there should also be practitioners of Net Art.

Anonymity and delocalization

'Things are often done simply to feature the equipment, I think as far as [technology] goes, just in itself, it can be an incredible snoooze. But if artists who know what they're doing use it, I think it can be interesting.'
Laurie Anderson

There is a tendency for the 'signature' or distinctive style of the artist to become less marked, if not to disappear altogether.

Changing traditional copyright into *Copyleft* (in other words a form of unprotected 'free licence'), Antoine Moreau turns the classic notion of copyright on its head by allowing surfers to appropriate works or objects available on the Net as a way of developing or preserving them. This can result in the creation of an enormous palimpsest, with the artwork – more than ever before – assuming the guise of work in progress. *How Are You?* (1997) by Olga Kisseleva takes the form of a collective work. Visitors gain access to it via e-mail or directly over the Internet. Visiting *panoplie.org*, they type in their message and click 'enter'. The letters making up the message then scatter and float around in the palm of the hand that fills the screen. There is no doubt that the situation described in Marshall McLuhan's statement above is today intensifying: artificial realities are now so widespread, so pregnant with meaning that they are starting to dominate everything. The caustic, critical contribution of the 'antidotes' or 'counter-environments' is itself starting to become diluted as a result of this growing phenomenon of artificialization, which causes a profound alteration in our relationship with reality or in our definition of what we call 'reality'. Virtuality and interactivity are the key words in the new artificial environments to which artists have now turned their attention. The power that new devices have to immerse us in their world is making us lose our footing and forcing us to submit to new illusions.

Designed as a piece of technical wizardry at the cutting edge of computer science, the device called 'The Cave' was developed at the beginning of the 1990s and has recently been made available to artists such as Jeffrey Shaw, Agnès Hegedus, Bernd Linterman (*Configuring the Cave*, 1996) and Maurice Benayoun (*World Skin*, 1997). *Configuring the Cave* uses as an interface a wooden dummy with joints packed with sensors. Visitors manipulate the dummy in order to move around a virtual universe in which they are immersed. *World Skin* is a kind of photograph safari in a world of war. Wearing stereoscopic goggles, the participant is immersed in a room whose floor and three of whose walls are covered with images of war.

Virtual reality

A simulation of a real environment using three-dimensional images; an artificial environment generated by computer that confronts the spectator, or in which he finds himself immersed. Various prosthetic devices (goggles, data gloves, sensors, etc) are used to further reinforce the illusion of reality. Virtual reality involves a profound disturbance of our traditional perception of space, with this 'virtual space' functioning as a kind of extra-dimensional universe, a ghostly, yet inhabitable place that is both perceptible and modifiable. 'The virtual space', wrote Paul Virilio, 'is a supplementary, fractional aspect of reality. It is not simply a relief effect. It is a place in which action is possible …' Individuals can meet inside this virtual space, surgeons can operate on a patient on the other side of the Atlantic and the 'doctor' Du Zhenjun can teach anatomy using his own cadaver.

Du Zhenjun,
The anatomy lesson of Du Zhenjun

Interactive multimedia installation, 2001

'Art is a shadow theatre, the shadow of a false reality that man pretends to consider real...'

This installation functions as a sort of high-tech homage to the famous anatomy lesson painted by Rembrandt. The visitor is confronted by a large screen. Attached to the screen, the real half of a wooden table juts out towards the visitor, its other half extending into the virtual space of the image. The semi-real, semi-virtual body of Dr Du is laid out on the table as the subject of an anatomy lesson for eight other Dr Dus in the background. When sensors register the presence of a visitor, the eight Dr Dus move forward from the back of the screen and position themselves opposite the spectator. When the spectator moves away, the eight figures leave the 'anatomy lesson' and return to the virtual background.

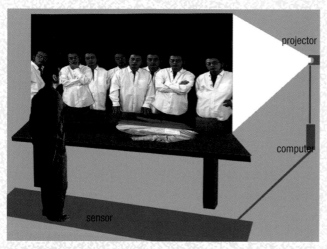

Diagram of the installation

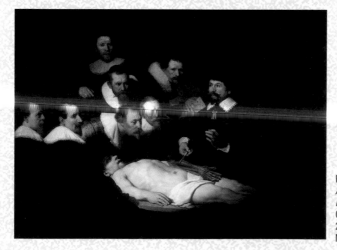

Rembrandt, *The Anatomy Lesson of Dr Nicolaes Tulp*, 1632. Oil on canvas, 169 x 216cm. The Hague, Mauritshuis.

The Cave

A cubic, stereoscopic room or installation in which a viewer is immersed in a three-dimensional environment. Rear-projection screens give participants the illusion that they are moving around in an environment that is both real and artificial at the same time. The projection surfaces (between three and six), the use of sensors and the participant's ability to control the directional positioning of the images all reinforce the sensation of disturbing strangeness experienced by the visitor.

'The Cave' also uses virtual-reality goggles and helmet (which, like the stereoscopes of the 19th century, allow the projections to be viewed three-dimensionally) and data gloves.

Using a camera equipped with sensors, the participant takes aim and shoots at the picture, making a portion of the image disappear with each shot.

Simulation and duplication of the universe can also be achieved using cartography, which has always presented a challenge for those wanting to master the world by visualizing it. *TerraVision*, an interactive installation created by ART+COM (between 1994 and 2001) is a virtual map of the world, accessed via an Internet terminal, which has been digitized using satellite-transmitted images and data supplied by aerial photography. An interface allows visitors to move around the map and zoom in on a particular place. Rather than offering a realist vision of the world, this installation is a simple localization tool. By adding other image sources, however, and incorporating events connected with different locations, the database can be considerably enhanced. The system (which is a permanently open one) has all sorts of applications – scientific, political and museum-related.

Participation and interactivity

'I would like the interaction with the audience to come... in such a way that they're carried along, and they can think their own thoughts and add their own input to it on a highly personal level...'
Bill Etra

There is nothing new about the participation of the viewer in a work of art. It has long been understood that an artist's work is only completed when it is viewed – an action which invests it with meaning and brings it to life. What makes 'interactivity' different from this, however, is the coupling of man with machine and the viewer's opportunity to intervene directly in the unfolding and functioning of the work. The man-machine pairing no longer takes place only when a work or installation is created, but also when it is made available to the public. This presupposes that the work incorporates a programme or scenario that can take one of many directions.

The user's contribution lies in the activation, control or development of operations. Sensors which can detect sound, touch and body movement are connected to computers which process the data transmitted to them and set in train a system of reactions. By this means, the installation responds to various kinds of prompting and interacts in real time. Some interactive installations are based on the extreme simplicity of the reaction provoked – a delicate artificial feather comes to life and flutters into the air when blown on by the visitor (Edmond Couchot, Michel Bret and Marie-Hélène Tramus, *The Feather*, 1988–92). *I Sow to the Four Winds* (1990) by the same artists is based on the same principle, this time using a dandelion. The visitor's breath gradually scatters its seeds. The point of an installation like this, according to the artists who made it, is that it 'plunges the creator, the artist, but also the viewer, into an intermediate zone at the interface between the real and the virtual'.

Real time

A computer or device reacting extremely quickly to any kind of instruction is said to be operating in real time. The reaction time between the command and the response is reduced to a minimum. This concept plays a very important role in all artworks that require a response or reaction from the public. The reaction time of the computer (or other device) is so short that it goes unnoticed and gives the impression of a 'live' interaction.

A history of artistic participation and interaction would show that we have gradually moved from the sensorial interactivity and participation associated with the happenings and environments of the 1960s to a form of participation in which the machine intervenes as a sort of medium or inescapable interface. Spectators can become participants by making themselves part of the machine's workings, by becoming an 'organ' of the machine. This is precisely the experience of the protagonist-spectators of installations such as Miguel Almiron's *Digital Anamorphosis* (2002). Confronted with a kind of fragmented picture or mirror, visitors suddenly notice that a camera is filming those who position themselves in front of the work, diffracting and multiplying their images. This process produces networks of movements, forms and colours. By changing position, jumping and moving around, viewers can alter the image. When the lens of the camera (situated below the 'picture') is briefly covered, lines and patches of colour return, both enriching and distorting the image.

At the origins of interactivity and participation are, yet again, certain happenings staged by Fluxus. Much of Nam June Paik's earliest work called upon the viewer to participate in a kind of game. In 1967, he showed a video installation at the Howard Wise

Gallery in New York that was based on participation of this kind (*Electronic Blues*), and in 1969 he returned to the same theme with a piece called *Participation TV*. Connected to his famous Paik-Abe Synthesizer, the camera filmed the spectators, enabling them to influence the image, modifying its shape and colours through their movements. This work also incorporated sculptures made up of television sets with built-in microphones. Any external sounds made by the public had the effect of distorting the image. What Paik, the pioneer of video art, was attempting to do here was to create the equivalent of 'perceptive fields' within which artist and spectator would form an inseparable pair.

Edmond Couchot, Michel Bret and Marie-Hélène Tramus, *I Sow to the Four Winds*, interactive installation, 1990.

For obvious technical reasons, however, it was the development of digital imaging, along with all its peripheral devices (sensors, data gloves, data- transformation software), that really caused interactivity to take off. One of the first interactive devices to respond to the public's commands was *Carla's Island* by Nelson L Max (1982–3), which was presented to the Musée d'Art Moderne de la Ville de Paris on the occasion of the 'Electra' exhibition in 1983. By adjusting the mechanism of a clock, the visitor can view the landscape (being shown on a screen) as it appears at different times of the day, right through to dusk and the middle of the night.

After this, interactivity gradually became more and more sophisticated. In 1986, a transatlantic arm-wrestling contest was staged between Norman White and Doug Back. One located at the Canadian Cultural Centre in Paris and the other in Toronto, the two participants pushed against levers equipped with sensors. These were linked to computers that were connected in turn to two telephones. On each side of the Atlantic, and at either end of the telephone line, each of them was able to feel the muscular pressure being applied by the other.

In *Telematic Vision* (1994) by Paul Sermon, two spaces are connected by an ISDN telephone line. In each of these spaces there is a couch, a monitor and a video camera. The images

Telepresence

The virtual projection of a person's image from one place to another. As this takes place in real time, the individual concerned is able, through his actions, to influence the environment in which he is only virtually present. Telepresence has often been used by artists, who have explored the ubiquity and the strong potential for strangeness that it affords. The technique is extremely fruitful as it allows two (or more) individuals in distant locations to meet in real time. It turns our concept of space upside down and relativizes our understanding of closeness and distance. Our perception is transformed, allowing in a greater element of the imaginary than before. Using the space of a virtual bed, Paul Sermon uses technology of this kind to set the scene for a 'physical' and 'virtual' dialogue with a real opposite number (*Telematic Dreaming*, 1992). 'It will also be possible to observe actions taking place at a very great distance from each other thanks to teletechniques' (Jacques Polieri, *Scénographie de l'image électronique*, 1963).

recorded in each space are immediately superimposed and shown on the monitors in both spaces. Visitors to each of the spaces are thus confronted by the presence, arrival or departure of strange, ghost-like visitors who appear in the other space and sit down on the couch. Some visitors feel they are being abused or manipulated and depart hastily.

In 1998, Laurie Anderson created an installation in Milan called *Dal Vivo* ('From Life'). In it, the image of Santino, a prisoner in San Vittore jail, was transmitted by cable and phone line to the Prada Gallery, where three times a day his image was projected live onto a cast of his body. Santino kept perfectly still; he could just be seen breathing. Occasionally he would move one of his hands or feet slightly. Thanks to a small video monitor that sent back a picture of the gallery, he could adjust his position so that it corresponded exactly to the cast. The prisoner Santino considered this adventure to be a sort of 'virtual escape'.

Other environments come across as psychologically more innocuous. Even though playful or poetic, however, they are not necessarily any the less disturbing. This is true of Laurent Mignonneau and Christa Sommerer's *Interactive Plant Growing* (1993). Here, by touching real plants that are physically present in the installation, the visitor can (thanks to sensors) cause a computer drawing of the same plants to appear on a large screen opposite. The spectator can then observe the evolution of this drawing as it hovers somewhere between a real, prickly plant and a mere phantom of the same plant: a simulation of ivy or cactus. In another installation (*Life Spacies*, 1995), the arm movements of visitors set varying numbers of birds flying. These alight on the screen opposite, framing the visitors' faces.

In *Riding the Net* (2000), another installation by the same artists, the visitor's voice explores the universe of the Internet, causing the screen to be invaded by a torrent of images relating to some word or other: 'moon', 'tulip' or 'Eiffel Tower', for example. Thus a visual poem of enmeshed images is created as a result of this random 'tapping' into the vast river of exclamations and words.

Kazuhiko **Hachiya**,
Inter DisCommunication Machine

Interactive installation, 1993.

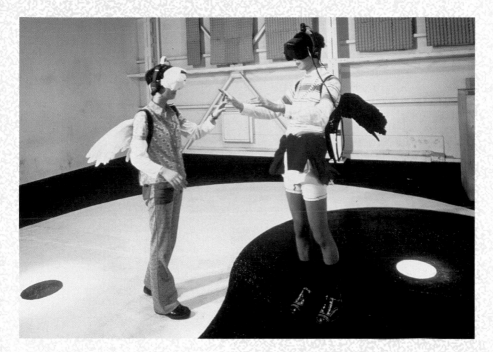

The apparatus at the heart of this installation allows two people to exchange fields of vision and hearing, with each of them seeing and hearing what is in the other's visual and aural fields. It takes the form of a kind of harness consisting of virtual-reality goggles and earphones. Each set of equipment is adorned with a small set of wings (one black, the other white) which make the wearers look like cybernetic angels. The installation has been shown in a number of different places. The 'set' includes a carpet bearing the yin-and-yang emblem – no doubt an indication that the two participants exchanging identities and points of view are to be viewed as 'masculine' and 'feminine'.

The spectators become components of the installation – indeed essential components, since it is up to them to call forth what would otherwise remain in limbo as mere potential within the system.

The Bus (1984–90) is an interactive work by Jean-Louis Boissier shown at the 'Les Immatériaux' exhibition at the Centre Georges Pompidou (1984–5). The work combines the layout and furnishings of a bus with videodisc technology. By pressing the vehicle's very real stop button, the passenger can stop at a particular video image. These video images replace the scenery that would normally be observed through the windows of the bus. By means of these images and a random element in the programming, we are admitted into the private lives of 80 individuals living between Stains and St. Denis on the outskirts of

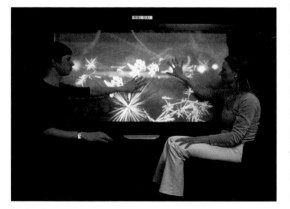

Paris. An echo of this bus is to be found in a later work by Mignonneau and Sommerer, *HAZE Express* (1999), an interactive installation in which spectators can alter the landscape that is 'going past' by touching the train window. More recently still, Maurice Benayoun developed an interactive station

Christa Sommerer and Laurent Mignonneau, *HAZE Express*, interactive installation, 1999.

project for the Franklin-Roosevelt metro station in Paris.

The virtual

'Virtual reality, both on the part of its manufacturers and of the people who watch it, necessitates an understanding of how my eye is related to that point there, this point here... from a moving position. Suddenly all these new possibilities of considering the art of perspective are opened up.'
Peter Greenaway

Art has always shuttled back and forth between the opposite poles of materiality and dematerialization, incarnation and disappearance. The art that is developing in the early years of the 21st century is no exception to this rule. While the proponents of

Graham **Harwood**,
Rehearsal of Memory

Interactive programme, 1995.

'This work is about people everywhere who are trying to remember the faces of the extras in the cinema of history.'

This work was created in collaboration with the patients and nursing staff of a hospital near Liverpool that is both hostel and prison for 650 offenders or disturbed individuals. Data collected from the scanned skin of participants in the project was used to create a composite person. By clicking on this naked, tattooed, marked and scarred virtual body, viewers can access details of the lives and stories of different participants. Our own gaze intertwines with those of the patients and carers, and the interactive element leads us into a kind of maze of the mentally ill – a maze that society normally refuses to enter.

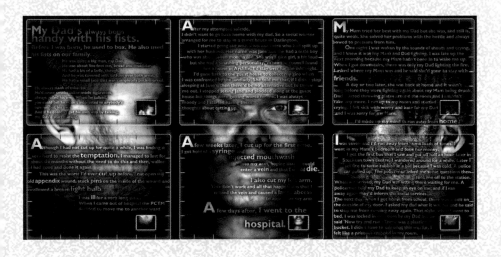

Body Art or other materialist trends continue to maintain the importance of the material, new technology seems to be leading artists towards an increasingly radical immateriality However, this is dependent on a technologically fragile support and the ever-present threat of what Paul Virilio has called a 'data crash'.

Art plays a considerable role in the ever more inextricable intertwining of real and virtual worlds. This role is undoubtedly due to the traditionally playful and imaginary character of artistic creation, whose aim has always been to compensate for, improve or idealize an unsatisfactory reality. And it must be admitted that the artificial universes being made available to us are becoming more and more clean-cut, hygienic and perfect.

Virtual works are today housed in virtual galleries, easily accessible to all and easily transportable. Virtual actors and dancers can combine with real actors and dancers or even replace them. This dematerialization goes hand in hand with the creation of virtual installations – artificial installations which tend to supplant or duplicate the older system of in-situ installations. All is now artificial. The only thing that remains real is the visitor or participant. But for how long? Virtuality has invaded the world of art in two ways. Firstly with so-called virtual installations, which suddenly started to proliferate between 1990 and the early years of the 21st century. Artists took delight in creating phantom spaces made up of light, shadows, sounds and linear, clear-cut forms: a universe of images in which the visitor moves through a hygienic world of simulation and manga characters.

But virtuality also entails a new method of navigation and new methods of presenting artworks. Holograms, CD-ROMs and interactive terminals are now accepted features of every modern museum.

From these real museum spaces it is possible to carry out virtual visits, viewing works in the form of ethereal imitations or doubles. Even a 'proper' visit to a real museum is often accompanied by a virtual visit – a kind of low level flying that allows us to dip in and out of abstract spaces. CD-ROMs and videodiscs have brought with them a new way of looking at art. The paths we take through virtual worlds are based on specific visual systems: for example, methods of scanning and navigation that can be implemented horizontally or vertically, in a circular movement or from left to right

(or vice versa). We can also penetrate into the depths of the image by clicking on windows. Elsewhere there are sliding tabs that open or close panels, leading to abstract or realistic windows of various sizes.

Communication

'Everyone was a participant, creating, receiving and transmitting information all at once. We had fun.'
Allan Kaprow

Video and electronic art revolutionized methods of disseminating and communicating art as well as affecting the art itself. This became apparent in the 1970s, when the different players in the art world – gallery owners, curators and artists – became aware of the infinite possibilities offered by the new media. In Düsseldorf in 1968, Gerry Schum founded the first video art gallery, which functioned both as an information centre and as a venue for happenings and performances. Artists were quick to appreciate the potential of the new medium for disseminating their works and sought access to the major broadcasters. In 1968, Otto Piene and Also Tambellini created, for the television station WDR in Cologne, a documentary on one of their actions (reworked using electronic procedures). In 1969, WGBH in Boston broadcast a programme called *The Medium is the Medium*. This consisted of short works by six artists. *Hello* (by Allan Kaprow) was a live transmission of a happening, in which a network of cameras and television sets connected the studio with a number of locations in the Boston area (airport, library, hospital, and so on). The various participants could therefore see each other and communicate with each other: *'Hello, I see you'*. In his contribution, Nam June Paik concluded his *Electronic Opera No.1* by directly addressing the viewers, enjoining them to close their eyes and switch off their TV sets.
Again in 1969, the first major exhibition devoted to video art took place at the Howard Wise Gallery in New York. Frank Gillette and Ira Schneider presented *Wipe Cycle*, a closed-circuit environment in which spectators were confronted with the immediate or delayed playback of their images using feedback techniques. These video 'portraits' alternated with images from ordinary television

programmes and the presentation of two video sculptures by Paik. The precise relationship between video, computers and sociological art needs to be stressed here: video and the medium of information technology were no more than simple intermediaries or tools in the process of exchange and communication. But then artists began to take on the role of main players in an enormous process of production and exchange; the fundamental thing, as McLuhan made clear, being not the information (transmitted or not) but the network used to distribute the information. Delocalization and liberation from spatial constraints became an increasingly important theme, with artists using technology that allowed their bodies to appear everywhere at the same time: networks, telepresence systems, virtual environments, and the main networks of exchange and communication (fax, telephone, Internet, etc). The whole range of artistic devices used – the transmitter, the receiver, the means of disseminating and transporting the work and even the work itself – began to bear the stamp of dematerialization. Some artists began to work directly on the Net, creating sites that are themselves genuine works of art, albeit immaterial and transformable. A whole swathe of sociological art became Internet-based, with artists like Vuk Cosic and Fred Forest operating within a kind of parallel, non-institutional network, facilitated by the fact that the Internet allows all kinds of counterculture networks to thrive in its midst.

Sociological art

An artistic movement that emerged at the beginning of the 1970s (centred predominantly on Fred Forest). Its aim was to examine, reflect and criticize aspects of social behaviour, employing the very means of mass communication (newspapers, television, networks) that it set out to criticize.

Allan Kaprow's *Hello*, mentioned above, united a number of individuals who were scattered about in various locations in the Boston area. These locations were linked by 27 monitors and 5 cameras that allowed the participants to greet those people that they recognized on the screen.

In the 1970s, the performances of Douglas Davies focused on the process of communication itself. Using a pane of glass as a symbol or metaphor for television, he asked visitors to approach the glass and attempt to communicate with him (*Handling [the Austrian Tapes]*, 1974). In another performance he attacked a real television, breaking or scoring with a knife a piece of Perspex placed in front of it (*The Last Nine Minutes*, Documenta 6, 1977). In 1980, Kit Galloway and Sherrie Rabinovitch

established a satellite link between the window of a large store in New York and that of a large store in Los Angeles (*Hole in Space*). For three days, cameras and microphones enabled people in one city to chat with people in the other.

The 'communication games' videos created by Jacques Polieri for the 1972 Olympic Games in Munich, the videos installed by Cisco at the Porte de Versailles in 1977 and the intercontinental 'games' set up by Polieri in 1983 (during the Vidcom event in Cannes) between New York, Tokyo and Cannes, were pioneering events in their field. In Munich, a 'Street of Games' was lined with double-sided video monitors and giant screens positioned at the end of the street. A central control room inside a dome allowed Polieri to establish a dialogue with the public, some of whom were invited to take part in a variety of games that others could follow on various screens. In this way, a form of dialogue, exchange and cross-participation between different members of the public was created. In Cannes in 1983, Polieri presented a system called *Man, Images, Machines*. Images of Japanese or American origin, in particular artificial moving images, were transmitted by satellite, shown on large screens and commented on by specialists in New York, Tokyo and Cannes. Giant artificial faces filled the screens and began a dialogue with the specialists.

Fred Forest has played an important part in communication art. From *The Stock Market of the Imaginary – The Stock Market of the News Item* (Centre Georges Pompidou, 1982) to *The Conference of Babel* (Galerie Création, 1983; involving 12 television sets, 8 video recorders and a closed-circuit television system, as well as other media such as an independent local radio station, a news weekly and a monthly magazine), Fred Forest's many actions stressed the communication that underlies every artistic process.

He soon began to use the medium of television critically and subversively, transmitting 'one minute of white' on France's state-run second channel in 1972. In order to avoid any confusion on the part of the viewers, an announcer issued the following warning: 'Your television set is not out of order', and continued a moment later: 'Please use this time for yourselves.'

Telephone, fax, telematics

'[N]etworking provides the very infrastructure for
spiritual interchange that could lead to the
harmonization and creative development of the whole
planet.'
Roy Ascott, 1990

The term 'technology' covers all the tools and instruments used by
man, including, of course, information technology. The use of
communications networks by artists goes back a long way. In
1922, Laszlo Moholy-Nagy ordered five paintings by telephone,
using a colour chart and describing in minute detail the drawing he
had made on millimetre-squared paper. The information was
decoded and the pictures were recreated by the factory at the
other end of the line. Similarly, in the 1950s, Picasso expressed a
desire to be able to send the different elements of a picture by
cable and thus to create a picture remotely. In the 1980s, artists
adopted two new means of data transmission: the fax and slow-
scan technology (the transmission of images by telephone line). In
1982, the group Dax produced *The World in 24 Hours*, the object
of which was to link up 16 cities on three continents in the space
of 24 hours. In 1990, their work *Dax Dakar d'Accord* connected
artists in Pittsburgh and Dakar by slow-scan television. Music,
dance, paintings and songs were exchanged in this way. A group of
Brazilian artists (including Gilberto Prado, Mario Ramiro and Carlos
Fadon) have been working with telecommunications systems since
the 1980s. Carlos Fadon's *Still Life/Alive* (1988) uses slow-scan
television in an original, palimpsest-like way: an artist receives an
image, uses it as the basis for a new work, photographs the new
work and sends this image on so that it can provide the basis for
another new work. The artwork is thus endless and permanently
enriched by new contributions.

In 1988, during an 'International Fax Night', Stéphan Barron
organized an exchange of drawings by fax between Caen, New
York, Paris, Rome, Brussels and Amiens. The following year, he
created *Orient Express*. During the course of a journey from Paris
to Budapest he took a Polaroid picture every hour. When he arrived
in Budapest the Polaroids were digitized and sent back to Paris.
On his return trip to Paris the artist followed the same procedure

in reverse. In 1991, Barron sent images of his garden (a tiny garden just coming back to life after the winter) to a gallery in Prague over the course of three weeks. This he again did by fax, which had become for him a sort of invisible thread or line linking all the different towns and cities on the planet and allowing individuals to exchange scraps of everyday information. In 1996, Barron merged images of the French and Australian skies (*Ozone + Night and Day*). Two computers connected to the Internet calculated in real time the average colour of the two skies – due to the time difference, one would almost always be light while the other was in darkness.

Karen O'Rourke, who founded the group Art-Réseaux (of which Gilberto Prado is a member), also manipulates the fax and the phone, diverting them from their intended purpose. In *City Portraits* (1990), participants scattered throughout the world were invited to exchange information by manipulating and transforming images they sent to one another by fax. Previously, at the *Electra* exhibition in Paris in 1983, Roy Ascott had produced an enormous collective narrative, *The Pleating of the Text*, whose elements were transmitted by teleprinter.

Network art

'When the machines are on and your fingers are on the keyboard, you are in connection with some space that is beyond the screen. And this space is only there when the machines are on. It is a new world which you enter. For me it was never a question of travel. For me it was always a question of presence, of passing through some membrane into another territory. It's not about things, it's about connections.'

robert adrian x, 'net.artist'

Our system of networks highlights certain problems around communication. Given the existing social, political and commercial reality of the production and dissemination of information, we need to look at how artists promote, reflect or thwart the systems that are in place. This question has long been at the heart of the relationship between art and the new technologies. The notion of an 'ecology' of the media and a 'social' treatment of information is

clearly an issue of enormous importance in modern society. As early as 1971, Video Hiroba, a group of Japanese artists financed by Fuji-Xerox, launched their project *Utopia Q and A*. This was based on an idea developed by the EAT group (Experiment in Art and Technology), founded in the 1960s and to which such prestigious figures as David Tudor, John Cage and Robert Rauschenberg had been godfathers. The project consisted in using the telex network linking Tokyo, New York and Bombay and initiating a dialogue between their citizens on the following subject: '1981, the near future: questions and answers in all categories'. Encouraging communication between people, improving the exchange of information and constructing networks that allow a dialogue to take place between artists and the public at large – these have always been among the aims of art. In the mid-1970s, Keigo Yamamoto started to work on installations involving public participation. Shown at the Museum of Modern Art in Kyoto in 1977, the video performance *Hands* invited visitors to clap their hands in time to a rhythm played on video. Another of his installations was based on a discrepancy between the videotapes being played on two monitors placed one on top of the other. One displays the movements that formed part of a previously filmed performance and the other plays back the visitor's own movements as recorded by a camera within the exhibition space. The communication process is seen here at its most simple, but the use of more sophisticated technology to facilitate long-distance communication (computer networks) has led to a significant growth in the number of exchange-based projects.

In 1984, operating from the Centre Georges Pompidou, Nam June Paik created his famous satellite link between Paris and New York, called *Good Morning, Mr Orwell*. Experimenting with the new 'meeting spaces' that would come to be referred to as 'networks', this event allowed a dialogue to take place between the public and numerous artists (including Robert Rauschenberg, Merce Cunningham, Allen Ginsberg and Laurie Anderson). It was also from the Centre Georges Pompidou that Maurice Benayoun 'bored' his *Tunnel under the Atlantic* in 1995.

Network

A collection of computers that are geographically remote from each other but interconnected by means of data links, allowing sounds, images and text to be continually exchanged between them. The establishment of networks has considerably simplified the process of communication. Communication is now global, and time and space seem to have shrunk. It is possible today to send and receive information almost instantaneously, in real time, on opposite sides of the world. The mesh of these networks, moreover, is becoming increasingly fine, leading to the development of growing numbers of parallel networks. Networks thus operate at two levels – the macroscopic and the microscopic.

Based on the double principle of interactivity and virtual reality, this virtual tunnel (bored in five days by the participants in the action) allowed the inhabitants of Paris to 'meet' visitors to the Museum of Contemporary Art in Montreal (by means of video images) and to hold a dialogue with them. Another tunnel (*Paris/New Delhi*) was 'bored' by Benayoun in 1998. This installation was identical to the previous one and allowed a similar form of communication to take place between the Cité des Sciences in La Villette and the Virtual Gallery in the heart of New Delhi.

The latest data transmission device to be used by artists is, of course, the Internet – that immense 'web' within which ever more varied exchanges are occurring at an incredible rate. The volume of art being created on the Web is also growing. A good example of Web Art is Fred Forest's *The Web Territory. Cyberterritories* (1996), an installation that combines video, information technology and an Internet connection, as well as the same artist's *The Centre of the World*, a 'universal communications centre' that was on show for three days in the Espace Pierre Cardin in Paris in 1999. This installation consists of nine screens that allow the artist's texts and ideas to mix with those of Internet users surfing the site. The use of webcams gave Internet users the opportunity to see themselves on the screen and to interact live over the Web.

This is perhaps the key point: communication is now unceasing, like a tape loop; indeed, there is a surfeit of communication. Olga Kisseleva's *Silence* (2000) is a critique of this utopia and its closed-circuit communication. When Internet users connect to the site, a hand is held out towards them accompanied by a message saying: 'Please leave a message, we will get back to you.' No sooner has it been written, however, than the message breaks up and becomes illegible.

Video games

'In "Toy Story" by John Lasseter, there is a little sign hanging on the door of a house that reads: "Virtual Realty".'
Philippe Parreno

At the end of the 1990s, the art scene was besieged by mangas and video games as a whole generation of artists immersed in this

world started to examine it with a fascinated or critical eye. There had already been a number of pioneers who had produced works involving games. One such was Dominique Belloir, who exhibited a pinball machine incorporating video (*Flippers*) at the ARC (Musée d'Art Moderne de la Ville de Paris) in 1974. The video game's first hesitant steps were taken at the beginning of the 1970s, when artists like Martin Parr (*Love Cubes*, 1972) dreamed of directly involving the spectator. In 1971, the first video-game machine (Computer Space) was installed on commercial premises in the United States – in a bar in Silicon Valley. It was also around this time that the Japanese firm Atari started marketing its first games (*Pong*, *Breakout*). The subsequent installation of terminals and game machines in public spaces was followed by the appearance of more and more compact games consoles that invaded the private sphere as well.

In terms of image, the influence of video games and mangas can be seen today in the use of scenery and characters like Ann Lee, a cartoon character created by a Japanese graphics studio and bought (as a computer file) by Pierre Huyghe and Philippe Parreno. They had the intention of turning her into a character that could be used by themselves and others – an 'independent' star that could appear in the work of various artists. So far there has been little difference (and then only small nuances) between the works produced by the different participants in the project (Pierre Huyghe, *Two Minutes out of Time*; Philippe Parreno, *Anywhere out of the World*; and Dominique Gonzalez-Foerster, *Ann Lee in Anzen Zone*, all in 2000. Pierre Huyghe added *One Million Kingdoms* for the Venice Biennale in 2001.) These works seem like so many clones of contemporary artistic creations: empty form, kit-like characters, build-it-yourself art. Anzen Zone (Japanese for 'security zone') is based furthermore on the principle of duplication and the cloning of the character into two versions, one Japanese-speaking and the other English-speaking.

Based on a system of predetermined, restrictive rules (and roles), video games generally involve a form of interactivity that is pre-programmed and predigested. It is precisely these restrictions that interest some artists. A number even go as far as emphasizing the masochism inherent in submitting to these rules. Others ridicule the system because of the infantilism and domestication it

induces. *Domestic Fighters* (1999) by Cynthia Delbart and Julien Prévieux takes the form of a combat game using a videoconferencing system. The player 'remotely controls' real actors who perform domestic scenes that are pre-codified and pre-regulated. Those wishing to play have to contact the artist, who sets a time for the 'battle'. Each sequence of the game is played out in a fixed place with real individuals who are allocated strengths and weaknesses. Among the different 'moves' listed are (for the garden) 'gather up the dead leaves', 'saw wood' and 'injure yourself accidentally', and (for the kitchen) 'sit on a chair' and 'put your fingers in the potato-masher'. The game reproduces real life and aims to be cathartic.

In other cases, the designers invert the normal rules of the game. The designers at Smart Studio (Sweden) have created a game in which two players, sitting opposite each other, are equipped with

sensors that record the electronic signals emitted by their opponent's brain (*Brainball*, 2002). At the centre of the table is a magnetic ball that moves towards the player with the highest level of brain activity. The aim of the game is

Philippe Parreno, *Anywhere out of the World*, 2000. Video of a 3-D animated film.

for the players to relax as much as possible in order to reduce their brain activity and thus keep the ball away from them and on their opponent's side of the table. Players are able to see their opponent's brain activity curve on a screen.

This is also the world to which the *otaku* belong – those 'children of the virtual world' (originally a Japanese phenomenon, but now to be found everywhere), who sit glued to their digital, audio-visual prostheses, shunning all contact with the real world and immersing themselves in the universe of games and manga heroes. These games – spatial games, games involving identification with strong

characters, war games, role playing games – produce a kind of extension of the sensorial capabilities of the individual, who moves through imaginary universes and acquires quasi-omnipotence. It is, in effect, childhood lasting into adulthood.

The central interest of video games lies in the fact that once a role has been assumed, the action can be repeated and endlessly played and replayed. Players can also continually change levels. They can pass from one space to another or choose a different identity and thus escape the constraints of time. Glued to their joystick or command lever, the gamer is in sole command of the game. Sometimes artists adopt characters that have already been used in commercial games (and are thus well-known) and transpose them into their works. In one of his videos (*Flames*,

Kolkoz Collective, *Kolkoz.org*, video game, 2002.

1977), the Greek artist Miltos Manetas recycles the character Lara Croft. Repetition and borrowing (itself a form of repetition) are the key to this process too, giving the artist a sense of mastery over this all-enveloping audiovisual world, which increasingly functions like a natural environment.

The continual improvement in video games – with great care taken over the scenery and the movements of the characters and with the use of proper screenplays – means that they are becoming more and more like a form of interactive cinema. The art world has also been drawn into this process and indeed in one instance has actually found itself recycled as a video game. In *Kolkoz.org*, the Kolkoz Collective has created characters based on some of the main figures – gallery owners and collectors – associated with the art galleries of the Rue Louise-Weiss in Paris. Players get their thrills from making them

wipe each other out. The same collective also developed the concept of virtual apartments dedicated to contemporary art, which can be taken over by artists, collectors and gallery owners. Parties and games are organized in them, producing a pleasurable game-within-a-game effect.

This embracing of the video game by artists demonstrates just how fluid art's borders are. Activities are being developed that come under both categories (art and games), occupying a space whose borders are constantly shifting. Those galleries of contemporary art that tackle the issue of video games on their websites (without distinguishing between games deriving from popular culture and those deriving from the art world) are merely responding to a current trend.

Artists' websites

'Machines are far more interesting than people. They are less predictable and more complex. The Web is faster, more efficient and more accessible than any other means of communication... The Internet brings art to the masses; it is a service everyone can use rather than a form of pleasure reserved for a select few.'
Vuk Cosic

The first works claiming to be Net Art were created in around 1996–7. Originating in Eastern Europe (Slovenia and Russia) and based on the principle of appropriation – that is, diverting something from its intended purpose – their target was the commercial use of the Net, and this led to discussion forums being set up. Vuk Cosic was one of the pioneers of this sort of work (from 1995 onwards).

This phenomenon had been preceded by various experiments. Roy Ascott's *The Pleating of the Text*, a contribution to the *Electra* exhibition held in 1983, used the IP Sharp network, which is often regarded as a precursor of the Internet. The exhibition *Les Immatériaux*, organized by Jean-François Lyotard at the Centre Georges Pompidou in 1984, inspired a number of artists. It focused on the immaterial flow of information at the heart of communications and the new technologies. Visitors to the exhibition were given the opportunity to play with a home computer

Olga **Kisseleva**

Born St Petersburg 1965. Lives in St Petersburg.

'The Web has changed the way I create; above all, it has changed certain aspects of the way society functions, which has changed the way I create.'

A painter by training, Olga Kisseleva discovered the new technologies during a trip to Silicon Valley. Today, the bulk of her work is created on the Internet. The Net provides her with a way of examining, often critically, the communication process. In *How Are You?* (1997) she asked the conventional question of the title, to which no one in the West gives a truthful answer. Key words were suggested to Internet users visiting her website. These people then communicated with the artist, attempting to reply to the question (in whatever language). The artist then varied the procedure by asking her question in specific locations: for example, the Venice Biennale of Contemporary Art, Silicon Valley or Tibet. Encouraged by the Dalai Lama, Kisseleva filmed Tibetan monks and posted their pictures on the Internet. In 1999, she collaborated with another artist, Nicolai Selivanov, on a project that twinned Versailles with St Petersburg (*Memory Flashing*). This involved filming two palaces: the Palace of Versailles and Peter the Great's palace in St Petersburg, which was largely inspired by Versailles. The idea was for participants to chat on the Net, using the mirrors of the two palaces as an interface (the mirrors are similar). The project was unable to go ahead due to lack of the necessary authorization, so the artists worked instead with postcards bought at Versailles. These were doctored and presented online together with the photographs taken in St Petersburg. It was ultimately impossible to untangle the knot and work out which of these images was the more 'real' and which the more 'artificial'.

SELECTED WORKS ON THE INTERNET
- *How Are You?*, 1997.
- *Memory Flashing*, in collaboration with Nicolai Selivanov, 1999.
- *Silence*, 2000.
- *Flying on Instruments*, 2004

BIBLIOGRAPHY
- http://www.kisseleva.org/

connected to the Minitel system. In 1986, the *PlaNetary Network* telecommunications project took place at the Venice Biennale. This involved gathering, mixing and redistributing all kinds of data from all over the world (digital images, network conferences, e-mails, interactive videodiscs, etc). A project dedicated to planet Earth (*Aspects of Gaia*) was undertaken in Linz, Austria in 1989. Images of all kinds, originating from the widest possible range of individuals and countries (from Australian Aboriginals to scientific contributions), threw an enormous, invisible web over the planet. Today, most artists have a website. This allows them to present their new work on an ongoing basis in what is effectively a personal virtual gallery. Such sites also provide information, making available all kinds of documentation relating to the artist (such as a biography, a bibliography, a list of exhibitions and reviews). Some sites also include discussion forums, giving the public an opportunity to air their views. Other sites are regarded as artworks in their own right. This is true of Fabrice Hybert's website (www.inconnu.net), which was set up during a two-month period in Paris, at the Arc de Triomphe, as part of the millennium celebrations. Researchers and artists were invited to come to the site and attempt to answer questions from Internet surfers. A monument to the glory of the past, honouring the 'unknown soldier', the Arc de Triomphe became the focus of an attempt to bridge periods of time, with questions and answers linking up and multiplying like the branches of a tree.

Verbarium (1999), by Laurent Mignonneau and Christa Sommerer, transforms text into shapes. Visitors to the website send a message and in return are sent a three-dimensional shape that might be organic, abstract, simple or complex.

The shapes are generated on the basis of the words contained in the message, with each word corresponding to a means of visual description. The body of texts received by the site constitutes a collective artwork – a kind of evolving organism that can be modified at any time. In 2000, Michel Jaffrennou devised an interactive 'Web Man Show' centring on a little character, called Diguiden, with whom players can identify. There is also a live version of the show, which Jaffrennou – taking the role of ringleader and puppet (or marionNette) master – is planning to

perform in theatres around the world.

In addition to the sites of well-known artists, a whole world of underground creativity has developed on the web, produced by artists who for the most part remain anonymous. These artists do what they do for the sole pleasure (or need) of communicating, expressing themselves and using their powers of invention without any expectation of making money or any desire to make a name for themselves. As always with new technology, at the outset it was a case of parallel uses being discovered by professional practitioners as they explored the extraordinarily expressive potential of the new media. The computer is both a creative tool and a medium for disseminating information and images. It is therefore natural that certain artists should want to bypass the official network of commercial galleries and museums and use the Net for creating, transmitting, selling and exchanging their works. The traditional art world, with its host of critics, dealers and middlemen, is thus turned on its head. Many artists are in this sense hackers – individuals whose passion is for exploring the possibilities (and pitfalls) of information technology and using the existing processes to subvert them.

Hence the appearance, at the beginning of the 1990s, of the concept of 'tactical media', as opposed to the mass media. This involved media operations mounted not by institutions and pressure groups, but 'cobbled together' by individuals or small groups. And this is what we are now seeing: the development of a mass of digital, rhizomatic (to use a term coined by Deleuze and Guattari) media initiatives that emerge and then vanish again like some gigantic sea monster. In 2002, during an exhibition of Net Art held at the Whitney Museum in New York (which, of course, had its own website), Miltos Manetas hijacked the official site and created a parallel one (whitneybiennial.com), inviting other artists to create work for it.

One of the most beautiful pieces of work on the Internet is by Jean-Pierre Raynaud. In 1997, in the virtual space of the brand new website Havas, Raynaud reconstructed the mythical space of his vanished house. In 1993 he had destroyed the house he had built (which was tiled completely in white) in order to safeguard it from excessive intrusion by human beings and the real world. By

reconstructing it on the Internet, Raynaud was simply returning to the virtual sphere what had, after all, begun life in the limbo of the artist's imagination. Art institutions are clearly not sitting and doing nothing: there are many virtual events organized by major galleries on the Net, not to mention their own official websites. In order to celebrate New Year 2001, the Museum of Modern Art (MOMA) in San Francisco devised a two-part exhibition. Operation *010101: Art in Technological Times* was launched on 1 January at 00:01 precisely, at the same time as a website exhibiting the work of 35 artists (visual artists, architects, designers, etc), some of whose work (installations, videos, sound works) had been created specially for the occasion. The second part of the exhibition took the form of an 'in situ' exhibition that ran from March to July 2001.

BIBLIOGRAPHY

King, L (ed), *Game On: The History and Culture of Videogames*, Laurence King Publishing, London, 2002

Waplington, N and McCormick, C, *Learn How to Die the Easy Way*, Trolley, London, 2002

New technology in the other arts

'Art is often a bastard, the parents of which we do not know.'
Nam June Paik

During the second half of the 20th century, new technology was widely embraced by visual artists. Video and computers became as familiar to artists as the paintbrush, the chisel, marble or charcoal (sometimes even more familiar). But the impact of the new technologies did not stop there. They also infiltrated and extensively reshaped the other arts (dance, theatre, photography, cinema, architecture, etc). At the same time, the dividing lines between the arts became blurred. The rapid development of multi-media installations and performances played an important part in a colourful converging of all the various means of expression. Dance, for example, made use of video. Theatrical sets and stage machin-

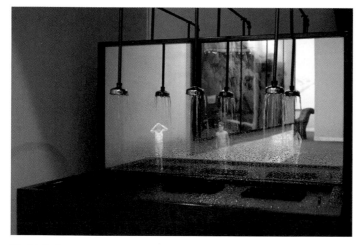

Pierrick Sorin,
The Showers,
video installation,
2001.

ery have become increasingly computer-controlled and the use of video on stage is not uncommon. Digital photography carried on the tradition of collage and photo-montage techniques, transforming them in the process. Cinema – both traditional cinema and digital cinema – moved into the area of the visu-al arts as projections and other moving images started to proliferate (*Passages de l'image* was also the title of an exhibition held at the Centre Georges Pompidou in 1990). The image was still the determining element of a work, although sound, voice and text were also integrated into installations. Even architectural forms were reinvigorated by computer graphics software that could produce increasingly complex structures.

At the same time, art galleries underwent a radical transformation, and today exhibition spaces are open to all kinds of arts. Visual artworks often take the form of events involving both the most traditional and the most advanced technologies. Increasingly, they draw on all the different arts, providing an unmistakable echo of the concept of 'total art' that was so dear to the avant-garde movements of the early 20th century (Dada, Russian Constructivism, Futurism, Surrealism, etc) and that was so brilliantly reactivated in the 1950s and 1960s (in the form of an 'anti-art'

inspired by life itself) by the Gutaï and Fluxus groups, the practitioners of Body Art and the organizers of happenings.

Boundaries between disciplines have again blurred, as installations become increasingly dominated by theatre, communications and animation. Thus, 'image-movement' (Gilles Deleuze) has been able to infiltrate (and be infiltrated by) the three-dimensional world of art. More than ever before, art is now a conglomeration of forms, colours and moving images; coloured and dynamic rhythms structuring an expanded space and time.

The dividing walls between the disciplines have doubtless fallen as a result of the expansion, virtualization and globalization of communications in art – an art that is increasingly seen as a kind of virtual currency or virtual game, exchangeable and manipulable by anyone anywhere in the world. However, this new 'total art' is not always characterized by a desire for seamless synthesis; new media artists also appreciate disharmony, cacophony and ambiguity – despite information technology and communications leading to a certain standardization of the new materials.

In the light of this, it may seem pointless to try to distinguish between the different disciplines. However, it is useful to do so, since it serves to highlight certain trends. In the 1920s and 30s, the Bauhaus had also championed the idea of a total art that would unite painting, sculpture, architecture, theatre and so on. The total theatre project devised by Gropius in 1927 at the request of the director Erwin Piscator involved twelve screens, one on each of the room's twelve columns, on which films could be projected from twelve cabins located in the centre of the room or around the edges of the set. The spectators were thus surrounded by a dense system of projections. Gropius championed the notion of a 'synthetic art' that would unite words, sounds, colours and movement, an art that fused all the different arts into a single, all-embracing means of expression. Contemporary artists working at the beginning of the 21st century are increasingly inspired by a time-honoured three-dimensional culture that has long incorporated the basic elements of an audiovisual, media-oriented culture.

Video, dance and computer graphics

'Camera space presented a challenge... The camera takes a fixed view, but it can be moved. There is the possibility of cutting to a second camera which can change the size of the dancer, which, to my eye, also affects the time, the rhythm of the movement. It also can show dance in a way not always possible on the stage.'
Merce Cunningham

Two-part dance work, 1993–4

'[Video] adds another level of perception... I wanted a complicated work.'

The first version of *Still/Here* by the American choreographer and dancer Bill T Jones involved five large television screens that could be moved around so that the fragile 'fabric' of the dance would not be 'torn' by the intrusion

of an over-mechanical coldness. In the end, Jones opted for the intermittent use of video, deciding that the screens would enter and exit the dance space and the dance itself. Video and dance are thus closely interlinked in this piece, like two separate threads woven together by the choreographer to form a whole. In *Here*, Gretchen Bender lined up five screens on the stage, each of them showing a beating, blood-red heart which is replaced by the fractured image of a woman who 'explodes' into fragments, falling back down like snow or raining glass.

In this work, Jones uses video recordings made in collaboration with Aids patients at survival workshops. They conclude with a video portrait of each participant. The initial video image in

Performance at the 1994 Lyon Bienniale de la danse, Bill T Jones/Arnie Zane Dance Company.

the prel-ude to *Still* is used to evoke a 'world of spirits'. The technology is meant to create a poetic impression and the tools themselves are supposed to be inconspicuous. 'Formally, it's beautiful. This line of faces — luminous, changing, smiling and looking out at you... To me, it says everything about what it means to be a social creature as we are as human beings.'

Because it records and reproduces the body's movements almost instantaneously, video has quickly become an indispensable choreographic tool. It allows rehearsals and shows to be recorded and dance sequences to be analysed and corrected. Used together with a computer, video also makes possible the extraordinarily precise regulation and control of movements. It has thus led to a creative renewal and exciting experimentation in the world of dance.

Merce Cunningham was one of the first dancers and choreographers to exploit computers as well as video. As early as 1986, Simon Fraser University in Canada developed the choreographic software *Life Forms* at his request. As well as being a simple technical tool, it can also be put to more creative use. Thecla Schiphorst developed applications for *Life Forms* in collaboration with Cunningham, and subsequently worked on the

Applications of the choreographic software *Life Forms*, as developed by Thecla Schiphorst for Merce Cunningham.

recording of dance movements and the creation of interactive installations in which certain data are modified in response to stimuli from the spectator (voice, movement, etc) (*Bodymaps: Artifacts of Mortality*, 1996).

Computers allowed Cunningham to explore the complexity of gesture and movement, encouraging the most daring and unexpected combinations of both. (It is well-known how much Cunningham's concept of dance has owed to chance, experiment and the exploration of daily life.)

183

At a relatively early stage, Frédéric Flamand and Plan K, the troupe he founded in 1973, developed a multimedia approach to dance based on the plurality of the arts. Much of their work has combined dance with cinema and video, as in *The Fall of Icarus* (1989), which uses an installation created by Fabrizio Plessi (which the artist later turned into a sculpture with the title *Liquid Time II*).

N+N Corsino, *Topologies of the Instant*, multimedia installation, 2001

The centre of the stage is taken up by a water mill consisting of 18 video monitors, each of which overflow with water – when they are not filled with flames. Two video monitors are attached to the feet of Icarus, and display the image of two walking feet.

'Video dance' took another direction in the work of Nicole and Norbert Corsino (N+N Corsino) (*Circumnavigation Vancouver*, 1994; *Crossings*, 1996). Their choreography is presented to the spectator by means of video alone. Video is thus not simply a tool, but the medium through which they express themselves. Interested in the kinetics of the body and its relationship to the landscape, they often work in situ, in ports or

open spaces, constructing three-dimensional installations and scenarios involving images. Video dance functions as a link uniting these works.

In 1995, they combined real dancers with computer-generated dancers (*Totempol*). From then on, doubles became a feature of their work. Dance movements are sometimes present in mere

skeletal or blueprint form: silhouettes appear, disappear, dissolve into space, reappear. Flesh-and-blood characters, shadows, silhouettes, digital bodies – the dancers perform their movements in a variety of ways. The image is a fluid, incessantly shifting environment. The space is a setting for circumnavigations, crossings, arrivals and departures, and long journeys. More recently they have enriched their range of visual images with new digital images and virtual dancers deployed in the open space of the installation (*Topologies of the Instant*, 2001).

In 1996, the English choreographer Richard Lord (director of The Big Room Dance Company) was the first to create an online dance show, called *Progressive 2*. Here the spectator is in charge: it is up to them to initiate proceedings and to combine the dance segments or superimpose the various movements as they see fit. In *Brownian Motion* (1997), Lord takes this a stage further. Now the spectator can choose which characters are involved and exercise a degree of control over their movement. Random movements follow the principle of Brownian motion. The spectator can 'attract' the digital dancers towards his cursor or 'drive them away' from it. Also worth mentioning in the field of dance on the Internet are the *Mini@tures*, a series of delightful short pieces by the Mulleras Dance Company. These are choreographic 'gags' devised for the Net and playing with the elasticity of the figures. Marie-Hélène Tramus and Michel Bret have developed software that allows a virtual dancer gradually to learn the movements of a real dancer. It is presented in the form of an installation (*Dance with Me*, 2001), and visitors are invited to teach the computer-generated marionette the dance steps they would like to see it perform. In *Paradise* (2001), José Montalvo sets his dancers moving against a background of changing scenery inhabited by hybrid figures – waders and other computer-generated birds and animals with human heads that seem to have escaped from a painting by Max Ernst.

Another interactive installation was devised by two Brazilian artists, Lali Krotoszynski and Luiz Camara, for *The Dance Jukebox* (1999). The spectator can choose from a selection of video dance sequences, filmed in a jerky style, and can choose different types of music to accompany them, thus radically changing the way each

sequence is perceived. For Pina Bausch's show *Agua* (2001), the stage designer Peter Pabst used striking video projections instead of scenery. The dancers are surrounded by images that are also moving and that evoke the cities of Brazil and the Amazonian forest. Here, the encounter between the fluid forms of dance and video creates strange clashes and a kind of vertigo, with the dancers' gestures absorbed into, and diluted by, the movement of the image.

Michel Bret and Marie-Hélène Tramus, *Dance with Me*, interactive installation, 2001.

BIBLIOGRAPHY

Ascott, R, *Telematic Embrace: Visionary Theories of Art, Technology and Consciousness*, University of California Press, Berkeley, 1999.

Corsino, N and Corsino, N, *Topologies de l'instant*, Actes Sud, Arles, 2002

Herbison-Evans, D, 'Dance, Video, Notation and Computers', *Leonardo*, 21(1), 1988

Smith, A W (ed), *Dance and Technology I: Moving Toward the Future. Proceedings of the First Annual Conference*, University of Wisconsin, Madison, WI, 1992

Theatre and video

'McLuhan said that had he been a man of the theatre, he would have written a play in which the actors were the TV, the radio, the fax and the video.'
Derrick de Kerckhove

The stage has always made extensive use of machinery. Both the theatre of antiquity and the Baroque theatre excelled in the creation of mechanical devices that allowed wonders to happen on stage. Contemporary technology is merely following an ancient tradition of illusionism. The total theatre project devised by Gropius in 1927 has already been described. Today, the traditional proscenium stage is giving way to the increasingly complex use of

multiple stages and the traditional relationship between stage and auditorium has been overturned. The theatre has become a multi-purpose space that lends itself to all kinds of reconfiguration and multi-site action.

For his 'video ballet show' *Scale of 7* (1964), Jacques Polieri used giant-screen video projection for the first time in the history of the theatre. Polieri's complex theatrical experiments were based on the use of combinatorial mathematics, with the result that each member of the audience had a different view of the same production. 'One observer', he explained, 'would see an action unfold from point A to point Z while another would follow the action from B to A, having successively passed from B to C, C to D and so on all the way to Z, only to finish at A ...'. This system culminated in a production called *The 'Book' of Mallarmé* at the Salle du Rond-Point on the Champs-Élysées in 1967. The use of a giant screen, an 'eidophore' (a large-screen television projector) and electronic cameras, as well as reversing the seating positions of a section of the audience, allowed many different actions to take place simultaneously and to intertwine, with the two sections of the audience seeing different scenes.

In 1979, Wolf Vostell developed a *Media Plan* for Hans-Günther Heymes' production of *Hamlet*. The equipment (consisting of a video camera, monitors and large television screens) was fully integrated into the production. Echoing the 19th-century fondness for theatrical ghosts, dioramas and other illusionistic devices, and continuing the experiments conducted in the 1960s by Josef Svoboda (one of the first to use video monitors in his productions) in his 'Magic Lantern' theatre, today's directors often turn to new technology when designing stage sets and machinery. In any case, it is often no longer practical to build heavy, elaborate sets. These have been replaced by simple effects that transport the audience to another planet or plunge it into a highly realistic world by the use of film projections.

Virtual scenery is gradually replacing cardboard and stucco scenery, furniture and real objects.

One of the earliest pieces to use video in the theatre was *Hajj*, staged by the American theatre company Mabou Mines in 1981. Turning her back on the public, the actress Ruth Maleczech sits

Robert **Wilson**

Theatre director, designer and visual artist. Born Waco (Texas) 1941. Lives in New York.

'Television's scale is so different from theatre's. The space, time, texture, colour – everything is different... TV is about close-ups, the movement of the eye, impact.'

In 1978, Robert Wilson made *Video 50*, a film for Swiss television (ZDF) featuring 30 short sequences or micro-events: a door closing, a chair floating against a dramatic sky, a little girl running through the forest, and so on. *Stations*, made in 1982, comprises 13 episodes that tell of the strange things that happened to a boy and his family in an isolated house in the country. Wilson also used video in an installation created in collaboration with the artist Ralph Hilton (*Spaceman*, 1976–84). This was a structure made of wood and transparent plastic, visible from every side, that incorporated a video wall and could contain real people. *Deafman Glance* (1981) returned to the images developed in 1970 for a theatre piece of the same name. It contains all the elements of the earlier work: the black child, the figure in a long black dress, the ritual of murder, the slowness of the movements. All this creates a strange, deeply disturbing atmosphere. The video retains all the ghostly, dreamlike quality of the original theatre piece.

SELECTED WORKS
Videos:
– *Video 50*, 1978
– *Deafman Glance*, 1981
– *Stations*, 1982
– *The Death of Moliére*, 1994.
Installation:
– *Spaceman*, Stedelijk Museum, Amsterdam, 1976–84.

BIBLIOGRAPHY
– *Robert Wilson*, exhibition catalogue, IVAM Centro del Carme, Valencia, 1992
– Leslie-Spinks, L, *Robert Wilson: Fourteen Stations*, Munich and New York, Prestel Verlag, 2000
– Quadri, F, *Robert Wilson*, translated from Italian, Rizzoli, New York 1998

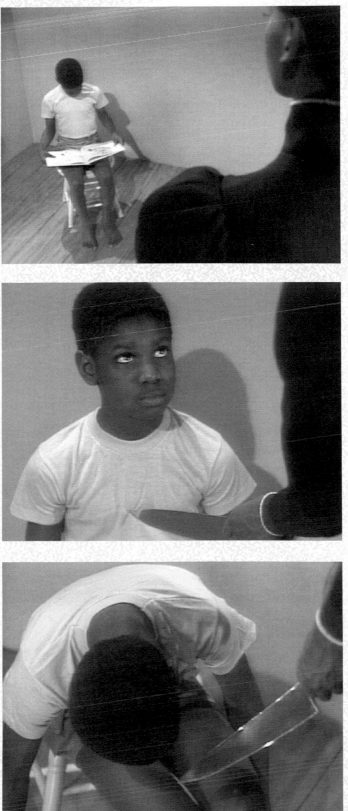

Deafman Glance, video (26:53 min, colour, sound), 1981.

down in front of a triple mirror. Video monitors flicker into life intermittently in the top, unsilvered sections of the mirrors, relaying live images of the actress talking to herself, looking at herself and putting on make-up. They also show images

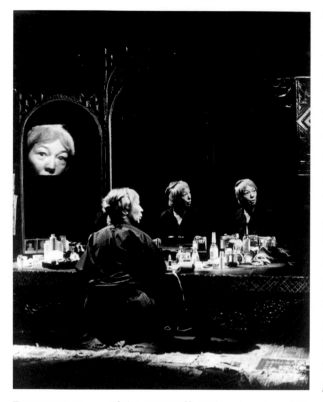

representing projections of the character's interior life – fragments from the past, memories and fantasies. This device, which uses theatrical illusion to great effect, is also a good example of the narcissism of video.

Much of the pleasure generated by these theatrical games comes from the illusion, ambiguity and sense of enchantment that they create. Some directors revel in all of this, introducing multiple misunderstandings and gleefully playing the reality

The actress Ruth Maleczech in *Hajj* (1981), written and directed by Lee Breuer and performed by the Mabou Mines theatre company.

of the actor off against images of the actor. In *Everything That Rises Must Converge* (1990), John Jesurun uses a system similar to Peter Campus's optical devices: a video circuit set up in such a way that one half of the audience sees the real actors and the other half only sees their images. The process is then reversed. Eventually a partition swivels round to reveal the whole set. In another of his pieces (*Blue Heat*, 1991), the action continues offstage ('out of shot'), the video monitor onstage showing actors who are no longer physically present.

No trickery is employed in relation to the time frame, however, as everything is live. Video thus allows the actor to be everywhere at the same time. One exception is *Slight Return* (1994), in which a simple wooden crate indicates the actor's presence/absence. Shut up inside the box, the actor is only made visible (that is, present) by cameras that film his movements and monitors that convey

them to the audience. But even here, everything is live and the physical presence of the actor is necessary even though he is not visible, or at least only visible on screen.

Peter Sellars is well-known for his use of video, and in particular for the way he uses video monitors as luminous, animated building blocks that show the action from countless different angles (*Saint Francis of Assisi* by Olivier Messiaen, 1992) like a kind of high-tech audiovisual cathedral. By making the actors wear cameras on their shoulders in his 1994 production of Shakespeare's *The Merchant of Venice*, Sellars was able to reproduce their movements on screen. The on-stage video monitors displayed a particular detail or posture. This multiplication of viewpoints allowed the audience to enjoy the nuances of an actor's performance from a number of different angles at the same time.

In *Grand Hotel of Strangers* (1993), Michel Lemieux and Victor Pilon, from Quebec, project video images onto transparent supports, exploiting changes of scale and the confrontation between 'real' and 'imaginary' characters. These images merge with one another, conveying through their superimpositions an idea of the fantasies and memories by which travellers are haunted. Robert Lepage, also from Quebec, is well-known for his multimedia productions (*Needles and Opium*, *The Seven Streams of the River Ota*, 1994). Lepage also plays with differences of scale, with real actors frequently being confronted by gigantic 'ghosts' or the duplication of their own image. In *Elsinore* (Montreal, 1996), Hamlet fights Laertes with a sword that has a camera fixed to its tip. The various episodes of the fight are shown on screens all around the stage in the form of halting, turbulent, muddled projections.

Projections of all kinds are thus becoming increasingly common in the theatre, playing a key role in productions that straddle different genres, including dance, music hall and drama. Beryl Korot and the musician Steve Reich have collaborated on a kind of video opera or musical that includes numerous video projections (*The Cave*, 1993). The set for *The Cave* takes the form of an aluminium structure or framework that accommodates the performers. Five screens are set into this structure, arranged over three levels. The images on the screens are treated musically. They appear and

disappear to the accompaniment of Reich's score, reacting to its rhythms and repetitions and contrasts of light and dark in a manner that recalls Nam June Paik's pianos of light. In another piece, based on interviews with artists such as James Turrell and Ann Hamilton (*Untitled*, 2001), Beryl Korot focuses on small details, lending a ritual, mystical dimension to the artists' movements.

Immersion in virtual worlds allows the audience to experience all sorts of 'artificial' sensations. Wearing a virtual-reality headset that creates an illusion of depth, and data gloves that allow them to experience tactile and kinaesthetic sensations (the famous force feedback), wearers plunge into virtual worlds and discover sensations that mimic those of the real world. But it is strange – exhilarating and disturbing at the same time – to feel the empty, somehow elided presence of virtual ghosts *physically*. Hence the strain of virtual theatre dreamed up by StrayLight Corp. or the system adopted by Magnus Wallin (manufactured by the computer, commercial and military research company Evans and Sutherland) that gives spectators the opportunity to 'launch themselves' into the air alongside the figures moving in all directions on the screen (*Skyline*, 2000).

One of the great advantages of video (which, unlike film, is used so often in the theatre) is without doubt its ability to relay an action live. The actor's image can thus be shown to the audience while the action is unfolding. Making figures disappear, transformations in full view of the audience, interplay between the real stage and the space of the screen – all of these present infinite possibilities. An action can start in the real world and continue in the parallel universe of the screen. Alice has well and truly climbed through the looking glass. But she can also, at any moment, return to reality, or skip between the two. The spirit of Jean-Christophe Averty and Michel Jaffrennou's artistic worlds also infuses their theatrical productions. Jaffrennou's *Electronic Video Circus* (1984) is a daring blend of all the different genres – including video art, circus, music hall and theatre.

The use of video allows space and time to become intertwined. Actors can appear on the screen either live or pre-recorded, enabling the dead to consort with the living and the absent to

invade the present. In 1993, Georges Lavaudant incorporated fragments of *Palazzo mentale* ('Mental Palace'), an older production featuring a deceased actor, into *Terra incognita*. Some of Jean-François Peyret's productions involve real-time, and therefore almost live, webcasts of fragments of the action as it unfolds in the theatre. Making shows and productions available to every corner of the globe is now a familiar, well-tried, mass-media procedure.

Technical devices and theatrical productions are thus becoming ever more impressive, and staging is often controlled entirely by computer.

As the role of technology in theatrical productions becomes more and more pronounced, a number of directors are choosing to accentuate it through the use of scenes-within-scenes and similar self-reflexive techniques. One of their favourite themes is the machine and in particular the absurd, machine-like aspects of contemporary society.

The circus show created by Roland Auzet (*The Drum Circus*) and performed at the Parc de la Villette in 2000 was a blend of different genres. This 'cyber zoo' presented virtual creatures controlled by flesh-and-blood tamers using 'ultrasound gloves'. In

Michel **Jaffrennou**

Born Angers 1944. Lives in Paris.

'What I like about the untidy mess of communications produced by the new technologies is that nothing is prescribed, nothing is complete and above all there is no pretence. Everything is wild, experimental, precarious, with no heavy history to drag around and no rigid circuits in place...'

Michel Jaffrennou's work is based on the principle of video sculpture. Television sets serve as modules that can be coupled or connected together, allowing the action to pass from one to another. Calculated in accordance with strict parameters, images (objects, characters, etc) slip or jump from one screen to the next, creating visual jokes and surprises, and involving acrobats, apparitions like those used by Georges Méliès and transformations worthy of Raymond Roussel. In 1979, Jaffrennou created the first ever 'video theatre' work (*Les Totologiques*, an 'entertainment' involving two actors and two synchronized monitors). The humorous little electronic theatre created by Jaffrennou and Patrick Bousquet draws heavily on the circus. It mocks or accentuates the limits (or edges) of the screen and exploits the effects of transparency. In *Filling Up with Feathers* (1980), a figure shown in the top monitor of a tower of four drops feathers down towards the bottom monitor, where they settle and accumulate until they reach back up to the top. *Electronic Video Circus* (1984) is an electronic acrobatics show. Here, the image no longer develops in a linear manner, but bursts forth in every direction, forming a cross, staggered rows, a pyramid, and so on. *Parade* (1986) is a puppet theatre comprising five video screens. All these works are 'shows' in the widest sense, uniting elements from various genres, including video, installation, circus and puppet theatre.

SELECTED WORKS

– *Les Totologiques*, 1979.
– *Filling Up with Feathers*, 1980.
– *Videoflashes*, 1982.
– *Electronic Video Circus*, 1984.
– *The Phenomenal Electronic Dance Band*, 1987.
– *Diguiden*, 2000.

BIBLIOGRAPHY

– http://www.mjaff.net/

Videoperetta, video show,
1989. Actor: René
Hernandez.

Filling Up with Feathers,
installation, 1980.

Machinations (2000) by Georges Aperghis, a real cast is supplemented by the Machine (a computer or large calculator) – an additional 'character' which is present on stage and is operated by an actor/stage manager. The text of the play includes numerous references to the long history of machines, from the automata of Hero of Alexandria to Alan Turing's Second World War conception of the computer as a thinking machine.

In *The Nerve Bible* (1995), a miniature camera fixed to the tip of Laurie Anderson's violin bow allowed a blown-up image of her face to be displayed on a giant screen behind her. Interactivity also plays a part in productions of this kind, many of which are halfway between installation and theatre. One example is *A Few More or a Few Less People* by the group Art Point M, presented as part of the 'Rendez-vous Électroniques' at the Centre Georges Pompidou in 2000. Audience participation, filmed and played back live, is now part of the fabric of the performing arts.

This brings us back to the performances given by Joan Jonas in the 1970s and the many artists who followed in her footsteps. We have already seen how the visual arts adopted and integrated specifically theatrical elements at a very early stage. These influences worked in both directions: the visual arts influenced the theatre and the theatre influenced the visual arts. And somewhere in the middle were installations of every conceivable kind.

BIBLIOGRAPHY

Anderson, L, *Stories from the Nerve Bible: A Retrospective 1972–1992*, Harper Perrenial, New York, 1992

Lista, G, *La Scène Moderne: Encyclopédie mondiale des arts du spectacle dans la seconde moitié du XXe Siecle*, Éditions Carré/Actes Sud, Arles, 1997

Digital photography

'With the digital image, the relationship between image
and reality has been destroyed forever. The day is
approaching when no one will be able to tell if an image
is true or false.'
Wim Wenders

Over recent years, traditional silver photography has been largely
supplanted by digital photography. Digital photography allows
photographic subjects to be hybridized, metamorphosed, and
cloned. We have entered an era in which images can be
systematically manipulated. With the digital image all sorts of
smoothing out and retouching are possible, resulting in hybrid
images of a quite different kind from the collages or
photomontages of the Surrealists or Constructivists. Using digital
recording and instantaneous transmission via computer networks,
digital photography is a malleable, plastic, fluid
medium.

Morphing

The process of gradually turning one
digital image into another by
changing their respective
parameters, allowing faces or
objects to be transformed or 'aged'.
Artists have made extensive use of
this procedure.

The American photographer Nancy Burson has been
making computer-generated photographs since 1979
(*Untitled*, 1989; *Untitled*, 1990). She is particularly
well-known for her composite portraits, which combine
the faces of celebrities (*First Beauty Composite*,
1982, is an 'average' of the faces of actresses including Grace
Kelly, Sophia Loren and Marilyn Monroe). *Evolution II* (1984) is a
synthesis of the face of a man and the face of a chimpanzee.
Using computer software, Burson has designed interactive
installations in which spectators can watch their own faces age.
This 'ageing machine' has even been used by the FBI to help it

Nancy Burson, *Untitled*,
digital photograph,
1989.

Nancy Burson, *Untitled*, digital
photograph, 1990.

trace missing children. An echo of these manipulations is to be found (this time on video) in the composite portraits created by Pierrick Sorin in 1998 (*It's Really Nice*). Spread over the 32 screens in the installation, the various composite faces stare back at the spectator with eyes that are, for example, slightly too large or slightly too bulging. There is something familiar about the deformity on display, which is achieved by simple digital distortion. The creations of some artists – such as the 'grafts', elongations or 'Cubist' distortions (*Regardez madame! L'escargot vola*, 1987) of Paul Thorel, or the cranial elongations and facial distortions of Orlan (seeking to achieve Incan, Aztec or Papuan hybridizations) – are thoroughly surrealistic. Other manipulations are more humorous: those of the Chinese artist Shi Yong, for example, who gives his countrymen and countrywomen blonde hair. The curious, cloned portraits of Keith Cottingham, including *Untitled (Triple)* (1992), are based on the repetition and juxtaposition of ambiguous, hybrid characters. These may be the same figure repeated or different, distinct inventions (it is impossible to tell). The image is becoming genetic. Victor Burgin also manipulates the images in his diptychs, triptychs and 'paintings', retouching,

Shi Yong, *Made in China*, digital photograph, 1997.

reconstructing, enlarging and juxtaposing different elements. The joins can be invisible in digital photography, which makes it somewhat disturbing, since it is actually a manufactured process far removed from traditional silver photography.

In *Spring/Summer Collection 2001*, Nicole Tran Ba Vang shows her naked models 'clothed' in scars, sporting curious skin grafts, and putting on and taking off underwear made out of skin. Digitally manipulated and carefully smoothed over, one particularly real-looking image shows a naked body wearing a second layer of skin that laces up at the back. Jeff Wall's grafting of images onto each

other gives his installations a sense of disturbing strangeness. A tree bending more than is normal, a cloud of papers scattered miraculously as if by the wind in *A Sudden Gust of Wind (after Hokusai)*, 1993 – the discrepancy with real life sometimes resides in the minutest of details. (The title refers to the Japanese artist of the Edo period.)

Nicole Tran Ba Vang, *Spring/Summer Collection 2001 – Untitled 06*, digital photograph.

This manipulation of the image is not a new phenomenon, but digital photography makes it much easier to perform transformations of this kind. It could almost be said that digital photography demands them. We are all now in a position to control, modify and distribute our own images without having to go through the traditional processing stage. Neither do these images need to be printed on traditional paper supports or in newspapers or magazines. Everyone is now in a position to master the whole process from conception (the subject can of course be virtual, with no existence prior to its creation) — to storage (on discs or hard drives) and distribution (on a video screen or on the Net, for example). More than ever before, photography merits its description as the art of the masses.

BIBLIOGRAPHY

Digital Photography, exhibition catalogue, Centre National de la Photographie, Paris, 1993

Mitchell, W J, *The Reconfigured Eye: Visual Truth in the Post-Photographic Era*, MIT Press, Cambridge, MA, 1992

Jeff Wall, exhibition catalogue, Museum of Contemporary Art (Chicago), Galerie nationale du Jeu de Paume (Paris), Whitechapel Art Gallery (London), Editions du Jeu de Paume, Paris, 1995

Wells, L (ed), *The Photography Reader*, Routledge, London, 2003

Cinema, video and computer graphics

'To use video like a cinematographer and to use cinema like a television director is to make a form of television that doesn't exist and a form of cinema that no longer exists.'
Jean–Luc Godard

The projected image has steadily grown more sophisticated through the adoption of increasingly ingenious technology. For a long time, projections used in theatrical productions consisted of fixed shots (slides) or film, until video – and later digital cinema – took over. In the 1970s, experimental cinematographers became interested in the electronic arts, which were still in their early stages. The work of Norman McLaren, a Canadian of Scottish origin (whose main area of interest was pixilation and the optical printing of images) played a pioneering role in this field, as did that of other Canadian and American artists such as Paul Sharits, Hollis Frampton and Woody Vasulka.

Because it was often based on the series principle, much early computer art focused on conveying movement. This could be 'real', as in the case of Roger Vilder's variations on coloured figures (*Colour in Motion*, 1971–5), which are in the form of a film, or 'induced', as in the case of Vera Molnar's ambling images of coloured squares (*Quadrilateral Structures*, 1986) that viewers are invited to animate or take imaginative journeys through. In order to realize their cinematic potential, however, these images needed merely to be enlarged and projected (against a curtain of water at the Festival des Arts Électroniques in Rennes in the case of Vera Molnar's work). Work of this kind comes under the category of what the philosopher Gilles Deleuze called 'image-movement' – all part of the exciting adventures in time and space first embarked on by Marey, Muybridge, Lumière and Méliès.

We have already seen that close links exist between sound and the video image. The film soundtrack also has a significant impact on the film image. Wear on the soundtrack translates into visual interference. Artists only had to tamper with the soundtrack,

Pixilation

Technique developed by Norman McLaren (*Neighbours*, 1952), used in animated films. It is based on the stop-motion (image-by-image) filming of a person's movements or the different positions of an object.

Optical printing

Procedure invented by McLaren for the creation of repeated and multiple images. His film *Pas de deux* (1968) applies this technique to the movements of two great Canadian dancers.

therefore, in order to obtain new and original visual effects. In France, Jean-Luc Godard was one of the first to become interested in lightweight video, and this undoubtedly influenced his films. The possibilities for altering, transforming and manipulating images during post-production are immense and far easier than with film. This influenced Godard's view of time and the use he made of letters and written documents. Words are shown in close-up and sometimes take the place of images or are superimposed on images. Godard's approach to time is rich and complex. Making regular use of slow motion and freeze frame, his time structure is flexible, close to how long things take in everyday life and without the ellipses and concentration of time generally used by artists. Godard takes his time, as much time as he needs. This is also true of his characters and even more so of his long, lingering shots.

Being able to see the image immediately, comment on it, criticize it and exercise permanent control over it appealed greatly to Godard. Later, he returned to the medium of video for 'scenarios' for two of his feature films: *Video Scenario for 'Slow Motion'* (1979) and *Scenario for the film 'Passion'* (1982). These are not scenarios or screenplays in the strict sense, but works in their own right that can be seen as commentaries on work in progress. They are examples of a kind of metalanguage or meta-film – as in the scene in the *'Passion'* video in which Godard appears as a shadowy silhouette, orchestrating the unfolding images like a maestro.

Peter Greenaway has often referred to the cinema of the 21st century as a 'mega-cinema' that will eventually incorporate the whole range of cutting-edge technologies, one of which is DVD. This new and powerful medium should provide an answer to the 'problem of how to combine the three different techniques of making images: the cinematographic tradition, the pictorial tradition and the language of television, which is still in its infancy'.

Due to the great visual richness of video and the opportunities it affords for collages and the accumulation of images, Peter Greenaway sees it as a tool perfectly suited to his own conception of film and the image. In particular, video seduced him with all the

Jean-Luc **Godard**

Film-maker. Born Paris 1930. Lives in Switzerland.

'Video taught me to see the cinema differently, to rethink my cinema work. Video represents a return to simpler elements. In particular, having sound and image together.'

Curious about new techniques, Godard became interested in video at a very early stage. He had thought of using it when making *The Chinese Girl* (1967), so that the protagonists could film one another with it in a 'film within a film'. He immediately saw video for what it was: a simple tool for the description and analysis of the process of communication, whose para-doxes form a distinct thread throughout Godard's work. In the wake of the events of May 1968, video represented for him a lightweight set-up that was useful for reporting and which he employed on a wide scale. Video was thus on the way to becoming a militant medium. With *France/Tour/*

Jean-Luc Godard and
Anne-Marie Miéville,
France/Tour/Detour/Two/
Children, video, 1978.

Detour/Two/Children (co-directed with Anne-Marie Miéville, 1978), a work commissioned originally for French television and shot in video, he extended the possibilities of the medium, using multiple slow-motion sequences, text insertion and direct filming without going through the preliminaries of devising a complex screenplay. This work also confronts the issue of the self-reflexiveness of the medium: in episode ten, 'Arnaud is watching a James Bond film on television. It is the afternoon. Robert Linard

talks to him about television ...'
Multiple images, division of the screen into segments, the insertion of texts – his later cinematographic works would show the influence of this experimentation in which the image refers to the image.

SELECTED VIDEO WORKS

– *France/Tour/Detour/Two/Children*, 1978.
– *The Power of Words*, adapted from Edgar Allan Poe's short story of the same name, 1988.
– *(Hi)stories of Cinema*, 1989.

BIBLIOGRAPHY

– Bellour, R (ed) *Jean-Luc Godard: Son + Image 1974–1991*, MoMA, New York, 1992
– Godard, J-L, *Godard on Godard*, translated and edited by Tom Milne, Da Capo Press, New York, 1998

Six Times Two/On and Beneath Communication

Jean-Luc Godard and Anne-Marie Miéville, video, 1976.

Jean-Luc Godard used his multimedia production company S image, based in Grenoble, to make h first few video series. These included ix Times Two, a 'magazine' or 'collage' of otage dealing with the process of communication. It consists of a series of 'interviews' – with René Thom on the noti of 'catastrophe with a small fa er on the subject of milk production, with Anne-Marie Miéville, who launches into a long monologue, and so on.

'*Six Times Two* tends to be remembered only in fragments. What was the overall plan of the work?' 'There wasn't one. The INA (the French national radio and television archives) had a commission from FR3 for twelve (six times two) films and asked me if I could make one in two months. I replied that it was impossible to make one hour-long film in two months but easy to make twelve. This is because to make an hour of interview takes an hou but to make a more traditional film lasting an hour about someone takes much longer. We presented them with a scheme and they okayed it.' (Jean-Luc Godard interviewed by Alain Bergala)

advantages it offers in terms of post-production, editing and the creation of images. The idea of a film catalogue, of a collection of images that one could flick through indefinitely, led directly – according to Greenaway – to the CD-ROM, to the archiving of a collection of data. *Death in the Seine* (1989) was inspired by research carried out by the English historian Richard Cobb into the records relating to the corpses fished out of the Seine during the revolutionary period in France between 1795 and 1801.

Atom Egoyan's use of video in the development of plot and film structure is well-known. He sees video as a tool that gives film a distinctive, freer character – *The Calendar* (1993), a film about Armenia that includes many sequences filmed in video, is a case in point. Television, in its everyday use, can also seem like a kind of personal film projection. Stan Douglas examines this private dimension in his installation *Evening* (1994). Three large video screens simultaneously play back the daily news as broadcast by three different channels. The sound system is set up so that visitors can either hear the three speakers simultaneously or else just the one corresponding to the screen in front of which they are standing.

Stan Douglas, *Evening*, video installation, 1994.

Douglas Gordon has also made an important contribution to introducing cinema into the visual arts. His composite installations

frequently refer to the 'memory of cinema', incorporating references to the great films of the past (*Words and Pictures* [I & II], 1996) or using slow motion to deconstruct and dilute (one image per second instead of the usual 24) the whole of Alfred Hitchcock's *Psycho*, which now lasts 24 hours (*24 Hour Psycho*, 1993)

Mass-market cinema, with its love of special effects, first accustomed us to virtual sets and virtual worlds (Steven Spielberg's *Jurassic Park*, 1993) in which flesh-and-blood actors inhabit artificial landscapes. A breakthrough has now been achieved with the creation of computer-generated actors able to operate in real environments.

Peter **Greenaway**,
Death in the Seine

Video documentary, 1989

'Questions regarding text and the image are endemic to the English culture, amd they are certainly my big concerns, as well.'

Between 1795 and 1801, 306 corpses were pulled out of the River Seine. An examination of the relevant historical records forms the basis of Peter Greenaway's reconstruction of events. He depicts in minute detail the examination of the drowned bodies undertaken by two employees of the morgue. Using the bodies of live actors (whose breathing can occasionally be seen) and archive documents as source material, Greenaway describes every little detail of the clothes, marks and scars of the various corpses. Editing plays an important role here, the film having been shot in black and white and coloured afterwards. The injection of patches or zones of carefully chosen colour gives the whole a strange appearance. Transparency and superimposition effects are used to add descriptive texts on top of what is already being described. The director plays with frames and with inserting images in the middle of certain frames. What interests Greenaway is the combination and blending of the properties of the three different languages of cinema, painting and video.

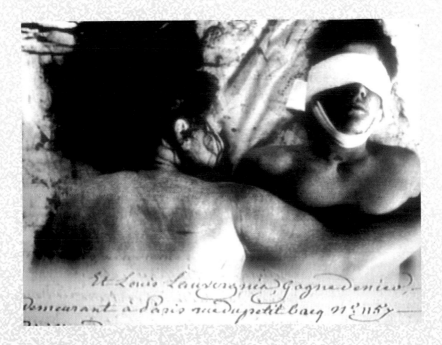

Virtual architecture

'Architects can now plan virtual spaces in the real space of their buildings... Tomorrow's architecture will include virtual alcoves.'
Paul Virilio

Computer graphics were quickly taken up by architects and now play an important role in the design and realization of architectural projects. Three-dimensional visualization – the ability to navigate through a building's different spaces – is at the heart of architects' love affair with this technology. But the role of computer graphics in architecture is not limited to the presentation of designs. The architectural forms themselves have been profoundly transformed, liberated even, by the enormous calculational potential that now exists. One can immediately see how Frank Gehry's baroque and visionary architecture (for example, the Guggenheim Museum in Bilbao, 1993–7) could result from the use of digital technology. When designing the *Experience Music Project* building in Seattle (1995–2000), he introduced images of guitars into the computer program, subjecting them to a morphing process that made their forms almost unrecognizable. The resulting forms were then translated into aluminium and steel, the ample curves and scrolls shaping the interior and exterior spaces.

Computer software today allows fluid designs to be developed that are far removed from the rigid forms that have dominated architecture for thousands of years. This is the direction taken by certain exponents of Anglo-American 'trans-architecture', such as Neil Spiller, who has been developing highly experimental projects since 1995 (*Sceptic Design Gallery, Heavy Metal Cathedral*, etc), or extremely daring architects such as Marcos Novak (Texas), a renowned specialist in liquid architecture and all kinds of

Dan Graham, *Video Projection Outside Home*, 1978. Architectural model.

hybridizations. The concept of 'morphogenesis' has also made its mark in the field of architecture. This uses software that allows forms to generate themselves. Developments such as these have led to architectural shapes that would have been unthinkable a few decades ago.

Other architects, such as Winy Maas (of the agency MVRDV), use information technology to design entire future cities. *Metacity/ Datatown* is a city designed to accommodate 241 million inhabitants. All its structures and infrastructures are determined by information technology. The project even predicts what the city will look like in its future ruined state and shows the contours of

Asymptote,
*Guggenheim
Virtual Museum*,
1999.

the mountains that will replace the buildings in a million years. Museums, in addition to setting up Internet sites that present and duplicate the institutions in their existing forms, are also moving towards purely virtual sites – museums located exclusively on the Net that can only be visited virtually. The Guggenheim Museum in New York asked two architects (Asymptote) to design the 'first

virtual museum of the 21st century'. This project is based on the idea of different virtual-space modules accessible by Internet alone. The main function of the modules would be to facilitate real-time exchanges with the world's other Guggenheim museums. The structures of this virtual museum are three-dimensional, mobile and adaptable to different categories of visitor (*Guggenheim Virtual Museum*, 1999).

As can be seen, the possibilities are extraordinary. Virtuality allows ever remoter spaces to become interconnected. Every real building in the future could contain as many virtual spaces or bubbles as are required. This would involve an amazing dilation of real space, which could be extended, expanded and 'haunted' by virtual spaces.

BIBLIOGRAPHY

Carpo, M, 'Post-hype digital architecture: from irrational exuberance to irrational despondency', in *Grey Room*, 1 February 2004, vol 1, iss. 14, pp. 102-115

Grosz, E, *Architecture from the Outside: Essays on Virtual and Real Space*, MIT Press, Cambridge, MA, 2003

Morgan, Conway L, *Virtual Architecture*, Batsford, London, 1995

Sound art

'From now on, we can no longer make a clear-cut distinction between the visual and the acoustic. The computer is there to guide us towards a total, all-encompassing form of perception and synthetic creation that quite clearly reflects the present state of human creativity and, above all, its future state.'
Nicolas Schöffer

It is not our aim here to study the relationship between music and high technology, which is an immense field in its own right. The visual arts, however, expanded their scope considerably over the course of the 20th century and embraced a number of new areas, including sound – we only have to think of Nicolas Schöffer and his luminous kinetic sculptures, which took on a cybernetic, acoustic dimension in the 1970s. The way in which new technology has affected the use of sound in installations and performances is

Atsuyoshi **Hikida** (Science Club), *Luminescence*

Light and sound installation, 1996.

'In this work, light is used like a kind of medium. It reacts like blood.'

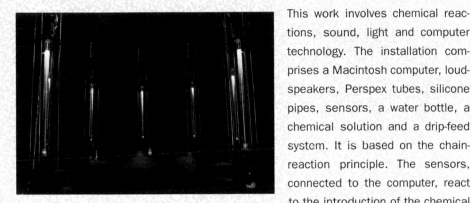

This work involves chemical reactions, sound, light and computer technology. The installation comprises a Macintosh computer, loudspeakers, Perspex tubes, silicone pipes, sensors, a water bottle, a chemical solution and a drip-feed system. It is based on the chain-reaction principle. The sensors, connected to the computer, react to the introduction of the chemical solution, which produces a luminescent effect that is immediately transposed and linked to a sound. A single drop of the solution is enough to obtain a luminescent effect that is immediately translated into sound data. After the reaction, the solution runs out of the cylinder and is collected in a container at the bottom of each tube. The luminous effect is never the same. The sound is synthesized from the signal sent back by the sensors. The sound of bells is used as the sound source. There are 21 different transformations of the sound for each sensor. The sound changes with each modification of the rate of flow of the fluid and with each variation of light. The installation functions like the beating of the human heart, which is never absolutely regular and differs from individual to individual.

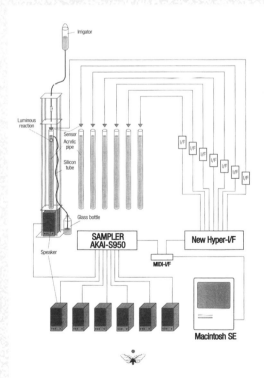

Diagram of the installation.

therefore worthy of some consideration. Most of the works described in this chapter involve an acoustic dimension that contributes to the sense of immersion that the artists are trying to achieve. Bill Viola's *Stations* (1994), for example, is an installation consisting of five cloth screens twinned with five slabs of black granite (laid flat on the floor). These polished granite slabs reflect the image of bodies falling through the air as projected on the screens. The installation also incorporates five localized soundtracks, each playing underwater sounds.

We have already seen that Nam June Paik integrated sound into some of his performances and installations, such as the event that was transmitted from 13 different countries and involved 13 different harpsichords. Other artists, such as Ziembinski, incorporate infrared sensors into their work; these capture movement and translate it into sound. Atau Tanaka operates a synthesizer using the nerve impulses in his muscles. Edwin van der Heide gives musical performances in an empty space with no instrument other than data gloves with sensors that allow him to control ultrasound transcoders. Using the telepresence system, Tanaka and Van der Heide have given a joint, live concert from two separate, remote locations. They were together only in the sense that they were united by video. Angela Bulloch's sound pieces (*Crowd Sound Piece*, 1990; *Yes Sound Chair*, 1991) are based on interactivity. Visitors are invited, for example, to walk over a carpet equipped with sensors, immediately triggering an outburst of thunderous applause.

We have already described Laurie Anderson's musical performances. In 1996, Tod Machover, a composer working at the MIT Media Lab, presented an experimental interactive opera called *Brain Opera* at the Lincoln Center in New York. Only partially written, the opera was completed by Internet users.

In 2001, at the Ars Electronica Festival in Linz (Austria), the composer Golan Levin devised a large scale concert performance using his audience's own mobile phones (*Telesymphony*). Using custom software, as many as 60 phones were dialled simultaneously, producing carefully choreographed melodic effects. The Japanese artist Haruki Nishijima gives his performers butterfly nets and sends them off to chase 'electronic insects' (*Remain in*

Light, 2001). These insects are actually sound frequencies translated into a swarm of multicoloured lights projected on a screen.

As in the field of video games, the border here between entertainment and art is a fluid one. We have seen a great many poetic or eccentric ideas on the Internet over recent years, among them the 'sound toys' presented on the Soundtoys website. The works on this site call upon different areas of expertise – those of artists, writers, designers, musicians, etc. The basic idea is to examine the relationship between sound, image and text. Internet users can thus explore the acoustic life of the ocean depths (Neal Cody and Ben Lunt, *Aquacoustica*, 2002), play with coloured blocks that produce sounds as they knock into each other (Peter Luining, *Traber 073*, 2001) or navigate through the normally inaudible, low-frequency, ambient-sound environment of New York City (Hidekazu Minami, *Infrasonic Soundscape*, 2001).

BIBLIOGRAPHY

Sonic Boom: The Art of Sound, exhibition catalogue, Hayward Gallery, London, 2000

Poole, S, 'Prick Up Your Ears', *The Guardian*, 17 September 2001

The visual arts and museography

'Access is becoming a conceptual tool for rethinking our world-view as well as our economic view, making it the single most powerful metaphor of the coming age.'
Jeremy Rifkin

Jeffrey Shaw's *Virtual Museum* allows visitors to move from room to room without leaving their armchairs. Designed in 1991, this installation comprises an armchair (equipped with levers) positioned in front of a television set and mounted on a revolving platform.

Seated in the armchair, visitors to this new kind of museum find themselves facing (on the screen) a large 'room' containing giant letters. Visitors find their way around the virtual museum by moving their heads forwards or backwards. When it was presented at La Villette in Paris, the installation was set up in a room with

Jeffrey **Shaw**

Born Melbourne 1944. Lives in Amsterdam.

'Virtual Reality technologies allow a heightened degree of viewer 'immersion' in... a virtual image space – they can simulate the sensual coordinates of the real world in a new arena of fictional visualization.'

Jeffrey Shaw started out working on large-scale multimedia shows using a

wide range of techniques, from pyrotechnics to lasers and multiple-screen projections. His fascination with the problems of perception and the complex questions posed by the replacement or mixing of an artificial environment with a natural one led him to create a large number of virtual installations.

The Legible City, interactive installation and digital images, 1989–91.

The Legible City (Manhattan, Amsterdam, Karlsruhe, 1989–91) is an interactive installation consisting of a bicycle and digital images. As they pedal and turn the handlebars of the bike, visitors travel through the maze of a virtual city, whose buildings – shown on the screen opposite – take the form of giant letters. Moving, three-dimensional, coloured words and phrases relate to the history of each city.

Other installations created by Jeffrey Shaw include the *EVE* (*Extended Virtual Environment*, 1993), a new form of visualization environment that is both immersive and interactive. Entering an inflatable semi-spherical structure, the visitor, wearing a helmet, controls the movement of images projected by a centrally positioned robot onto the inside of the structure.

SELECTED INTERACTIVE INSTALLATIONS
– *Invention of the World*, 1986.
– *The Legible City*, 1989–91.
– *The Virtual Museum*, 1991.

BIBLIOGRAPHY
– Duguet, A M, Klotz, H and Weibel, P (eds), *Jeffrey Shaw: a User's Manual, from Expanded Cinema to Virtual Reality*, ZKM Cantz, Ostfildern, 1997

four coloured cubes (red, green, blue, yellow) in the corners. On the screen, visitors were presented with a computer-generated replica of the real room in which they were sitting. By swivelling the chair, visitors also set in motion the platform on which it was mounted. At the same time, the screen displayed a moving panoramic view that turned like the platform. Four galleries or exhibition rooms (corresponding to the four cubes in the real room) floated in the corners of the virtual room. Users could pass through their walls and visit the 'exhibitions' on the other side. This *Virtual Museum* also illustrates how the dematerialization of the artwork creates a new kind of relationship with the work, leading to a modification of art itself. Most importantly, it is the presentation of the work and the way in which viewers move around it that are changing, with virtual museums and galleries establishing a new kind of relationship between art and the viewer. Today, every art gallery and museum has a digital double. Interactive terminals by the entrance or inside the museum offer a sort of preliminary tour. Other kinds of museums and cultural institutions also have their own websites. Our relationship with art – whether we are talking about the digital reproduction of paintings and ancient works of art or, at the opposite extreme, 'immaterial' works designed and created specifically for the Net – has thus been largely 'dematerialized'.

In 1997, Benjamin Britton put forward plans for an interactive virtual-reality installation that would reproduce the Lascaux caves in the Dordogne and allow 'visitors' to navigate their way around them. Visiting the Tate Gallery or the Guggenheim Museum on the web is a radically different experience from visiting them in person. Our apprehension of a work of art changes completely. We are now dealing with an image rather than a real work – an image that we are invited to explore in the minutest detail and about which we are given a lot of information.

The detailed nature of these commentaries means that we know everything there is to know about the work, the artist and the context in which the painting (or sculpture) was created. But can we really say we have been in contact with the work that was painted or sculpted by the artist? More than ever before, we live in an age of pre-programmed interpretations and guided tours that,

although often faultless, are pre-packaged and pre-digested. A real visit is often coupled with a second, virtual visit. We have entered an age in which we duplicate and repeat our social procedures. In 1991, Antoni Muntadas came up with the expression 'museum-town' to describe the city of today – a city that has taken on the appearance of an enormous, open-air museum. The borders between art and the city, reality and fiction, now allow a two-way traffic. But unlike what was happening in the 1970s, when there was a desire for art to be largely influenced by real life, we are now seeing the exact reverse of this: 'real' and previously 'natural' life is being increasingly taken over and replaced by the artificial. Complete, illustrated, detailed websites allow us to 'visit' the permanent collections and temporary exhibitions of most of the world's major museums without having to travel to the ends of the earth.

In parallel with these virtual trips through the websites of museums and galleries, a number of art organizations are trying to develop other kinds of projects using the new technologies. The New York gallery The Project, for example, is offering people the chance to reconfigure an artwork of their choice on computer. Then, once the colours have been chosen (from a very extensive palette), the work is simply printed out. Reminiscent of commercial photographic or video portraiture, it could be seen as 'art in kit form'.

Artists have also adopted these new techniques. In 2001, Pierrick Sorin made a video documentary about a group of fictional artists. With complete seriousness, the video shows these imaginary artists putting forward their ideas for a monumental artistic project (*Nantes, Artists' Projects*). Parodying the commonly held view of the gallery as a burial ground for living art, and acting as the organizer of exhibitions in an imaginary museum of an altogether different kind, Kazuhiko Hachiya created an Internet work called *Electronic Cemetery* (1999–2002). Visitors to the site can create their own obituaries for publication on the site after their death. As the artist explains, in future people will have two graves, 'one for the body and one for the mind'.

CD-ROMS

Dictionnaire multimédia de l'art moderne et contemporain, Hazan/Réunion des musées nationaux, 1996.

SELECTED WEBSITES

The Hermitage (www.hermitagemuseum.org).

The Guggenheim, New York and Bilbao (www.guggenheim.org).

MOMA (www.moma.org).

White Cube Gallery (www.whitecube.com).

Tate Online (www.tate.org.uk)

The National Gallery (www.nationalgallery.org.uk)

'The new technologies uproot things. Does this also mean they will make us free...?'
Jean-François Lyotard

The above question highlights two main issues: on the one hand, the incredible physical, spatial, temporal and mental liberation brought about by new technology and, on the other hand, the all too understandable anxieties to which these changes (which are also social, cultural and economic) give rise. There is a whole series of crucial questions here that need to be addressed.

As we have seen, developments in video art have led to a radical renewal of the visual arts over recent years – indeed over decades, since the foundations for this renewal were laid in the 1960s. It is only today, however – thanks to the recent vogue for video installations and their inclusion in art festivals such as the Basel Art Fair, the Documenta, the FIAC and the Venice Biennale – that we have been able to assess the impact of this technology, whose commercial development dates back to the post-war period. Computer art, which has its origins in the late 1950s, took longer to become established. It was mainly as a result of its use in installations that digital art made its mark, in particular in recent interactive and virtual-reality applications.

There has been a large increase in the number of experiments aimed at integrating technological art into the city. A particularly successful example of this type of work was the Chaos Computer Club's inventive use of one of the façades of the Bibliothèque Nationale de France (on the banks of the Seine) during an all-night event in October 2002. The hackers of the Chaos Computer Club transformed the glass wall of the national library into an enormous screen. Lit from the inside, each of its windows represented an individual 'pixel' that could be given a particular value of brightness. Computer-controlled figures, shapes and lighting effects appeared and disappeared on the giant screen of the façade. Moreover, by dialling a number on their mobile phones, members of the audience could connect with the installation and transform the façade into an interactive game.

It should be remembered, however, that these changes in art have taken place within the context of a far greater transformation: the globalization of civilization. Communication is no longer organized around a central axis from which all information is distributed there is no central axis any more and societies can no longer be thought of as having a tree-like structure – but according to a system of continually operating networks with multiple connections. The term *rhizome* was coined by the French philosopher Gilles Deleuze to describe this system and it is currently more applicable than ever. This structure is repeated ad infinitum, expanding like a network of blood vessels or a gigantic spider's web.

The increasingly fine mesh of this network is also of decisive importance. Previously, these new technologies were the privilege of the few. Artists had access to them only via universities and research labs. Today they are within the reach of large numbers of people (admittedly in their simplest, most economical forms) and digital technology is finding its way into more and more homes.

We therefore need to take into account the two phenomena that form the background to the current transformation of civilization:

– globalization (and its corollary, the 'shrinking' of the planet);

– an alteration in the relationship between space and time (as a result of the considerable acceleration in the transmission of information).

Today, artists have a wide range of techniques at their disposal, some of them extremely old. These older techniques should not be forgotten, as they constitute an huge reservoir on which artists still draw. The other techniques (which we have attempted to analyse in this book) are based on more recent scientific and technological developments – video, computer-generated images, holograms, interactive installations, biogenetics, and so forth.

Technologies have always had an impact on the development of the various arts and have always had a profound effect on the societies that promote them. In the context of today's technology, a number of changes can be observed. These changes represent certain tendencies of varying importance that are currently taking place, but they do not, by themselves, affect all the art that is being created.

Rhizome

An underground stem with a highly developed system of shoots. The term has been used by Gilles Deleuze and Félix Guattari to describe the 'network' structure of today's society: 'The rhizome operates by variation, expansion, conquest, capture, offshoots... the rhizome pertains to a map that must be produced, constructed, a map that is always detachable, connectable, reversible, modifiable and has multiple entranceways and exits...'

(*A Thousand Plateaus*, 1980)

A change in our relationship with materials

'The key underlying common element now is not appearance, it is use. This is what is defining value. And the key currency of the interchange of this value is the image.'
Bill Viola

What, then, are these changes that have taken place both in the process of artistic creation and in our relationship with the artwork? The first change concerns our relationship with materials. Artworks have become lighter. They are no longer dependent on 'heavy' supports such as wood, marble, stretchers and frames (for paintings), and so on. Increasingly, the disembodied image of the new media – fluid, immaterial and weightless – is its own support.

Installations fix spectators at the very heart of the image. Visitors are physically and sensorily immersed in them, like the body of Pipilotti Rist floating in lava (*Selfless in the Bath of Lava*, 1994).

Immaterial

Having lost much of its material substance and weight. Characteristic of virtual worlds, which appear to be transparent and to float.

Technical constraints play just as big a role as before. Indeed, it could even be claimed that constraints are becoming greater as the networks and the technical equipment used become more and more sophisticated. Indeed, nothing is more materially constraining than the new kind of installation in which the spectator – wearing a costume, a virtual-reality headset and data gloves – is immersed in an environment bristling with computers, sensors and optical fibres. In addition to these technical constraints, there are also the economic constraints that come with advanced technology: the high cost of the equipment, its maintenance and the ongoing risk (familiar to many organizers of multimedia exhibitions) of system failure.

One particular aspect of this new relationship with materials is the modification of our relationship with space and time. We have already looked at the phenomenon of telepresence with reference to the way Laurie Anderson used it in her installation *Dal Vivo* ('From Life'; Milan, 1998). The ubiquity made possible by telepresence and the disturbing sight of the ghostly yet 'real' figure who can be 'in two places at the same time' highlight its potency. We have also seen changes in the way works are presented, with virtual museums and galleries offering the viewer a completely new way of looking at art. This art is dematerialized as well, whether we are looking at the digital reproduction of older paintings or sculptures, or 'immaterial' works designed and created specifically for the Internet. A virtual visit to the Musée d'Orsay (or any other major museum) is completely unlike a visit to the 'real' museum. The way we approach the works is more abstract, more conceptual. And, most remarkable of all, the works themselves are transformed. They lose their physical dimension, appearing increasingly like clones or doubles of themselves, or immaterial ectoplasm, or hesitant ghosts on the threshold of the visible, beckoning us into strange worlds.

A change in artists' relationships with the artwork and the public

' In terms of rhizome or multiplicity, puppet strings...
do not run back to the assumed will of an artist or
puppeteer, but to the multiplicity of nerve fibres that
form, in their turn, another puppet following other
dimensions connected to the first.'
Gilles Deleuze and Félix Guattari

The network artist Roy Ascott recently floated the idea of 'shared'
creation, where the work becomes a collectively owned product.
This new idea applies in particular to the field of interactivity.
Interactive works are conceived openly and their completion
requires the presence and intervention of the spectator, which

changes things considerably. It is even possible for works of art to be devised and created anonymously, such as the images on the *Poietic Generator* website. This project, launched by Olivier Auber in 1986, involves the collective construction of an ever-changing, moving mosaic by people located at opposite ends of the earth. The complex intersecting of nerve fibres, together with the fact that each of them depends on another intersection of complex lines, brings home the truly staggering dimensions of each network. What could previously be called the 'authorship' of a work is infinitely diluted and becomes lost in the network's capillary system of fibres and threads.

Ubiquity

The ability to be in several places at the same time. Telepresence makes possible a sort of 'delayed-action' or 'remote' presence, which duplicates (and re-duplicates) a material body.

Increasingly, there is a participatory relationship between the viewer and the artwork. The dilution of the work across the networks, as well as the sudden appearance and disappearance of works specifically designed to be disseminated on the Net, recalls Nietzsche's fable (in *Philosophy and Truth*) about a far-off planet. The inhabitants of the planet are intelligent animals, and one day they invent knowledge. No sooner does the star of knowledge appear, however, than it disappears again. This fable illustrates the fragility of human affairs, and could be specifically referring to today's world.

Andy Warhol's ideas led him to promise that everyone would be famous for fifteen minutes. What a luxury that would be, in comparison with the ephemeral existence of artworks that literally 'pass by', circulating on the Net and then disappearing.

The phenomenon of dilution and the trend towards anonymity or collectivization meet, naturally enough, with some very strong resistance. This resistance comes from self-important artists, from the art market – which needs the artist's name in order to validate the work – and from social conservatism based on several centuries of an artistic 'star system'. And at the present time no one knows which tendency will prevail.

A change in our relationship with reality

'Reality can no longer be precisely determined. Place,
time and matter have been liberated to an extent that
could not have predicted a short time ago.'
Paul Valéry, 'Reflections on the World Today'

In our changing relationship with reality, too, the system of telepresence plays a significant role. When contemplating Laurie Anderson's installation *Dal Vivo* ('From Life'), are we in the presence of reality or a 'clone'? Where is reality? Where is the real Santino – in the all too real-seeming image, or locked up in the enclosed space of the prison, which we are informed is 'real'? We might ask the following question: given what we see, does Santino (the prisoner) still need to escape from jail?

The simultaneously open and closed environments that visitors are invited to enter produce an experience of total immersion. All the visitor's senses are called into play; the visitor is surrounded by, immersed in and saturated with images and stimuli. We are no longer dealing with a picture or a statue, to be perceived as an object exterior to ourselves. These new installations, more than ever before, resemble the dream process described by Freud and for this reason are perceived and experienced as if they were real. Everything is dramatized. We even seem to inhabit these imaginary worlds, to the extent that we experience the same vivid sensations that we thought belonged only to the real world of perceptions.

Shi Yong, *Made in China*, digital photograph, 1997.

The idea of a virtual 'landscape' or environment is thus becoming increasingly common. Every installation is presented to visitors today in the form of an artificial landscape. A work such as *The Nap* (1995), a homage by Antoni Muntadas to the Dutch film-maker Joris Ivens, can be seen as a metaphor for the collective dream which today's artists make available to the public.

Antoni Muntadas,
The Board Room,
video installation,
1987. Detail.

At the centre of the installation is an armchair draped in a sheet. A montage of old films is projected onto the cloth covering the chair and the screens positioned around it. Distorted by the contours of the chair and the folds of the sheet, a succession of images of the industrial world (machines, factories, workers, etc) can be seen, like fragments of an old dream or memory. On either side of the installation other images can be seen: not of the industrial world but of those who hold power, shuffling and fiddling the cards in the background. There is a current tendency for installations – often expanded to fit the dimensions of the city – to radically model and remodel the urban environment.

The expansion and dilution of art

'Art is life and life is art.'
Wolf Vostell

Long ago and in a completely different context, Karl Marx set out his vision of a classless society in which professional artists would no longer exist as all men would be artists. More recently, the artist Joseph Beuys also emphasized the creative capacities of each individual and insisted on the need to see art in wider terms and as a form of 'social sculpture'. The particular way in which art is expanding and becoming diluted at present would probably please neither Marx nor Beuys, but it is nevertheless remarkable that they both foresaw this possibility. New types of artists are currently emerging with technical or scientific backgrounds and there is a blurring of boundaries between disciplines and professions. Many technicians have thus found themselves caught up in art.

Now that the borders have come down and art has expanded to include all areas of non-art (areas that could not previously have been considered as falling within the aesthetic sphere), art no longer exists as a separate entity. Today, everything can be included in the category of art and, as a corollary of this, there

Antoni Muntadas,
The Nap, video
installation, 1995

has been much talk of the global aestheticization of civilization. Duchamp played an important role in this decentralization of art and showed that the will of the artist (and today the interplay of the media and our globalized society) was enough to transform any object or act into a work of art. We only have to think of the aura that has grown up recently around exhibition curators and collectors. Indeed, the latter seem poised to become the new 'artists', capable of raising or lowering the stock of individual works. Interactivity today takes the form of a vast social game, a network within which everyone acts, participates, operates and communicates. We have to wonder, however, about the nature of this interactivity, which is often rather hollow and devoid of meaning (something which is itself becoming a less and less important factor).

Interactivity and use of the Net call for creativity on the part of each and every individual, and this hints at the form of universal art that could be looming on the horizon. We are certainly not about to witness the disappearance of the so-called professional arts, but the old, attractive dream of art by all and for all is nevertheless raising its head once more. The increase in leisure time and the expansion of spare-time pursuits only accentuate this tendency. Will this result in an activity or form of expression that resembles what we know as 'art'? We cannot know. In the near future we may well have to revise our definition of what is and is not art.

Art as game

'If art didn't amuse me, I would stop playing with it.'
Michel Jaffrennou

Artists often treat new technology like the firecrackers and rockets of an enormous firework display. Their relationship with technology is playful, festive and often mocking. The new media have revived the party spirit, and the party is an electronic one. Anticipating the future wonders of new technology, Pierrick Sorin recently had the idea that people might be able to make a rainbow appear in the sky simply by exchanging information (only good news, of course) on their mobile phones.

Others have a more serious belief in the inherent virtue of technology and in the advantage of combining different techniques. An enormous range of techniques have been passed down over the years and these are now available to today's artists. It is often the combination of improvised solutions with cutting-edge technology that gives contemporary artworks their high-tech and yet somewhat quirky flavour. We have also entered an era of prostheses, in which the living and the artificial are increasingly closely intertwined. Some might see this as alarming, but many artists approach it in a playful spirit.

Nam June Paik's relationship with technology has always been driven by a sense of wonder and play. For him, new technologies are tools that allow him to play with the world. His familiarity with technical equipment led him to surround himself, in an ironic fashion, with an family of televisual robots (father, mother, aunt, uncle, children, etc) which he presented in a variety of different forms from 1986 onwards. In doing so, he was reviving a fantasy from early on in his career, when he constructed his famous remote-controlled *Robot K-456*, constructed largely of wire. During an exhibition at the Whitney Museum of American Art in 1982, Paik took the robot out onto the street. It took a few steps down Madison Avenue before being knocked over by a car at a crossroads. The accident had been pre-planned by Paik, who claimed it was the kind of accident one would have to come to terms with in the 21st century. Artworks started to become more and more participatory and playful. Today, it could even be said

that the game is becoming a paradigm of the artwork, the artist's role being to devise the rules by which spectators and Internet users can play. The proliferation of interactive installations is contributing to the acceptance of this concept of art as play. Increasingly, visitors to virtual environments and installations ask themselves: How does this work? What button do I press? Which lever do I pull? All in order to be delighted by the effects produced. At the centre of these playful installations is the image, and it is with the image that viewers are required to interact. This image is experienced as a kind of material: plastic, malleable, fluid, tactile. There is a tendency for these images to become familiar – which goes hand in hand, of course, with the loss of the sacred, of the aura that once characterized art, a loss greatly regretted by Walter Benjamin. The resulting art is increasingly *domestic* (in other words it can be enjoyed at home, in the private sphere as well as in a public space). It is also *domesticated*, since control of the different parameters of the image seems to be one of its essential components.

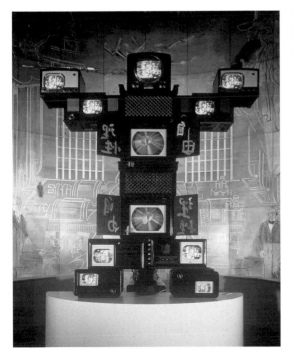

Nam June Paik,
Voltaire, video
sculpture, 1989.

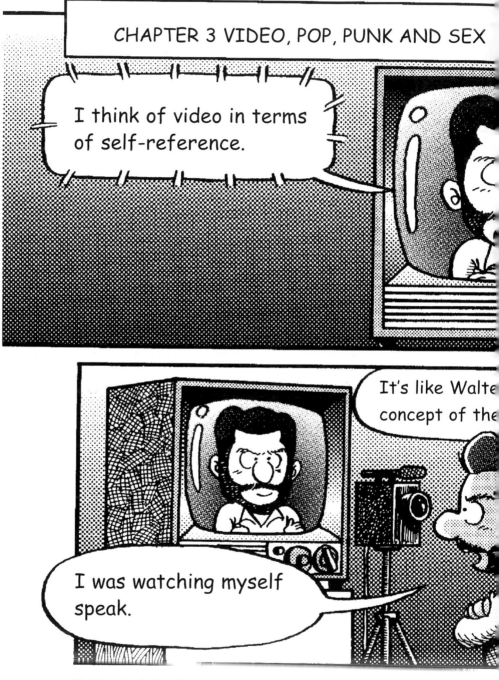

The Manga Dan Graham Story,
written by Fumihiro Nonomura,
illustrated by Ken Tanimoto.

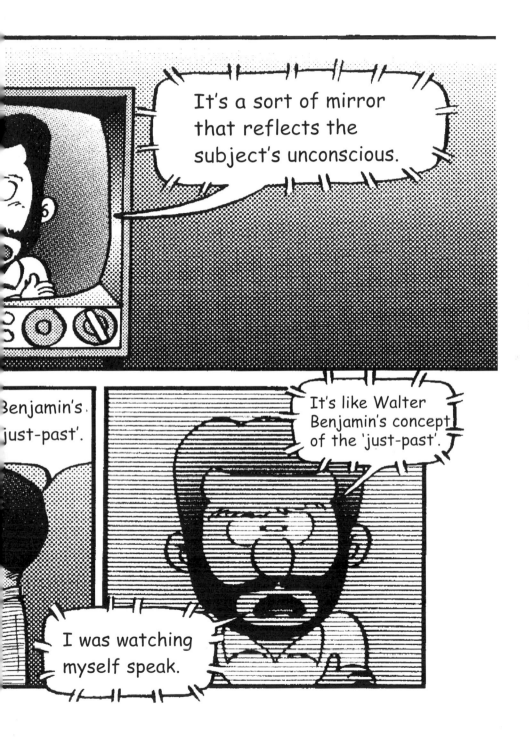

Conclusion

'Technology does constantly provoke us to ask what is real. Is television real? Some people say no, yet it has more effect on people today than the natural landscape does... We already are, and always have been, in an imaginary landscape of perception.'
Bill Viola

What, then, of the relationship between art and technology and art and society in the early years of the new millennium? Video has already played an important role in the last few decades of the 20th century in extending the notion of art, particularly through what we now refer to as the installation, but also through performance art – the screen providing artists and viewers with a time-delay mirror in which to observe themselves and society.

Ordered, controlled, corseted – the digital image inherited all the properties of academicism long ago. It is only by combining with other forms of expression, disrupting them or providing them with a framework, that it has become interesting. The development of interactive installations and virtual environments has also made a significant contribution to the revival of the visual arts. The participation of the viewer is increasingly called into play in works that stimulate all the senses. Artworks now resemble constantly evolving collective rituals, and art is becoming more theatrical and media-oriented. It is having an increasingly conspicuous effect on the world around us, invading the environment through events and interactive installations in our cities.

The 'centrifugal' power of images – making them expand, spread and fill the whole of an environment like a stage set – is wonderfully illustrated by an installation with the same title (*Centrifuge*, 2002) by the Japanese artist Kazuhiko Hachiya. This installation is based on a large vertical ring to which a number of small cameras have been fixed. The cameras capture the images of visitors who pass through the circle to reach the stage at the heart of the installation. These images are immediately displayed around the perimeter of the installation.

Many claims have been made for the harmony of certain

mathematical curves and for the aesthetic potential of pure technical or scientific functionality. Occasionally, 'artworks' are developed by technicians with a purely practical goal in mind and are only acclaimed for their aesthetic qualities after the event. The history of technology is full of such phenomena. It is the same today with certain types of images, such as fractals. Technicians thus become unwitting artists and sometimes end up being drawn into the business of creating art. The world is becoming aestheticized. Art is spreading in society, at the same time being diluted by a sort of capillary action which is becoming increasingly uncontrollable. This will delight some and worry others, but one way or another it looks as if we are on the brink of a major transformation of society.

This has led to a number of ambiguities and misunderstandings concerning the relationship between art and technology, art and science, and art and society. These misunderstandings are perpetuated by the fluid status of the artwork, art having expanded to such an extent that it is no longer possible to distinguish clearly between artistic and non-artistic spheres. There has been a flood of people declaring themselves to be artists as soon as they have drawn their first line. This has led to the production of a large number of thoroughly conventional artworks that might be interesting from a technical point of view but are often based on outdated aesthetic ideas.

As for the mechanical creation of art, this is nothing new. Due to its rapid growth, however, it has made research and the application of criteria by which to judge art that much more difficult. Consequently, the general public is thrown back on its own subjective responses. This subjectivity is strongly influenced (and manipulated) by changing trends and the pre-established aesthetic discourse that currently proliferates (under the guise of mass information and education of the various target audiences). The dominance of technology seems to be a fundamental aspect of much of today's art. In this context, the role of the artist seems more than ever to lie in adopting, controlling and stretching the

limits of the various conflicting data (material, physical and sociological).

Art has become a kind of common currency traded by the members of an international tribe. This universal aestheticization is built on globalization. We should not delude ourselves: interactivity can conceal programmed actions and predetermined pseudo-choices. We should also be wary of the all-embracing pedagogy taking root almost everywhere and which increasingly confines the spectator's actions and reactions to a well mapped-out path. Should the function of art be to smooth and polish rough reality? Should art be turned into a kind of apprenticeship for social, political and economic life? Should we be using interactivity in art as a way of preparing individuals for their future roles in society? In doing so, would we not run the risk of establishing a narrow, predetermined view of both art and society, and this within a society whose interactions are increasingly pre-programmed and formalized? Would we not run the risk of 'roboticizing' the world? It is not our intention to object to art's educational function. Art institutions play a significant part in this function, and indeed it needs to be developed further. But this 'utilization' and 'manipulation' of art should only be regarded as a secondary stage, beyond the art itself. The art produced by 20th-century avant-garde movements was seen as a critical form of art that broke with the past. All this has changed today with the appearance of the 'art-mirror' – an art of reflection using programming systems and becoming ever more closely involved with global strategic issues, be they social, political or economic. Is today's art destined to serve as a mirror, reflecting the state of global civilization?

The inventiveness and talent of those artists who use the tools and language of the modern age to construct daring, poetic environments should be warmly applauded: Tony Oursler, Gary Hill, Bill Viola, Thierry Kuntzel, Laurie Anderson, Pipilotti Rist, Pierrick Sorin – not to mention all the artists who are currently pitting their wits against the language of digital technology, virtual technology and the networks. More than ever before, art today has a vast

range of possibilities at its command. The potential for creativity and playfulness is enormous.

However, we should remain sceptical of an art trapped in prefabricated 'networks', an art that runs the risk of turning into a kind of global, collective 'art in kit form', delivered ready-made and accompanied by a set of instructions. All the user would then have to do is choose from certain parameters in order to determine the ultimate form taken by the work.

It is not healthy for art to be too closely integrated with the society from which it springs or to be totally diluted within it. This would result in its losing its traditional critical function. It is therefore necessary, more than ever before, for artists to maintain a distance between their work and the world in which they live if their art is to be anything more than a simple mirror reflecting changing trends.

At issue is the changing definition of art, and all its far-reaching implications. And, of course, this definition is closely bound up with our definition – or redefinition – of what we call civilization.

Kazuhiko Hachiya, *Centrifuge*, interactive installation, 2002.

Glossary

Analogue image See page 97.
Artificial image See page 97.
Artificial light See page 97.
Avionics The use of electronics and information technology in aviation.
Bit A basic unit of information in binary code, having either of the two values 0 or 1.
Cathode-ray tube A device in which a beam of electrons is directed onto a fluorescent screen where its impact produces an image. Main component of television sets and the visual display units of computers.
Cave, The See page 157.
CD-ROM See page 137.
Colourization An electronic process whereby black-and-white images are transformed into colour images.
Computer A machine that processes data automatically, using arithmetical and logical programs.
Computer graphics Technology permitting the representation and processing of images by computer.
Cut-in See page 46.
Cybernetics The study of automatic command and communication processes in living organisms and machines. Theory first developed by Norbert Wiener in the 1940s.
Cyborg See page 149.
Database A collection of specific information stored and managed on computer, accessible online and remotely.
Digital image See page 97.
Electronics Technology using variations in electric current to capture and transmit information.
Ergonomics The study of workers and their environments, aiming to achieve the best possible adaptation of equipment to the user.
Feedback See page 39.
Force feedback The artificial stimulation of various sensations (touch, pressure, resistance, etc) relating to objects and devices that are either virtual or real but remote from the viewer.
Fractals See page 109.
Graphics palette See page 19.
Hacker A person who circumvents copyright laws relating to the protection of computer software, particularly on the Internet.
Hardware The mechanical, electrical and electronic components of a computer (as opposed to software).
Holography The recording and reproduction of three-dimensional images based on the interference between two laser beams.
Hypermedia A technique permitting the organization and linking of information stored as text, image and sound.
Hypertext A database allowing navigation from one text to another using pre-established routes.
Immaterial See page 218.
Information technology The automatic processing of information using computers and software.
Installation See page 59.
Installation space See page 64.
Installation time See page 67.
Interactivity Reciprocal action taking place in real time between a human user and a technical device. Interactivity encourages contact between the public and an artwork. The viewer becomes involved in the work and participates in its operation.

Mechanical data processing The sorting, processing and transformation of information using punched cards.

Memory An electronic device for the recording, storage and retrieval of data.

Random access memory (RAM) Storage of volatile data that can be both read and modified by the user.

Raster A normally rectangular pattern of parallel scanning lines forming or corresponding to the display on a cathode-ray tube.

Read-only memory (ROM) Storage of non-volatile data that can be read but not modified by the user.

Morphing See page 197.

Multimedia art See page 120.

Network See page 170.

Optical printing See page 200.

Oscilloscope A measuring instrument that displays variations in voltage on a cathode-ray screen.

Paluche See page 56.

Performance See page 38.

Pixel A recorded image is composed of single-colour dots called pixels, which are the smallest constituent element of a picture. The number of dots that can be displayed on the screen determines the definition or resolution of the image.

Pixilation See page 200.

Real time See page 158.

RGB (red, green, blue) colour See page 55.

Rhizome See page 217.

Sensor A technical device designed to capture physical data (body movements, visual and acoustic stimuli, etc). Can be used in conjunction with a data-processing system.

Simulation The replacement (for research purposes) of a phenomenon or system by a simplified computer model that behaves in a similar fashion.

Site A virtual location; a collection of information (or Web pages) available on the Internet and accessed via a server (a computer that manages and distributes databanks).

Sociological art See page 166.

Software A set of rules and computer programs allowing information to be processed in a specific way (as opposed to hardware).

Telepresence See page 160.

Television The transmission by cable or radio waves of images that can be displayed on a screen as they are received.

Three-dimensional (3-D) image Unlike the two-dimensional (2-D) image which has only length and breadth, the 3-D image captures the subject from a number of angles and thus has depth as well.

Tournette See page 46.

Ubiquity See page 220.

Video installation See page 59.

Virtual reality See page 155.

World wide web A system for accessing and retrieving multimedia information over the Internet, whereby documents stored at numerous locations worldwide are cross-referenced using hypertext links, which allow the user to move from one document to another.

Index

Photo credits

We reserve the right to reproduce illustrations in cases where we have been unable to obtain contact details for the author or eligible party despite research, and in cases where no credits are specified.